This is not a hoax

This is not a hoax

Unsettling Truth in Canadian Culture

Heather Jessup

WILFRID LAURIER
UNIVERSITY PRESS

This book has been published with the help of a grant from the Canadian Federation for the Humanities and Social Sciences, through the Awards to Scholarly Publications Program, using funds provided by the Social Sciences and Humanities Research Council of Canada. Wilfrid Laurier University Press acknowledges the support of the Canada Council for the Arts for our publishing program. We acknowledge the financial support of the Government of Canada. This work was supported by the Research Support Fund.

Library and Archives Canada Cataloguing in Publication

Title: This is not a hoax : unsettling truth in Canadian culture / Heather Jessup.
Names: Jessup, Heather, author.
Description: Includes bibliographical references and index.
Identifiers: Canadiana (print) 20190053577 | Canadiana (ebook) 20190053615 |
 ISBN 9781771123648 (hardcover) | ISBN 9781771123655 (EPUB) | ISBN 9781771123662 (PDF)
Subjects: LCSH: Truthfulness and falsehood in art. | LCSH: Hoaxes—Canada. | LCSH:Deception—
 Canada. | LCSH: Literary forgeries and mystifications. | LCSH: Tricksters.
Classification: LCC N8254.7 .J47 2019 | DDC 700/.453—dc23

Cover design by Michel Vrana. Front-cover image by francescoch (figure), sorrapong (texture), both from istockphoto.com. Interior design by Michel Vrana.

Lines from "Essay on What I Think about Most," from *Men in the Off Hours*, by Anne Carson, copyright © 2000 by Anne Carson. Used by permission of Alfred A. Knopf, an imprint of the Knopf Doubleday Publishing Group, a division of Penguin Random House LLC. All rights reserved.

© 2019 Wilfrid Laurier University Press
Waterloo, Ontario, Canada
www.wlupress.wlu.ca

This book is printed on FSC® certified paper. It contains recycled materials, and other controlled sources, is processed chlorine free, and is manufactured using biogas energy.

MIX
Paper from
responsible sources
FSC
www.fsc.org
FSC® C103567

Printed in Canada

For Mari

Contents

List of Figures

Little Disrupters

ONE MORNING I WOKE UP, ATE BREAKFAST, WALKED TO THE ART Gallery of Ontario, toured through the basement of the historical home of the Grange, believing that I was seeing an archeological dig, did not see what I expected, and was changed. Since then, I have spent years of my life examining books and works of art in Canadian culture that at first glance appear to be factual, non-fictive, documentary, but in fact tell lies in order to wake people up. I have chosen the company of people who do not exist so that I can better understand the real, living relationships we navigate daily between make-believe and myth, trust and discomfort, truth and lies. What I came to realize is that these fictive companions have been accompanying me throughout my life. Hoaxes, in their various guises, are everywhere.

Attending elementary school in Regina, Saskatchewan, I first saw the paintings of Paul Kane, inaccurate depictions of Indigenous people and culture that I took to be truth in my childhood education and which I now find terribly troubling. In my teens, growing up in Vancouver, I frequently visited artist Jeff Wall's large-scale cibachrome transparencies lit up on the plain white walls of the Vancouver Art Gallery—not knowing whether his photographs documented real life, captured images of posed actors, or something

in between. At the age of twenty-five, I lived in Montreal and attended Erín Moure's book launch of *Little Theatres* in a loft in Little Italy, where I first met the name of her heteronym, Elisa Sampedrín, believing Elisa to be real. In Toronto, on that fateful morning in my early thirties, I visited an archeological dig because I was intrigued by the life of a maid named Mary O'Shea, only to be caught in a hoax, a ruse, a trick, a performance art piece.

When I examined these experiences of being hoaxed, I came to understand that it was the experience of *re-seeing* that was, and continues to be, most captivating to me. I wanted to understand *why* I had believed these stories. What were the markers that made me feel that the stories were *true*? Why did I trust those markers? How often had this kind of tricking happened to me in other circumstances? How often had I believed something, only to discover later that it was not true as I had originally perceived?

Or, put a different way, how often had I trusted in a simple, uncomplicated belief, only to realize that life was much, much more complicated?

I began to realize that everything that mattered intensely and deeply to me had been revealed—in some capacity, at some point in time—to be a hoax. Or, at least, that my original understanding of what *love* was, what a committed *relationship* was, what *religious belief* was, what it meant to be a *Canadian*, what it meant to be a *student* or a *teacher* and—jumping back to my first ever critical theory class that made my head feel like it was going to explode reading Barthes and Derrida and Foucault—what my understanding of a *text* was, or an *author*, or what it is I do when I *read:* all of these moments and values became richer when my beliefs, habits, and unthinking expectations were revealed to me, and I was forced—often against my will or desire—to revise my thinking. Re-examining what I had previously taken for granted made me more grateful, more engaged, and more attentive to the most important aspects of my life.

No matter where and when one looks in the history and geography of human culture, tricksters can be found in stories told from Northern Europe to South America. Characters such as Loki, Hermes, Anansi, Coyote, and Raven create confusion and populate myths all over the globe.[1] Fernando Pessoa hoaxed in Portugal. James McAuley and Harold Steward hoaxed in Australia. In an issue of the *Classics Journal* from 1817, scholars discuss how portions of Plato's dialogues were surely written by other authors, how "a multitude of spurious productions have been published" by "impudent monks" under such names as Homer, Aesop, Euripides, Hippocrates, Aristophanes, Plutarch, Virgil, Ovid, and Seneca.[2] In 1996, the cultural studies journal

Social Text published an article by New York University physics professor Dr. Alan Sokal, which, although believed to be a legitimate interdisciplinary argument concerning linguistic constructs, was in fact composed of citations from previously published articles and books in order to express Sokal's dismay at what he felt was the "haphazard appropriation" of scientific terms by humanists, which he aimed to confront through a "modest (although admittedly uncontrolled) experiment."[3] Currently, the Museum of Jurassic Technology, founded by David Hildebrand Wilson and situated in Los Angeles, California, houses astonishing historical, archaeological, and botanical discoveries in cabinets of curiosity. The veracity and origins of the artifacts—such as the Cameroonian stink ant, the Flemish fruit-stone carvings of the Crucifixion, and the Floral Stereoradiographs of Albert G. Richards—are all dubious.[4] To museum visitors, it is extremely unclear which curios in the cabinets are fake and which are real.

Despite their universality, what began to interest me most were hoaxes that had happened in the places I had lived. By luck, Canada is my birthplace and my home, and like Linda Hutcheon in *The Canadian Postmodern*, I believe that when I write "the impulse to situate is important" and what I produce is inescapably "a direct product of my own positioning."[5] Like Hutcheon, I do not consider writing about Canada a "patriotic duty," for if I have any patriotism it is accompanied by a great deal of pain and sadness at our country's violent colonial history and at what we have taught to generations of Canadians as "truth" in our cultural and educational institutions with a pointed exclusion of peoples and stories outside of legislated, hegemonic, and colonial "norms." This book is instead an exploration of the literatures and landscapes that have helped confuse, rile, inspire, and unsettle me in my knowledge of the literature, history, culture, language, and art of the places I have called home. Friedrich Nietzsche once remarked in *Beyond Good and Evil* that any form of philosophy—and I would argue any form of writing or art—is a kind of "involuntary and unconscious autobiography," and so too is this book.[6] This book is an attempt to trace some of the unsettling moments I have had looking at art and reading literature in Canada that have surprised and shaped me as a writer and scholar.

I choose to study contemporary works because I can be physically present, in galleries and at literary readings, fully alive alongside the artists, writers, artwork, and literature I study. These works, and reactions to these works, are continuing to unfold. I am honoured to be a part of this ongoing conversation. Because this process of experiencing and writing about hoaxes has changed

4 | INTRODUCTION

the way I perceive stories, offer and accept trust, view the roles of cultural institutions, and engage with scholarship, literature, and art, my bold hope is that my reader will be challenged and changed by my observations, and might challenge my observations in return so that the conversation can continue.

As a writer and reader, I perceive the forms of written language to be intrinsically linked to the content of a written work: a choice of a line break can be as important as the language in a poem; the use of omniscient third-person narration or first-person confessional are part of a novel's meaning. Yet what I have noticed when reading scholarly work on hoaxes is that the forms often do not attempt to embody the style, work, or praxis of hoaxes themselves. How can one learn about the slippery, sneaky, and unsettling nature of a hoax through written forms that are primarily linear, taxonomical, and didactic? Even turning to the *Oxford English Dictionary*'s definition of hoax—"an act of hoaxing; a humorous or mischievous deception, usually taking the form of a fabrication of something fictitious or erroneous, told in such a manner as to impose upon the credulity of the victim"[7]—reveals the dilemma of attempting to write a unified definition or taxonomy of hoax. The definition of hoax found in the *OED* indicates that hoaxes resemble numerous other acts: jokes, errors, fictions, and mischief. Moreover, the definition addresses one experience in the relationality of a hoax—the experience of the "victim"—but does not identify who or what might produce a hoax, or, indeed, why a hoax might want to compromise credulity. When one looks to the definition, further questions arise: is compromised credulity an act of deliberate betrayal, or, on the other hand, an act performed to encourage awareness and attention to the stories we are told? The definition mentions humour, but could not a hoax also lead to serious philosophical contemplation? Or could some people just not find hoaxes funny? The more fiercely one endeavours to discern a uniform understanding of *hoax* from the dictionary, the more slippery a hoax seems to become. Hoaxes create disorder. Hoaxes defy rather than classify, not simply for the sake of chaos alone, but so that the perceived stability of classification and definition is shaken, and so that historical ideas of identity, hierarchy, and institutional trust are re-examined. Yet, regardless of the disruptive nature of hoaxes, studies on the subject are often written in forms that employ the classification and hierarchy that hoaxes aim to topple; the methodologies of studying hoaxes rarely match the subject's unruly material.

When one turns from the dictionary to deeper scholarly approaches to understanding hoaxes, the same problems arise in attempting to delineate what is inherently, duplicitously various. Hunter Steele aligns hoaxes in visual

art directly with forgeries, as works of art that "falsely purport to have a given history of production."[8] An example of this might be a portrait painted by a woman living in Muncie, Indiana, in the late 1980s who claims that the work's origin is actually mid-seventeenth-century France. But there are numerous hoaxes that operate differently than forgeries. Many hoaxes do not want to fool the viewer forever, but ultimately want to be found out. Julia Abramson notes the importance of this moment of a reveal in her book *Learning from Lying*. She chooses to use the word "mystification" in her work to explain how hoaxes might differ from forgeries, specifying that writers and artists who create mystifications will *always*, ultimately, want them to be found out: "Where forgery conceals its origins and depends for viability on the cloak of secrecy, mystification discreetly points out its own art of invention."[9] Yet, this definition still feels too narrow for the subject. Given that the task of revealing a hoax is an act that exists between an artist and a viewer, or a writer and a reader, often within the context of an authoritative space such as a book or a museum, a single defining moment of reveal, orchestrated solely by a hoax's author, is not a reliably universal definition. The author's intention to hoax cannot be the only requirement in defining such a complicated experience in which many have agency and in which discoveries can be various and unplanned. K. K. Ruthven's scholarly work on hoaxes also seeks a singularizing definition. He tries out the word "superchery" as "an organizing term for a study of fake literature," but ultimately confesses that even this singular word creates more variation than delineation.[10] Brian McHale suggests that there are three types of hoaxes. The first type, genuine hoaxes, are "perpetrated with no intention of their ever being exposed."[11] McHale cites as examples James Macpherson's "Ossian" poems, the art forgeries of Han van Meegeren, and Konrad Kujau's forged Hitler Diaries. The second type, trap-hoaxes, are "designed with didactic and punitive purposes in mind," wherein "the hoax is exposed by the hoaxer himself or herself when the time is right, to the discomfiture of the gullible."[12] The Ern Malley hoax is McHale's key example, wherein James McAuley and Harold Steward jointly composed a set of sixteen modernist poems by a fabricated poet in order to embarrass and discredit the Modernist Australian journal *Angry Penguins* and its editors. The third type, mock-hoaxes, are like trap-hoaxes in that the deception is temporary,

but, where trap-hoaxes depend for the effect on the dramatic moment of exposure ("gotcha!"), mock-hoaxes are meant eventually to be seen through without any traps being sprung. To that end, they typically refer in a more or

less veiled manner to their own double nature, leaving it to their readers to draw the relevant inferences.[13]

Examples cited include heteronymic poetry published under the names "Alberto Caeiro," "Alvaro de Campos," and "Ricardo Reis," which are, in actuality, created (along with their elaborately cultivated poet-personas) by Fernando Pessoa. McHale's categories are helpful and persuasive, yet what McHale's, Ruthven's, Abramson's, and Steele's definitional approaches also produce is further proof that hoaxes are not easily classified. Their scholarship ultimately confirms that each hoax is unique, variable, contextually dependent on the institutions in which the hoax takes place, and relational to the readers or viewers who encounter the work. Each hoax has its own particularities and unique qualities, and, like a live performance or a first kiss, can happen only once for an individual reader or listener in a singular, unrepeatable moment. There are in fact an infinite number of hoaxes, taking place anew with each reader or viewer's discovery of a work's falsity, untrustworthiness, and trickery.

Because scholars such as McHale, Ruthven, Abramson, and Steele, and many more before and since, have laid down such concise taxonomical and definitional frameworks in their publications, I want to add to these conversations about hoaxes in a slightly different way. I use methodologies in my study of Canadian hoaxes that attempt to listen to and formally match these marvellously tricky objects of study as closely as possible. In an introduction, one is meant to outline one's methodology—but identifying what forms of writing have inspired and riled me is perhaps a better way to describe my approach. While I've been thinking about hoaxes over the years, a number of philosophers and critics have inspired me with their alternative approaches to studying, learning, and writing about what they see in the world: Ludwig Wittgenstein's theory of family resemblances; Mark Kingwell's additive definitions; Geoff Dyer's and Jorge Luis Borges's taxonomies that manage to unfurl taxonomic structure through hybridity and humour. Also key to my thinking have been Jonathan Lear's ideas about irony and disruption, and Ami Harbin's philosophical work on disorientation.

In his *Philosophical Investigations*, Ludwig Wittgenstein advocates understanding through "objects of comparison,"[14] that is, objects or concepts that share characteristics with each other—perhaps even belonging to the same family—while also remaining distinct. In explaining his theory of "family resemblances," Wittgenstein asks his readers to consider "the proceedings that we call games," including "board-games, card-games, ball-games, Olympic

games, and so on."[15] He asks, "What is common to them all?" while insisting that his reader not just say there must be something in common or they would not all be called games. Wittgenstein advises that the reader look not just to theory but to examples from the real world: "*look and see* whether there is anything common to all—For if you look at them you will not see something that is common to *all*, but similarities, relationships, and a whole series of them at that."[16] Wittgenstein reveals how, if one is searching for a single unifying commonality amongst games, one will quickly fail. Starting with board games, moving to ball games, and then on to chess and tic-tac-toe, he asks: "Are they all amusing? Or is there always winning and losing, or competition between players?"[17] For every example, there is always an exception or a complication: "In ball-games there is winning and losing; but when a child throws his ball at the wall and catches it again, this feature has disappeared."[18] Wittgenstein then tries the unifying measures of skill and luck: "Look at the parts played by skill and luck; and at the difference between skill in chess and skill in tennis. Think now of games like ring-a-ring-a-roses; here is the element of amusement, but how many other characteristic features have disappeared!"[19] He insists that one can "go through the many, many other groups of games in the same way; can see how similarities crop up and disappear."[20] As a result of such an examination one comes to see "a complicated network of similarities overlapping and criss-crossing: sometimes overall similarities, sometimes similarities of detail."[21] In the end, what Wittgenstein surmises is that "I can think of no better expression to characterize these similarities than 'family resemblances'; for the various resemblances between members of a family: build, features, colour of eyes, gait, temperament, etc., etc. overlap and criss-cross in the same way—And I shall say: 'games' form a family."[22] Likewise, I shall say that hoaxes form a family. Such a non-taxonomical strategy excites me because it means readers, viewers, and scholars can revel in the particularities of each hoax. In seeking "objects of comparison," scholarship on hoaxes need not get bogged down in trying to determine taxonomies. Yet we can still see the webs, lace patterns, and double helixes that connect distinct hoaxes to each other through the sharing of genetic material.

Canadian philosopher Mark Kingwell, rather than seeking a discrete and distinct definition for a hoax, riffs on a non-taxonomical response. Kingwell's is a kind of defining that urges scholars to use an accretive rather than taxonomical epistemology: "A gag, a goof, a blindfold; a spoof, a jape, a deceit; deliberate equivocation; fakery, impersonation, infiltration. Pretending what

is not the case. The triumph of appearance over reality. A joke that functions by way of deception."[23] Kingwell's definition does not delimit but multiplies. His definition of hoax mimics the varieties of deceptions hoaxes instigate. Rather than feeling sheltered in one idea or feeling safely at home in one line of thinking—a comfort that a generalizing definition often offers because it is streamlined, uncluttered, and uncomplicated—Kingwell's accretive response to the question "What is a hoax?" frustrates classifications just as hoaxes themselves do. His definition consists of a bit of the chaos that hoaxes likewise instill in their readers and viewers. Just as Wittgenstein insists that his readers look not just to theory but to practical examples from the real world, to "objects of comparison," to gain understanding, so too does Kingwell's definition point us to examples, to objects, to acts of hoaxing, that are related but cannot be stabilized into a general definition. His definition makes us "look and see" multiple examples, as Wittgenstein advises, rather than grasping for taxonomical structures or unifying definitions.

Geoff Dyer and Jorge Luis Borges are two more writers who question taxonomical and hierarchical orderings in scholarship by enacting creative and humorous alternatives that deepen a reader's phenomenological experience more than they seek essentializing definitions. Dyer re-examines the practices of taxonomy using a different methodology in his wonderfully imaginative book on photography, *The Ongoing Moment*, in which an entire section is dedicated to the category "photographs of blind accordion players," another to "photographs of hands," and others to "park benches," "picket fences," and "people wearing hats." Dyer's system of classification is absurdist in its taxonomies, the categories themselves being seemingly arbitrary groupings. Through the peculiarity of his classifying systems, his critical work encourages his readers to question the practice of placing objects and ideas into categories, and to imagine classifying systems that operate in unconventional ways. Along related lines, Borges (through a surprisingly bizarre and arcane "encyclopedia," imagined in his book *Selected Non-Fictions*, a book that primarily and contrarily consists of works of fiction) creates humorous and absurd encyclopedic classifications. The classifications mock the general scholarly desire to create order from disorder, which can be at times both arbitrary and obsessive. Animals are divided into taxonomies whose imaginative groupings subvert the desire for taxonomical classification altogether: "(a) those that belong to the Emperor; (b) embalmed ones; (c) those that are trained; (d) suckling pigs; (e) mermaids; (f) fabulous ones; (g) stray dogs; (h) those that are included in this classification; (i) those that tremble as if they were mad; (j) innumerable

ones; (k) those drawn with a very fine camel's-hair brush; (l) et cetera; (m) those that have just broken the flower vase; (n) those that at a distance resemble flies."[24] Borges, like Dyer, subverts the conventions of taxonomies by using order arbitrarily to create a kind of disorder, and, further, pokes fun at the systems of classifications that have undergirded the history of scholarly pursuits since Linnaeus first devised taxonomical systems during the Enlightenment.

Jonathan Lear asks, "What if the *OED* gives us the history of our *routines* with the word, but there is also a phenomenon that underlies and disrupts these routines? What if this little disrupter is crucial to the human condition?"[25] Lear's idea of words and concepts being constructed out of our *routines* but also vulnerable to the sway of an inherent *disrupter* is another interpretive model that works well in relation to hoaxes. Following Lear's descriptions of Socratic *eirōneía*, hoaxes, like irony, have the characteristics—as Socrates himself did standing in the Agora asking questions—of disrupting routines and routine assumptions, including definitions themselves. Just as Lear argues for the fruitfulness of ironic disruption in scholarly routine, Ami Harbin claims in *Disorientation and Moral Life* that "our experiences of disorientation can teach us about how to live responsibly in unpredictable circumstances."[26] Harbin's consideration of the personal moral transformations that can occur when being disturbed and disrupted is, likewise, vital to a scholarship of hoaxes. I am interested in thinking about hoaxes and writing about hoaxes in ways that attempt to interrupt scholarly routines and help us to imagine how the precarity, uncertainty, and unpredictability innate to an experience of a hoax can be fruitful in disrupting current stalwart—oftentimes harmful—beliefs about what Canadian culture even means.

A rich variety of hoaxes come from this country, and they interact with the history, landscapes, and people of this particular place. Because of their unruly nature, the works of contemporary Canadian artists and writers Iris Häussler, Brian Jungen, Jeff Wall, Rebecca Belmore, Erín Moure, and David Solway offer unique opportunities for reflection and revision to individuals and institutions—such as the museums, laboratories, libraries, art galleries, publishers, and universities—that are responsible for guarding, taxonomizing, ordering, and disseminating human ideas in this country. I will focus on Häussler's *He Named Her Amber*, Jungen's *Sketches Solicited for Wall Drawings*, Wall's near-documentary photographic techniques in *Fieldwork*, Belmore's performances in *Wild* and *Vigil*, and the heteronyms of Erín Moure and David Solway—all of which question assumptions about Canadian culture and aim to test individual and institutional authority.

Cultural and scholarly institutions give shelter to ideas; they are homes for thinking. Categories and classifications endeavour to keep at bay confusion, murkiness, ambiguity, and duplicity. Hoaxes, on the other hand, frustrate classifications and the protection from chaos that institutions and their inherent taxonomies attempt to provide. Yet, these contemporary Canadian hoaxes do not dismantle systems of thought or the taxonomical curation of ideas and artifacts simply for the sake of destruction. The works of Häussler, Jungen, Wall, Belmore, Moure, and Solway operate with the understanding that institutions are necessary—if problematic—guardians of cultural artifacts and human knowledge, and that we ought to be able to trust universities, museums, art galleries, publishers, and governments to support and protect the production of human invention. What these hoaxes provide, however, is a momentary glitch in the system that gives pause—pause enough to consider why and how we classify knowledge at all, to examine with what colonial assumptions these systems and institutions continue to operate, and to question what gains and losses we acquire through scholarly and cultural institutions in Canada and their practices of capture, study, and dissemination.

My hope is that each section will be accretive in its approach to the artworks and literature, not employing unnecessary delineation or hierarchy. I have chosen these case studies not because they exemplify some uniform structure or pattern that I see as essential to all contemporary examples of hoaxes, but because these artworks and texts, although they are members of the same family, differ in numerous ways, including in their audiences, authors, and genres. The works examined could be classified as archaeology, visual art, anthropology, performance, poetry, or translation. Many of the works, however, could be placed under more than one genre, and many thwart conventional genres altogether. I endeavour to identify the methodologies and conventions that each hoax engages with and then frustrates. I map the various pacts that each hoax complicates: the pacts between artist, gallery, and patron; between ethnographer, museum, and museum visitor; between author, publication, and reader.

Hoaxes are imperative forms of literature and art that complicate and mess with clear taxonomical understandings. Hoaxes operate as moments of disruption to our personal and institutional habits and routines. These hoaxes disturb and disorient readers and viewers, and this disorientation is integral to acts of pause, contemplation, and revision—forms of thinking that are of service to deeper self-reflection and institutional self-awareness. By their insistent disobedience, hoaxes demand that we re-examine conventions of

systematic and generic order, unquestioned institutional trust, and moments of self-assurance, or even self-righteousness, that can, at times, lead us and our institutions to become hardened in their ways of thinking and resistant to adaptation and change.

Contemporary Canadian culture is shifting fiercely these days. The Truth and Reconciliation Commission's Calls to Action ask all Canadians to honestly and humbly disrupt our national myths of Canada as a bastion of friendliness, peacemaking, and egalitarianism in order to face the ramifications of cultural genocide committed against Indigenous peoples on this land. These Calls ask Canadians to recognize and change the inherent racism against Indigenous peoples that exists in our current judicial systems, education systems, financial systems, medical systems, and religious practices. Hoaxes remind us that to revise our thinking, to re-see ourselves and our histories, is a lifelong practice that is necessary for any hope of reconciliation (or even conciliation) in this place. Academic institutions that have maintained exclusionary hierarchies in their funding allotments, hiring practices, tenure selections, and student enrolments based on gender, race, and affluence are being questioned by student bodies and donors. Movements such as #MeToo and #TimesUp have unburied long-standing deeply misogynistic and racist cultures of abuse toward graduate students, research assistants, and teaching assistants in academic institutions. Even universities and professorships, hoaxes remind us, are not stable institutions; the academy's unquestioned traditions are deeply in need of change. The hoaxes I examine attempt to disrupt the hierarchical taxonomical structures of humanity's most respected cultural institutions. They act to ensure that galleries, museums, works of literature, and universities do not cease to be places of learning and self-examination, and that they remain open to the transformations that can occur when one recognizes they have been disrupted or mistaken.

Iris Häussler's *He Named Her Amber* encourages an examination of the trust that patrons place in the institution of the gallery, and the varied responses and reactions viewers have when that trust is broken. The disorientations and interventions spurred by a hoax have the capacity to rejuvenate reflection in the disciplines of artmaking, art history, and curation, even as a hoax has the potential to leave viewers feeling hurt. In the case of methodologies employed in the disciplines of ethnography and anthropology specifically, I am interested in nineteenth-century ethnographic practices foundational to imperial expansion and the establishment of Canada as a colonial nation. Through an examination of Paul Kane's sketches and portraits

of early Canada, and, subsequently, *Sketches Solicited for Wall Drawings* by Brian Jungen, the photograph *Fieldwork* by Jeff Wall, and the performances *Wild* and *Vigil* by Rebecca Belmore—contemporary artworks that employ a decolonizing technique known as "reverse ethnography"—I explore the ways these contemporary artworks, familial with hoaxes, disrupt myths of the "peaceful settler" and the "vanishing Indian," damaging myths still existent in contemporary ideas of Canadian history and identity. Jungen, Wall, and Belmore encourage viewers and institutions to examine persistent, often-times violent, colonial prejudices. The heteronymic writings of Erín Moure and David Solway foreground translational felicity over fidelity through unconventional translational approaches. In particular, their use of invented authors disrupts the common conception that authorship, translation, and even selfhood are seamless acts or identities. Moure's and Solway's heter-onyms, through their disruption of generic and authorial conventions, have the capacity to change current publishing practices and governmental policies on translation in Canada. Throughout the differing cases in this book, hoaxes instruct readers and viewers disruptively and often paradoxically. Hoaxes are capable of revealing hardened habits that have come to be considered truths. Hoaxes remind readers and viewers that it is not the taxonomies of cultural institutions that protect humanity from chaos and bestow knowledge, but the human capacity for flexibility and adaptation, which helps us endure, and perhaps even at times delight, in those inherent "little disrupters" underlying institutional practices and personal routines.

I also want to be sure to recognize that the contemporary Canadian hoaxes I have the privilege to think and write about are of a particular kind—they are art. These hoaxes rely on the trust and habits of museum-goers and gallery attendants, of readers and publishers, in order to thwart trust and overturn habit. These hoaxes have made me uncomfortable. They have been mimetic of the inescapable and often most painful of experiences—mistak-enness, uncertainty, error, loss, hurt, and distrust—which inevitably occur in the course of a human life, and which, despite their undesirability, are often intrinsic to psychological growth. Hoaxes have the capacity to remind readers and viewers that in order to withstand, and even thrive from, the inevitable confusion and hurt in our lives, our ascribed narratives, expecta-tions, and hopes must occasionally be revised. Yet these contemporary hoaxes discussed in this book are *not*—I believe—irreparable lies that constitute abuse, create severe psychological damage, or help to instill or uphold his-torical and cultural erasure. These hoaxes are trying to crack open Canadian

cultural systems that have, at times, participated in such cruelty.[27] Hoaxes lie. Hoaxes rely on trust and perform deliberate acts of betrayal. But I want to clarify that there is an immense difference between lies and deceptions that bruise and recklessly damage lives, and trickery and fictions that leave us restless for change.

Since the morning that I woke up, ate breakfast, and walked to the Grange, what I have learned about hoaxes is this: they mess us up. They have the power to make our habits, what we have come to rely upon, unsteady and uncertain. But our being and our learning in this world are heightened when we question the facts we are given and when we require revision to understand our current circumstances. It is the instant our expectations unravel that we understand the potency of momentary confusion and come more fully to appreciate the remarkable capacities that we have—individually, culturally, nationally—for adaptability and change. To be tricked into believing a lie and then to recognize our mistakenness may in fact be the best thing that could happen to us.

A Novel in Three Dimensions

Iris Häussler's Historic Reconstruction at the Grange

IRIS HÄUSSLER'S HISTORIC RECONSTRUCTION AT THE GRANGE

ARCHIVISTS AND ART SPECIALISTS IN THE CITY OF TORONTO FIRST discovered Mary Amber O'Shea's waxen shapes in June 2007. The discovery began with a handmade clay-and-wax pinch pot globe, hidden for over a century beneath the stairs and behind a wall panel in Toronto's oldest surviving brick home. The Grange, as the Georgian house is known, is a beloved historical site in downtown Toronto. The colonial-style mansion overlooking sweeping green lawns was originally built by D'Arcy Boulton for his wife, Sarah Anne, and their eight children in 1817.[1] The splendid dining room, billiards room, and library quickly became a social hub for the gentry of the expanding British Empire. Over the years, the Grange was host to many great writers, civil thinkers, and philosophers—among them Charles Dickens, Ulysses S. Grant, and Matthew Arnold.[2] The Grange housed a thrice-elected Toronto mayor, a former tutor to the Prince of Wales, a determined gambler, and a handful of philanthropic widows.[3] There were also, of course, numerous servants who came and went, about whose lives not much is known—that is until Mary O'Shea's wax artifacts were discovered through the forgotten diaries of a butler.

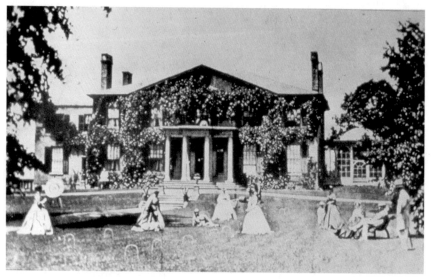

Figure 1. Archery and croquet on the lawns of the Grange, ca. 1866.
Photographer unknown. Image © 2018 Art Gallery of Ontario.

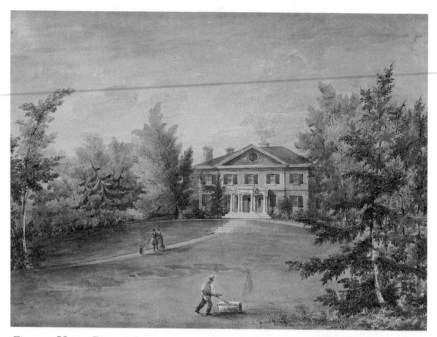

Figure 2. Henry Bowyer Lane, *The Grange*, ca. 1840. Watercolour on paper, overall
28.6 × 44.1 cm. Toronto, Art Gallery of Ontario, gift of Mrs. Seawell Emerson,
Marblehead, MA, 1972, transferred from the Grange, 2008.
Image © 2018 Art Gallery of Ontario.

The Grange has had a long history in Toronto—long, at least, if one considers the history of the city through the timelines of settlers and colonizers of the land. Well before the Boultons set foot in the mud of Toronto, the site had known human activity since Turtle appeared from the water, creating land and space for the Island's first peoples. The Grange land is the traditional territory of the Haudenosaunee, Huron-Wendat, and Petun First Nations, the Seneca, and the Mississaugas of the Credit River.[4] The territory was part of the *Dish with One Spoon Wampum Belt Covenant*—the first peace treaty made in North America between Indigenous nations before European arrival, who made a promise to each other to share resources so that none would go hungry.[5] In terms of settler history, the Georgian home is a sign and symbol of a prominent colonial family who settled in Toronto, and the preservation and celebration—through the meticulous care and collection of canopied beds, hat stands, stained glass windows, portraits, china sets, butter churns, and all manner of domestic accoutrements—of one family's prosperity and wealth. The building was transformed from a coveted private residence into a public civic site of arts and culture when the Grange was

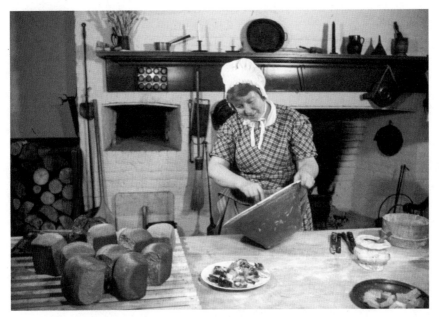

Figure 3. At the Grange, in the 1817 kitchen. *Household act: Ruth* [Keene, historical interpreter at the Grange] *baking the day's bread*, 1973. Photographer unknown. Image © 2018 Art Gallery of Ontario.

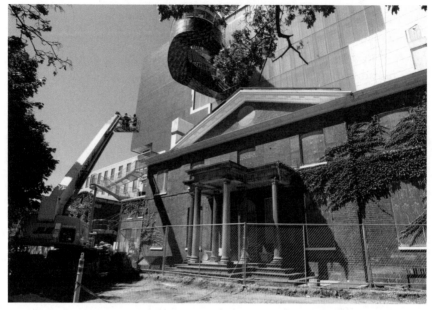

Figure 4. Exterior of The Grange: AGO Transformation, south facade, 2008.
Photo by Carlo Catenazzi. Image © 2018 Art Gallery of Ontario.

bequeathed to the city in 1911 to found the first Art Museum of Toronto,
later renamed the Art Gallery of Ontario (AGO).

Over its lifetime, the house has seen many changes. The AGO and its
collection of art outgrew the house and a new gallery building was built
behind the Grange lands on what became Dundas Street. The Grange ceased
to be a gallery space and was instead used for curatorial offices, storage, and,
for a brief time, a breakfast parlour for the gallery staff. In the 1970s, the
Junior Women's Committee for Toronto spearheaded a heritage preservation
campaign and the building was restored to its 1835 appearance so that tours
of the historical home could be opened to the public. The rooms were filled
with historic furnishings and costumed interpreters. Women dressed up
in old-fashioned maid's costumes and baked bread in the lower kitchens.
Children spied into the upstairs rooms. All the while, visitors, staff, and
volunteers had no knowledge of the strange Irish maid whose handiwork
was hidden beneath the floorboards and behind the walls.

It wasn't until Frank Gehry's architectural renovations to the Art Gallery
of Ontario were underway in June of 2007 that the papers of Henry Whyte, a
former butler at the Grange, came into the possession of the AGO. Amongst
the butler's counts for linens and silverware and the dates of hires, dismissals,

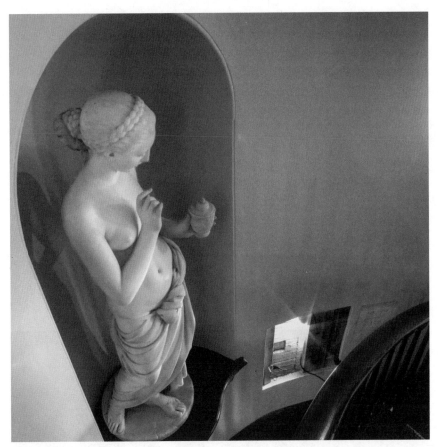

Figure 5. Overhead view of the main hall in the Grange, where an excavation site
is visible beneath Odoardo Fantachiotti's sculpture *Pandora*
(ca. 1870, marble, 152.4 cm. Gift of the family of W. R. Brock, 1924).
Photograph by Iakub Henschen.

and unexpected leaves for each groundskeeper, maid, and valet, a map of
the grounds caught archivists' attention. Whyte had marked sites on the
property where a new seventeen-year-old maid from Kilkenny, Ireland—
Mairín "Mary" O'Shea, whom Whyte inexplicably referred to in his notes
as "Amber"—had hidden handmade objects, described by Whyte as "waxen
globules."[6] The first object recovered was found behind a wall panel below
the original staircase in the Grange's main hall.[7] Like the majority of the
artifacts recovered, it is made of beeswax drippings from candles and clay
from the grounds. At the core of each object, materials seemingly obtained
on the property have been found: dried flowers, shards of china, flakes of

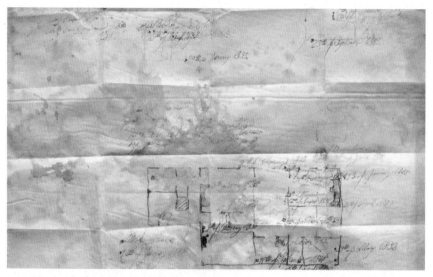

Figure 6. Henry Whyte's hand-drawn map of the Grange, ink and pencil on paper, 40 × 50 cm.

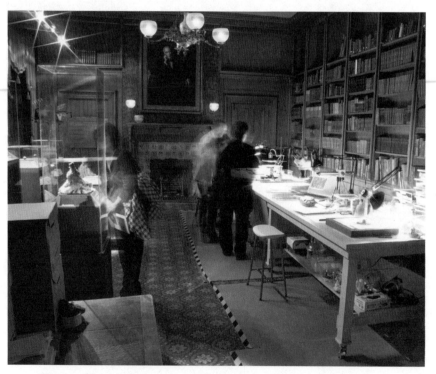

Figure 7. Visitors explore the artifacts displayed in the Grange library. Photograph by Iakub Henschen.

human blood from an unknown Caucasian female source, cinnamon, sugar, a lock of hair, a child's milk tooth, and animal bones.[8]

Due to the findings in the Whyte notebooks, anthropological contractors were called into the Grange building in the spring of 2007 to perform an initial investigation into the veracity of the mysterious hidden globes. The chief anthropologist on site was Korean-born Stanford graduate Dr. Chantal Lee, a specialist in historical reconstruction.[9] Under Dr. Lee's direction, Anthropological Services Ontario began to excavate the walls and floors of the Grange building, ultimately uncovering numerous waxen objects. At the request of the AGO, and under the supervision of Dr. Lee, Anthropological Services Ontario permitted public access during scheduled guided tours by a team of trained volunteers. The Grange became, once more, a busy hub for artists, patrons, tourists, and scholars curious about these waxen and clay shapes. (What to call Mary's globes precisely? Brute art? Irish folk superstition? An obsessive compulsion? Mourning for a miscarriage or for the death of family in Ireland? Visitors have speculated upon all of these possibilities.) Between November 14, 2008, and June 26, 2010, more than sixteen thousand visitors experienced the excavation site at the Grange.[10]

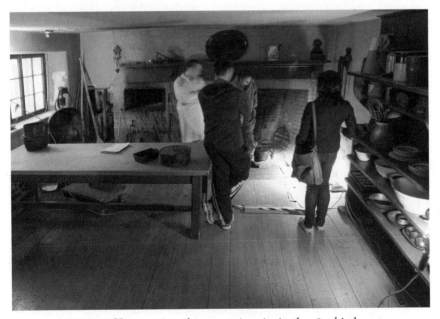

Figure 8. Visitors view the excavation site in the 1817 kitchen.
Photograph by Iakub Henschen.

The extraordinary findings of Mary O'Shea's handiwork, alongside Dr. Lee's openness to discussing the archaeological significance of the site—she handed out her business cards and a letter to each visitor who happened upon the tour—inspired tour-goers to offer their genealogical, financial, scientific, and bibliographic expertise to assist in the Grange's discovery. Dr. Lee's letter was taken and read by many of these sixteen thousand visitors—on planes, in cafés, at their homes, and in their hotel rooms. One respondent even reported having read Dr. Lee's letter in the bathtub.[11] Yet, as convincing as the archaeological instrumentation, the excavation, and the historical details of Whyte's and O'Shea's stories were, the letter revealed a startling turn. When visitors read to the bottom of the page, they found that the letter was not signed by a Dr. Chantal Lee at all, but by another woman who specializes in "historic reconstruction." The dig at the Grange was in fact an elaborate fiction, an art installation by Toronto-based visual artist Iris Häussler: yet one more story to unfold on Turtle's back.

Hoaxes, like members of a family, resemble each other differently, fulfill divergent purposes, and possess different traits and personalities. Iris Häussler's *He Named Her Amber* is one portrait of an artwork that displays hoaxy resemblances, amongst other such works in contemporary Canadian visual art and literature. *He Named Her Amber* is but one case study. One purpose I see in Häussler's work is that it acts—as I also see in the work of Jungen, Wall, Belmore, Moure, and Solway—as a relatively safe experience in which patrons are able to discover, respond to, and examine feelings of contingency and surprise instigated by a sudden disruption to habituated institutional trust. The disorientations and interventions spurred by these works have the capacity—despite, at times, being felt by patrons as hurtful—to rejuvenate reflection in the disciplines of artmaking, art history, scholarship, and curation. More broadly, Häussler's work embodies the unanticipated disruptions that can occur to the expected narratives of our lives. The artistic, theatrical, and narrative components to *He Named Her Amber*, which are then cleverly combined with facts of the Grange's history, evoke questions in participants about how history is made, whose stories are told, and whether a holistic physical, emotional, and intellectual connection to the past is possible and, if it is possible, which aspects of our connection to history may be real and which are imagined.

When Wittgenstein discusses his model of family resemblances he advises thinkers to employ a particular tactic of inquiry: "look and see."[12] Throughout this section, I have tried my best to give an experience to the

reader of being able to "look and see" Häussler's hoax. My aim is to ground any arguments and theoretical observations this section makes in heuristic evidence. My hope with an observational model of inquiry is that readers will also be able to, as much as is possible through a written text, experience their own physical, emotional, and intellectual responses to Häussler's hoax, as if they too were one of the sixteen thousand visitors who experienced the excavation site at the Grange between 2008 and 2010.

HAPTIC CONCEPTUAL ART

Like multiple sites of historic reconstruction in Canada—Black Creek Pioneer Village, Toronto; the Fortress of Louisbourg, Cape Breton; Fort Walsh National Historic Site, Cypress Hills, Saskatchewan; the Habitation at Port-Royal in Nova Scotia's Annapolis Valley—Mary O'Shea's waxen globes substantiate a physical and sensual experience of the past oftentimes lacking in history books. The acts of popular historic reconstruction taking place both at the National Historic Sites of Canada and in Häussler's haptic art share the important trait of physical immersion, yet the objectives of the two immersive experiences are quite different. The National Historic Sites of Canada commemorate and celebrate primarily the settler-colonial history of the country through an "accurate" portrayal of what "life was like then." The animators are dressed in the proper brass buttons and the correct number of petticoats. They occupy well-rehearsed roles, whether that of a school mistress, a Jesuit priest, a canoe builder, or a member of a Scottish settler clan in full tartan regalia. The immersion experienced in National Historic Sites is meant to be—through an intimate, physical experience of history—nationalizing. One is left with a sensuous relationship to Canada's formation as a country. The narratives primarily build a sense of nationhood by centring around stories of the lives of European immigrants arriving in a place of wildness and wilderness and how they struggled to domesticate or dominate the land and the Indigenous inhabitants and cultures they encountered while occupying this "new" territory. Focusing the narratives primarily on European settler history in turn enacts the theory of *terra nullius* held by Europeans at the time: the idea that because they were non-Christians, the Indigenous populations present were not human and therefore the land was empty. Many of the narratives told at National Historic Sites celebrate Native and Métis culture, but often only so far as it relates to the lives and the survival of European colonizers. In contrast, the immersion experienced in Häussler's haptic conceptual art

is meant to evoke in visitors not solely a passion, pride, or connection to the history of the Grange but conceptual questions about how history is made, whose stories get to be told, whether a physical and emotional connection to the past is possible, and, if it is possible, what aspects of these experiences may be real or "accurate," and what is accessible only through our imaginations.

The phrase "haptic conceptual art" was coined by philosopher Mark Kingwell to describe how Iris Häussler's art works. In his essay "Imagining the Artist" Kingwell examines ten types of art and artists over the course of history—from Plato's image of the artist as a politically disruptive figure, to the artist as a "toiler in the workshop," to the artist as a "romantic genius," to the artist as a "philosopher," noting Duchamp's *Fountain* which "draws our attention to the contours of the art world itself."[13] Kingwell then ends his historical overview by describing an eleventh category of art beyond the philosophical postmodernism of Duchamp, in which he discusses an earlier artwork of Häussler's, similar in execution to *He Named Her Amber*, which took place in a small house in the Trinity-Bellwoods neighbourhood of Toronto. *The Legacy of Joseph Wagenbach* was an immersive installation based on the fictitious narrative of an elderly artist who filled his home with sculpture.[14] The home was then opened to the public for tours during what was perceived to be archival cataloguing by a civic task force that had been entrusted with the job after Wagenbach supposedly left the premises to enter long-term care. Kingwell calls this work "haptic conceptual art": *haptic* as in touch, sensation, physicality; *conceptual*, as in reflection, thought, and inhabiting ideas about the experience and purpose of art. His terminology recognizes that Häussler's art is rooted in conceptualism—art as a means of exploring new ideas—but that in Häussler's case the ideas of the artwork are experienced through touch and physical sensation. Kingwell recognizes that Häussler's work is "art not just of ideas, but art about the idea of art" and what is different or remarkable about her work is that this conceptualism "functions only because of the viscerality of the experience."[15] Kingwell mentions both "viscerality" and "ravishment" as being intrinsic to haptic conceptual art. It is this physical, as well as intellectual or emotional, bombardment to tour-goers that makes the first part of Häussler's hoax—an imagined and fabricated scenario being presented as real—believable. Once the reveal has taken place, this physical believability is key to viewers' pause, reflection, and revision of what, at first, seems to be an undeniable experience.

Full immersive belief in the excavation is a necessary part of Häussler's hoax. David Moos, the curator responsible for commissioning *He Named Her*

Amber, notes that the "undeniability of the hole in the foundation, perfumed by the damp smell of the excavated still-wet earth piled high in a room, counteracts whatever hesitancy the visitor may feel."[16] Moos believes that Häussler's art hinges on her recognition that "the sheer reality of the physical" is "the key to psychic belief" and that "this clash of sensibilities—disbelief in the presence of physical fact—is the fulcrum of Häussler's approach as an artist."[17] Viewers must at first believe that they are experiencing the actual physical objects and life stories of a real historical person, in order—when told that Joseph Wagenbach or Mary O'Shea are imagined historical figures—for those same viewers to question their systems of belief, their knowledge of history, and, further, to question the role of the artist and the historical institution in the formation of these beliefs.

Häussler does as Kingwell claims; she extends art's exhibition outside of the gallery's walls into a daily twenty-first-century existence. This extension of art into the world intersects our lived lives with artistic encounters. With *He Named Her Amber* Häussler is also, as a contemporary artist, intersecting history with contemporary daily existence. Unlike a National Historic Site or even a small historical house museum, the purpose of this intersection of the past with the present, of fact with fiction, is not *only* to enter into a believable physical history as a National Historic Site would have visitors do for nation-alizing purposes; her work prompts viewers to reflect on how perceptions of history come into existence, and how accurate these perceptions of the past truly are. Häussler's art works within a paradoxical dynamic: hers is a haptic conceptualism that roots a hoaxical artistic practice in the historically factual. The outcome of this artistic approach is twofold: historical legitimacy and plausibility are lent to Häussler's fictional stories through her inclusion of historical research, and history is animated, enlivened, but also significantly *shaken* through her artistic imagination. A historical novel can do much the same, except that Häussler's work is not directly presented as fiction. We are not safe in our generic assumptions about the people, places, and narratives that we are being offered. In *He Named Her Amber*, fictions are presented as fact, make-believe as actuality. The lines between what definitively happened and what could have happened in the Grange home are muddied, such that categories of fact and fiction become unstable. This instability is in marked contrast to the upheld authority of the Grange home as a historical landmark, and the museum as a trustworthy institution.

Kingwell also makes the claim about Häussler's haptic conceptual art that with this new category "the image economy of the artist collapses, and

the artist actually disappears."[18] But I disagree with Kingwell that Häussler's art "disappears" the artist completely. Rather, once it has been revealed in the case of *He Named Her Amber* that this archeological dig is, in fact, art, the artist is an important part of what is revealed. The reveal recognizes that an "author" or "artist" is at work behind the histories we are told, and that this role of artist or author can have a significant impact on our beliefs and can itself be a kind of performance or position of authority. *He Named Her Amber* demonstrates the complexity, multiplicity, and at times, duplicity of an artist or author's role in the creation of art and in the writing of history. In fact, important questions Häussler asks with her haptic conceptual work are about authorship in our understanding of history.

Häussler frequently centres her artistic narratives on the daily existences of those who may have been overlooked or forgotten by official annals. A letter handed out at the end of each Grange tour is the first chance a gallery patron has of receiving a direct explanation from Häussler of her haptic conceptual practice and the intentions behind her deceptions. In the letter Häussler reflects on her art practice and the construction of the tour at the Grange, along with the statement that "revealing the fictitious nature of Amber's story after a time of reflection is as much a part of my artwork as constructing the story in the first place."[19] For many visitors the letter, presumed to be from Dr. Lee, is the instrument through which the reveal takes place. Yet the letter is still not entirely straightforward. The letter is not written in Dr. Lee's voice alone, nor in Häussler's voice alone, but consists of three different female voices. The letter begins in the scientific voice of the fictional chief archeologist Dr. Chantal Lee, it ends with an explanation of the artwork and a signature from Iris Häussler herself, and, along with these two voices, is the voice of a real historical woman of the time: Mary Walsh from Drogheda, County Louth, Ireland, as quoted from Judith Beattie and Helen Buss's collection *Undelivered Letters to Hudson's Bay Company Men on the Northwest Coast of America 1830–57*. Häussler's choice to reference Beattie and Buss's scholarly monograph *Undelivered Letters* is to signal to readers that the excavation at the Grange, while partly fictive, is connected to historical archives, monuments, and reconstructions of a feminist, populist, and affectively centred form of scholarship that seek to make publicly accessible previously untold histories—namely, domestic or familiar narratives more often found in artifacts such as letters, wills, death certificates, locks of hair, pressed flowers, or acceptances of marital engagement than in more "official" historical accounts. Most of the *Undelivered Letters* collected by Beattie and

Buss are written in women's voices and address the "smaller" concerns of familial loss and financial hardship, which are not traditionally present in the historical accounts of national monuments, in classroom history textbooks, or even in typical narratives given on house museum tours in homes belonging to the powerful and wealthy, such as those narrative historical tours given for many decades at the Grange.

The missive from Beattie and Buss's collection quoted in Häussler's letter recounts hardships and deaths endured by the Walsh family in Ireland during the Great Famine:

> We are Badly of Just now and only for your Aunt that Gets the Little washing we Co would not be to gathr ... you wish to Know the Particulars About your fathers Death I am sorry for to have To tell you He Died on the 27 July 1849 and your Poor Mother About 3 weeks After which was and is a very Great Loss to us.[20]

It becomes clear through Häussler's inclusion of Mary Walsh's letter in her moment of reveal that an intimate relationship to history through letter writing, story, and personal artifacts is foundational to Häussler's artistic practice of haptic conceptual art, "a practice," Dr. Lee's letter tells us, "that deals with deep questions of the human condition, but initiates them through direct experience, rather than through theoretical discourse."[21] Artifacts, the letter insists, are not just lifeless objects, but are remnants of living and feeling people to whom we can—through our own work of imaginative "historical reconstruction"—gain access.

If Dr. Lee's letter is read "straight," it functions in a manner typical of many pamphlets offered at such historic homes and national sites as Fort Walsh or Black Creek Pioneer Village that offer further insight into the artifacts and architecture of the place. But by including a fictional female scientist, her own voice as the author and artist of the ruse one has just walked through, and the historical voice of Mary Walsh, Häussler reveals to patrons the layers of narratives they have just experienced, both factual and fictional, that came together to create a visceral experience of both art and history in the trusted cultural institutions of the museum and gallery. It is—as Kingwell has described in his definition of haptic conceptual art—the *visceral* elements of these stories, questions, ideas, and layered voices that the letter hopes will remain with tour-goers. The letter handed to tour-goers encourages visceral reactions: reactions relating to inward feelings alongside conscious reasoning.

Häussler creates a link between the historical Mary Walsh and the fictive Mary O'Shea and asks patrons to physically imagine what it would have been like to be an Irish immigrant girl who has left behind her family:

> How much does hope weigh, when it is burdened upon the shoulders of a child, a daughter, a sister? What kind of burden is that? Does one remember it every morning, with every prayer? Is it a lump in the throat or a cramp around the middle? Or do you forget it for days, maybe weeks at a time until the next letter arrives? How does such a burden feel? I would argue, this is the only question that counts. Yet the question means so little to me when it is posed in an abstract, academic space.[22]

The wording of the letter highlights how this viscerality is anatomically traceable to the body, to one's viscera, the interior organs in the great cavities of the body (e.g., brain, heart, liver), especially in the abdomen.[23] These physical parts of the body are also associated with emotional understanding, with an affective epistemology. With choices of diction such as "a cramp around the middle" or "a lump in the throat," the inclusion of Mary Walsh's letter claims that inducing a physical and emotional knowledge of history, alongside an intellectual one, is of primary importance to the tour—indeed is "the only question that counts."[24] The immersion, the haptic nature, of Häussler's tour at the Grange is an intellectual, physical, and emotional exploration of how we access history, and how we tell personal stories. We experience three-dimensionally (and through three aspects of knowing: reason, emotion, and bodily sensation) our beliefs and understandings of the past. This intellectual, emotional, and physical immersion can also be seen as a form of resistance to academies and institutions that, over time, have become Cartesian in their approach to education and knowledge dissemination, separating the mind from the body. Häussler's *He Named Her Amber* encourages a holistic rather than Cartesian response from tour-goers that encompasses the corporeal, the emotional, and the intellectual through the historical, the fictional, and the personal.

We know Mary O'Shea through her "factual" rootedness in place and time, through our emotional connection to her story, and through our sensual experience—through the smells, sights, and textures—of the waxen globes she has crafted with her hands. Yet then, through the letter's reveal, this seemingly solid knowledge and belief in history itself is questioned. A haptic conceptual engagement with epistemology becomes an evident

part of Häussler's artwork. As they would on a tour of a National Historic Site, tour-goers at the Grange may feel that they know Mary O'Shea well through the physical, emotional, and intellectual immersion of the tour, but Mary O'Shea never did live or feel. She never did exist. Once tour-goers are fully engaged, once our belief systems have been cemented through holistic engagement, only then, through the haptic conceptualism of Häussler's art, are our ways of knowing forcibly drawn into question.

THE MUSEUM LABEL'S PACT

"If this work were labelled as a project of contemporary art, would the label protect the visitor, or would it deny the key experience?" asks Häussler.[25] Imagine visitors entering the Grange building, where they see a label on the door stating:

He Named Her Amber.
Iris Häussler (1962–).
large-scale site-specific installation: fabricated artifacts: wax, clay, fabric, scientific equipment, historic materials (i.e., recovered barn wood, children's Victorian porcelain dolls), Post-it notes, library books, sleeping bag, display cases, fake museum labels, etc.
performance art: narrative tours set within the frame of the historic Grange house which, in turn, acts as a theatrical set;
objects fabricated to appear constructed circa 1828–1857
but were, in all honesty, constructed circa 2008.

With such a preamble, the experience of immersion into the story of Mary O'Shea, Henry Whyte, and Chantal Lee would not have the same effect on the viewer as when the artwork is experienced "directly," pre-reveal. The story of the excavation would not, perhaps, engage the sympathy of the participant as radically as the work does when she is unaware that what she sees is art: "The difference between thinking about emotions and actually experiencing them," Häussler states in the concluding letter, "is huge."[26] *He Named Her Amber* does not (cannot in fact, if it is to remain intact) ask the viewer her permission before she enters. The viewer must give of her sympathy, must go on trust, ultimately to have that trust broken. The label would, in this sense, "protect" the visitor from having her trust broken, but that label might also inhibit or prevent the same visitor from experiencing the artwork's rapture and delight.

Kingwell's observation that haptic conceptual art may not just be a form of immersion but one of "ravishment"—a word connoting both pain and delight—acknowledges the double-edged nature of a hoax. While there is affirmation and surprise, even wonder, in realizing one's participation in a new form of art, having one's consent taken away—not being able to *choose* to participate in the hoax beforehand—is, to say the least, not a trifling matter. To think of hoaxes as a form of ravishment speaks to their profound and fundamental risk: a hoax can produce delight and engagement in viewers, but the non-consensual nature of a hoax can likewise be interpreted as a serious form of aggression. While a hoax's attack may well be directed toward injustice or the undue power of an authority, the inherent exclusion of a participant at the start of a hoax can also be, upon reveal, interpreted as a deliberate betrayal, embarrassment, or personal affront. It is this double-edged nature of a hoax, "the audacious practical demonstration of conviction by means of deception," that make it "a risky business,"[27] "a dangerous and tricky weapon,"[28] and "ethically risky"[29] as a form of art.

The relationship between a work's intention, production, and interpretation does not occur solely within the frame of the artwork or the pages of the text but also in the work's paratexts, which Gérard Genette—in the context of literary texts—describes as "those liminal devices and conventions, both within and outside the book, that form part of the complex mediation between book, author, and reader."[30] An example of paratext in the context of an art gallery is a museum label. Even though the label is external to the artwork itself, it shapes a viewer's interpretation. Philippe Lejeune goes so far as to argue that "everything depends on the label. In a museum, people almost spend more time reading the labels than they do looking at the paintings."[31] In fact, the world's most famous art forgeries, frauds, and hoaxes demonstrate the contingency of the label.

When a work painted by Han van Meegeren in the mid-twentieth century is labelled and hung in the Boijmans Museum with a tag that reads "Johannes Vermeer," van Meegeren has successfully perpetrated a hoax that has fooled critics and art professionals into believing that his own work is that of the seventeenth-century Dutch master.[32] When an Eric Hebborn painting is hung in the National Gallery of Canada with a label that assures viewers the work is a sketch by Stefano della Bella, we have been paratextually duped.

Unlike van Meegeren or Hebborn, Häussler does not seek to convince the viewer that her work is that of a master artist. Her work colludes with rather than deceives the art museum by removing the label that would declare

her work at the Grange to be art. Instead, Häussler inserts labels that mimic a museum's showcasing of historical remnants from lived lives. Due to these paratextual disturbances, distinctions between whether we view an object as an artifact or as a piece of art become disrupted. As the revelation sets in, the work fluctuates between two readings: history and story, artifact and art. The glass display cases make beeswax and clay—simple materials attainable to nearly anyone—appear to have important historical and sociological value.

The initial intention of *He Named Her Amber* to have a viewer intellectually and emotionally respond to a fiction as if it were history or archaeology draws our attention to the paratextual markers that determine how we make the distinction between what is true and what is false. In highlighting the framing devices of the institution of the museum itself—such as the glass display cases that signify the value of the objects they encase, the wall tags that signify the object's historical or artistic origin and value, and the docents who signify the reliable expertise and authority of the museum's staff—the museum's artifice in displaying artifacts, the deliberate process of the construction and dissemination of knowledge, is revealed, along with the public's often unquestioning trust in an institution's cultural authority.

Authors of hoaxes thwart the contract or pact they have with their readers. For example, through both the text and paratexts of a book, an author and publisher of a hoax propose a contract for a verified history, but then give the reader a fiction instead. In order for the hoax to work, the reader must be convinced by the style and form of the text and paratexts and must not know of the author's intent to break the contract: that is, the author's intent to deliberately deceive the reader into thinking a text is one kind or genre (non-fiction) when it is really another (fiction). There are numerous examples of textual hoaxes that rely on an author and/or publisher thwarting the contract or pact they have made with their reader: historically this can be seen to occur most frequently when a work claiming to be history, memoir, or autobiography is, in fact, fiction.[33]

Häussler's work, rather than comfortably being historical or fictional, reminds us that seeking any form of "truth" is an extremely complicated endeavour. By including inauthentic artworks inside the glass walls of vitrines, by giving false pedigrees and dates to "historical" objects, Häussler's work questions the museum and gallery's authority to automatically indicate the inarguable aesthetic or historical importance of a work of art or an object of cultural production, or to generically determine what art is and where it should be housed.

Causing further confusion to the distinct paratextual and generic markers of art, history, and contemporary life, Häussler's work extends "the art world to every corner of existence,"[34] to places both geographically and aesthetically surprising and unconventional to producers, authorities, and patrons of the art world. Häussler chooses to make and perform her artworks in spaces geographically "outside" the gallery, as well as in ways that thwart commonly held aesthetics or a desire for the permanent collection and commodification of art within the walls of an institutional space. With *The Legacy of Joseph Wagenbach*, Häussler plants her art in a small rundown house in Toronto's Trinity-Bellwoods neighbourhood. Such homes are regularly torn down for stylish new condos considered to be more aesthetically and commercially appealing. None of the objects in the house, including Joseph's sculptures, are for sale as people walk through. The thwarting of authority, commodity, and the clarity of the works' genre all thwart the paratexts we—often unconsciously—read when determining what is a work of art. Further, when given the chance to create a commissioned work for the AGO within the walls of the institution, Häussler displays *He Named Her Amber* not in a major exhibition room, but in the most liminal spaces of the gallery: the dusty crevices of a basement, easily forgotten amongst lavish celebrations marking the opening of the renovated AGO, just as an old man might be forgotten in a gentrifying neighbourhood, or an Irish maid might be forgotten in British colonial history, while the men that history remembers eat the meals she has prepared, upstairs in the fancy dining room.

The master art forger Eric Hebborn notes, "We are all aware of the close association in our minds of such words as art and artfulness, craft and craftiness, artifact and artifice."[35] Häussler's work endeavours to highlight how the border between these concepts are oftentimes porous. Authenticity and history can be shaped by institutions with the power to disseminate knowledge, and, democratically, can also be shaped by participants engaged within those institutions. With a book, it is the writer, the publisher—with its editors, designers, and marketing teams—and readers who make its meaning. Likewise, Häussler reminds us, it is not the artist alone who makes art: it is also the gallery—with its curators, tour guides, staff, and patrons.

COMPLICATED COMPLICITY: THE NECESSITY OF A VIEWER

A hoax cannot exist without a reader or viewer. Häussler's art comes into existence as art once a museum-goer understands that what they have experienced

as fact is fiction, that the artifacts and archaeology of the dig at the Grange are art. Moos writes, "As visitors digest their experience of *He Named Her Amber*, they become aware that they have in fact participated in a performance and have actively aided in the making of the work."[36] Indeed, if a reveal were not meant to be a part of the artwork, Dr. Lee's letter would not exist. Häussler intends to deceive only temporarily—having similarities to what Brian McHale identifies as a *mock-hoax* and what Julia Abramson calls *mystification*—meaning that the work happens, is made, and wholly exists only once a viewer understands that they have been a necessary part of the work's creation. The whole of *He Named Her Amber* is its production *and* the viewer's participation and interpretation.

The disorientation, reaction, and redirection of a reader are as much requirements of a hoax as is the tall tale told. Thus, some critics have argued that the reciprocity that exists between reader and text, viewer and artwork, is highlighted in the experience of a hoax. In *Learning from Lying*, Abramson's optimistic view of what a revealed hoax can accomplish is compelling. She claims that "mystification brings reader together with writer to talk about texts,"[37] and that a hoax rouses a reader "out of intellectual slumber."[38] The process of retroactive reinterpretation, or revision (re-seeing what we may have cursorily walked by before), can be one of the most deeply empowering and transformative experiences of art and literature: it can awaken us to the complex layers and details of history through a more careful attention, and it can remind us of the part we take in constructing the narratives of our own lives. Indeed, the more deeply held our systems of belief, the more radical will be our transformation, but also the more radical the betrayal we may feel. The deep sense of betrayal that can arise from a hoax is a fact that Abramson's optimism ultimately skims over. Experiencing a hoax can certainly change the way we perceive our participation in creating the world around us. As David Moos claims, "Häussler adheres to the idea that art must shift the viewer's consciousness and can play an affective role in shaping, or re-shaping, reality."[39] Put differently, hoaxes ask readers to be active participants, to pay attention. As readers we undergo a gestalt shift, wherein, upon reflection, we are able to see ourselves in multiple modes of understanding: as readers in earnest, as investigators, as mistaken, as spectacularly awed, as duped, as discomforted, as betrayed, as hurt, or as transfixed with wonder. Whatever the reaction, the participants in a hoax cannot remain passive.

It is the protection of trust about which critics of hoaxes speak most vehemently, while the proponents of hoaxes tend to focus on the bending of rules and expectations that may, in turn, revitalize our sense of astonishment,

pleasure, and social engagement. The only assumption one can make when deliberating over the response of a public is that readers' reactions will be diverse, if not divided. But it is worth pondering in greater detail why readers often have such diametrically opposed responses to a hoax. Who feels included in a hoax, and how does that inclusion take place? Who feels excluded from a hoax, and how does that exclusion take place?

For the artist to effectively and temporarily deceive the viewer into believing in the authenticity of a work, the hoaxer must be aware of their audience: "the mystifier must understand the 'horizon of expectation' of his readers, picking carefully the moment, the setting, the details of his text, and his victims."[40] It is this "temporal and cultural specificity," Abramson argues, that "permits the writer to wink at a specific group of readers."[41] "Anyone," she notes, "may participate in a mystification. Only those readers who share the culture of the writer to a sufficient degree will be equipped to see the joke."[42] Indeed, just as Linda Hutcheon observes to be the case with irony, hoaxes are "more easily understood in a well-defined or even closed group whose members share a 'social environment.'"[43] A hoax can therefore be seen, on one hand, as "an elitist act of simultaneous inclusion and exclusion, or, on the other, as a utopian generation of 'reflective community,'"[44] depending, presumably, on whether one feels included or excluded. Once the hoaxical nature of Häussler's *He Named Her Amber* has successfully been revealed to a tour-goer (whether through Dr. Lee's letter, a friend, a hunch, or other means), the tour-goer has been "winked at," is in on the joke, and this inclusion can be considered a shared experience with a "reflective community," a group who are also in on the hoax. This moment can also, though, equally be considered an act of exclusion: the exclusion of those tour-goers who do not yet know the final twist to Häussler's artwork, as compared to those who do; or the exclusion of the tour-goers who, once in on the hoax, do not in any way delight in the lie but, instead, resent their experience and do not find it engaging or meaningful.

When a hoax is interpreted as an inclusive act, the hoaxer and hoaxee experience the pleasure of "joining, of finding and communing with kindred spirits,"[45] and a hoax can be understood to be a "communal achievement"[46] in the same way that "laughter and humour can both build emotional bridges and make intellectual connections between people."[47] A hoax, when interpreted as inclusive, flatters and compliments an interpreter by making him, her, or them feel special for being included in a group who have figured out, or who have been informed of, their deception. The viewer who has realized

the hoax thus assumes the same interpretive plane as the hoaxer by sharing in the knowledge of the hoax.

However, just as a hoax can unite reader and writer on a shared plane where they collude and delight in their common knowledge, a hoax can just as easily promote a dynamic of superiority and inferiority. Those who have understood the hoax can be seen to be superior to those who have not. Hutcheon, citing Wayne Booth, has observed similar hierarchical language in critical discussions of irony:

> There is a depth model where a deep (ironic) meaning has been placed below the surface, and lies waiting to be perceived by the knowing audience;[48] another is the image of the "building" of irony, of its reconstruction so that the interpreter too can live "at the higher and firmer location" from whence to look down on those who "dwell in error."[49] What these metaphors share is a sense of hierarchy: deeper and higher = better.[50]

Understood in this sense, the hoax, like the ironic utterance, becomes not an inclusive space of reading, but a test of intelligence and emotional fortitude that permits a reader to ascend to a higher level of comprehension, and, implicitly, inclusion. "Success depends on these 'victims' or readers, who must be of sufficiently receptive intelligence and resilient character to transcend the shock of deception."[51] The hoax seems to ask: are you smart enough to realize that you were being duped? Are you emotionally adaptive enough to withstand being "wrong" and to adjust your system of beliefs once these beliefs have been put under question? Even Abramson's accomplice model of hoax, where "an implicit pact ... unites reader and writer of fiction,"[52] becomes dependent upon, as she understands the role of the accomplice, the reader having enough receptivity, intelligence, and resiliency to, in a sense, *survive*, or live through, the hoax. But, even if lived through, this feeling of inclusion also depends on readers *wanting* to be included in the hoax, of feeling that sense of intelligence and resiliency which Abramson identifies, rather than feeling angry and excluded because no consent was given for this moment of entry or inclusion into knowledge of the hoax. Whether intentionally or not, hoaxes have the power to exclude as much as include, and intelligence certainly does not determine one's reaction to a hoax.

Superior intelligence and power are often notions that the hoax fights against. With *He Named Her Amber*, it is the museum's institutional practices, traditions, and choices of collection, display, and curation that Häussler relies

upon for the creation of her artwork. However, it is also these institutional practices she is asking viewers to question (for example: Whose art gets included in a gallery? Whose stories get included in history?). In order to question the curatorial practices of museums or the entrenched imperialism, colonialism, and patriarchy of history, one has to be familiar with the modus operandi of those powers in the first place. (One must know of the political decision before one "gets" the newspaper's political cartoon.) To be included in a hoax, one must already be an initiate to the conventions being questioned. One must implicitly know, or be initiated into, the conventions of a historical house tour, or be habituated to the convention of valuable art being housed within frames and glass displays.

IMPROVISED CHOREOGRAPHIES: THE ROLE OF THE TOUR GUIDES AT THE GRANGE

Looking again with what Iris Häussler calls "open eyes" at *He Named Her Amber*, it becomes clear that much of the hoaxical nature of the work greatly depends on the Grange tour guides. Like musicians playing a composition or dancers performing a choreography, the guides are the ones who enact Häussler's vision for her artwork to the public. Like the best musicians, Häussler's performers must take a score, make it their own, and enliven it for their audiences.

It is the docents who must stay in character as museum guides, "relying on the script which is always adapted to circumstances," for "even while the tour is under way ... some of the participants may disbelieve the fiction being offered."[53] The guides must remain faithful to their role as storytellers, but the performance of *He Named Her Amber* makes room for improvisation, depending on questions, comments, and observations of each group of tour-goers, just as in contemporary choreography there are often open moments where dancers can rework a theme or respond to the moment or music in individual ways. By attending six separate tours of *He Named Her Amber*, with six unique groups of patrons led by six different tour guides, I can attest to the fact that every single tour guide tells a slightly different story, and that the questions and whims of the group are essential in creating the direction of the narrative tour that unfolds throughout the half hour at the Grange. One group's questions, for instance, kept returning to Whyte's obsessive interest in O'Shea's movements and actions in the home. This group frequently speculated that these two servants might have been in love. The

tour guide then began to focus her tour notes on the relationship between these two characters. Another group kept raising questions on the practices of witchcraft in Ireland during the time of O'Shea's service at the Grange home. The tour guide spoke convincingly about Irish folk superstitions and incorporated the curiosities of the group within his narrative tour. The tours are unique to each tour guide, but are also, in many ways, determined by the group. Each time *He Named Her Amber* is enacted, the story becomes an unrepeatable collaboration between patrons and guides in a haptic world devised by the gallery and the artist.

Conventionally, a visitor to a museum or gallery will receive information fairly passively from the artworks themselves, from the informational tags affixed to a museum's walls, and from guided tours, whether live or recorded. With *He Named Her Amber*, in contrast, the museum visitor's questions and speculations become a part of the artistic work they are experiencing. This dynamic of having a set story that unfolds differently throughout the duration of each tour depending on the guide and the group is comparable to other live and improvised forms of performance. For example, Susanne Chui, Canadian choreographer and Artistic Director of Mocean Dance, describes the choreography she built for *Threnodies*, which was performed live at the Halifax Jazz Festival to the music of improvisational jazz guitarist Geordie Haley: "Within the songs, there are sections of improvisation like solos and there are sections that are task-oriented, but the performers compose within the tasks.... The dancers can respond to how they feel or how the music is affecting them in the moment."[54] The parameters of Chui's choreographic style are similar to the parameters Häussler gives to her guides. The performers must adapt to the moment, not breaking from their commitments to the performance: "'What I like about improvisation is the surprise,' [Chui] says, both for the audiences and the performers. 'We can't plan our reactions, and that's exciting.'"[55] The improvisational and collaborative aspects of *He Named Her Amber* attempt to unsettle authoritative power structures inherent in a museum's dissemination of knowledge. Improvisation and collaboration in the creation of O'Shea's story resist fixed linear narration and passive top-down learning, the pedagogical styles that have traditionally and most frequently been employed in Western museums' approaches to cultural knowledge dissemination.

One might argue that "straight" tour guides likewise must improvise their scripts depending on the questions and curiosities of gallery-goers, but with *He Named Her Amber* the speculations of patrons are never deemed right or

wrong, as, for instance, a biographical question about Pablo Picasso from a patron might be confirmed or denied by a traditional tour guide; rather, wild theories and imaginative conjectures are affirmed on a tour of Häussler's work and become a part of O'Shea's "history" on that particular tour. Depending on patrons' speculations, opinions, observations, and obsessions, on each individual tour of *He Named Her Amber* O'Shea's story will become something quite different than on any other. Like any live performance, a tour of *He Named Her Amber* is not repeatable: the circumstances, timing, and combination of people engaged in the story in that particular moment will never again exist.

If a patron becomes suspicious of the elaborate narrative being constructed on a tour of *He Named Her Amber*, they may try to find inaccuracies—such as incorrect dates, names, and historical details—within the unfolding fiction as a first means of testing the story's veracity. However, because the enacted fictional narratives of *He Named Her Amber* are nested within historical fact, an initial detection of the hoax based on the lives of historical figures or the accuracy of historical dates becomes extraordinarily difficult. Much of the script that Häussler's tour guides have delivered to the thousands of visitors they've led into the cellars and crevices of the Grange during the course of *He Named Her Amber*'s exhibition has been a part of the official historical narrative offered on Grange property since such tours first began in the 1970s. In Häussler's work, fact and fiction are mixed, just like O'Shea's clay and melted wax, hardening the real and imaginary together, making it difficult for even the most historically initiated patron of the Grange tour to suspect Häussler's deception at first.

The foundation of history upon which Häussler places her own fictive narrative and the developing narrative of each tour helps to shore up the beliefs of her viewers for a time, so that the artwork's reveal has the power to be all the more perspective altering to its participants. Astonishingly—despite O'Shea's story being "fraught with curious, even suspicious elements"—as the narrative grows more elaborate in both its facts and fictions, the story sustains its ability to remain convincing.[56] Questions may arise amongst visitors as the tour progresses: "Is it really plausible that there would be a secret basement room, concealed for all these years, in which Amber maintained her wax workshop? Would Dr. Chantal Lee really be sleeping in her Grange office on a cot, camping out in a sleeping bag?" Yet the spell of the tour, the authority of the museum, the dynamic of viewing art as a member of a group, and the veracity of the physical objects tend to ward off complete doubt a little while

longer. "Could the museum deliberately mislead visitors?"[57] the viewer might ask herself, to which she will likely answer quickly, at first, "Certainly not," without hesitation. Yet Häussler complicates matters for her brave actor-guides: "The artist has laid out cues that trigger suspicion."[58] Indeed, when we re-walk the Grange tour—whether in our minds after the reveal has taken place, or in person, as many tour-goers have done, returning to notice details of the tour that were passed by upon first visit—we notice particularities to which we previously did not give much attention: construction techniques, lighting, storyline, and allusions to other trickster artists.

WITH OPEN EYES: REVISING THE HISTORICAL TOUR

In walking through *He Named Her Amber* again, one begins to see a number of hints at the theatricality, allusion, and trickery embedded in the construction of the narrative and the fabrication of the objects in each room on the tour. What we took for granted upon first glance is given to us again with a possibility of revision and new insight.

The Grange library, the first stop on this second open-eyed tour, reveals many tricks of the theatrical trade that, on the first visit, encourage patrons to feel at ease in the unfolding narrative. The lighting and the entrance and exit for each of the rooms have been meticulously set by Häussler herself, just as the lighting, stage set, and entrances and exits of a play are designed, constructed, and directed in a theatre. The light switch on the wall of the library, we might notice this second time, has been duct-taped to a low setting so that the overhanging chandelier may give off a precisely warm yet haunting dimness that contrasts with the sharp, bluer lights emanating from the scientific equipment laid out on the lab tables.

In one of the library's display cases a series of historical artifacts from the time of the Boultons' residence at the Grange are housed: a wooden box, strings of beads, a pair of gloves. Inside the box, if we peer in closely, is a note handwritten by Häussler in pencil that reads *empty*. The beads themselves are curved into an alphabetical clue for the viewer, spelling out in beaded cursive the word ART. A pair of lady's leather gloves rhymes with the white cotton archival gloves resting on the archaeologists' lab tables, creating unexpected and cross-disciplinary connections. With these details subtly observed, we might begin to ask, What is real? What is being staged? Indeed, "when we reflect upon such details which have the aura of a stage set," Moos observes, "it does indeed seem uncanny that the narrative can become so convincing,

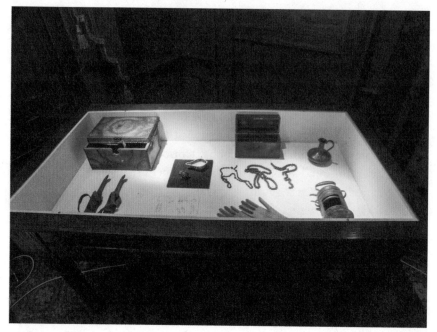

Figure 9. Display case in the Grange library. Photograph by Iakub Henschen.

blossoming vividly in the imagination."[59] For most of us, despite the hints we may have chanced upon during our first tour, the narrative that is told during our first walk-through of the library remains relatively credible. This credibility is particularly reinforced by the surety of scientific technology—the tables of lab equipment, microscopes, and steel dissection trays—which indicates controlled empirical experimentation, the veracity of which we socially seldom question.

In heading downward to the basement, we might, at first, notice factual discrepancies. For instance, the wooden bins in the 1840 kitchen hold an inexplicable amount of dirt for the square-footage of earth that has been excavated. Looking carefully, we see that the lighting in this workspace is also peculiar. The floodlights rest on the floor—obscured behind pallets of bricks, mouths of resting shovels, and orange buckets—rather than illuminating the workspace from above, as would be necessary for archaeologists sifting through the earth in the storage bins for further indications of Mary's artifacts. What becomes more and more apparent, as we adjust to this new open-eyed perspective, is how freely and unquestioningly we give our trust to historical account, to museum display, to the belief that technology is a sign of accuracy, progress, and unquestionable benefit to human intelligence.

Along with the materials and objects that may arouse slight suspicion in viewers, Häussler also deliberately reveals allusions to the artwork of other artists concerned with navigating the subtle distinctions between documentary and artistry. While allusion is seen, like irony, to be a rhetorical form that initiates feelings of inclusion or exclusion (you either understand the reference one work makes to another form of literature or art or you do not), Häussler's allusions help situate and connect her artistic practice to the geography and local history of her work's location, and to a broader art history specific to her artistic practice. The orange buckets, for example, were procured by Häussler at great expense and with much difficulty from a wholesaler in the United States in order to reference *Fieldwork*, a photograph by Vancouver photographer Jeff Wall.[60] As will be discussed further in the second section of this book, Wall is known for a style of photography that he has called "near documentary,"[61] which plays with concepts—also explored in *He Named Her Amber*—of biography, documentary, staging, and storytelling.

Figure 10. Visitors in the 1840 kitchen. Photograph by Iakub Henschen.

In employing allusion, Häussler references other artworks that defy the classifications of history, fiction, documentary, and art, revealing resemblances, latticework, and connective tissues between genres, disciplines, cultures, and art practices, which can often become delimited in the specialization increasingly inherent to academic forms of study.

For instance, also in the downstairs kitchens, if we look more carefully at the large containers of earth beside which the buckets rest, we discover one of the most prolific of Häussler's many allusions: a shadowy image of a rabbit, standing in the *O* of ASO (the acronym for the fictive Anthropological Services Ontario, Dr. Chantal Lee's archaeological contracting business "hired" by the AGO to work at the Grange). On the sides of the wooden containers, as well as on many of the walkways, lights, protective equipment, and scientific materials throughout the excavation, the figure of Nanabozho marks the proceedings. The website of Anthropological Services Ontario— whose address, www.anthserv.ca,[62] is printed on each of Dr. Lee's business cards and on the front of the folded letter given to tour participants—provides the story of Nanabozho to visitors.

Figure 11. Logo of Anthropological Services Ontario.
Photograph by Iakub Henschen.

The website and the allusion prove to be yet further layers of Häussler's work. The website of the ASO introduces us to the history of their effusive mascot: the great trickster hare, Nanabozho. "In the mythology of Ontario's Anishinaabe First Nations," the site tells us, Nanabozho's power as a trickster is manifested in his ability to "change into the shape of any animal or thing simply by wishing it."[63] He is also responsible for fashioning "a new world from a small grain of sand" and giving "a name to all the plants and animals."[64] In Häussler's work, Nanabozho appears as an archetype for the world-creating abilities characteristic of art and fiction. Like the dissolvable division between truth and invention explored in the Grange excavation, the morphology of Nanabozho remains constantly in flux. Nanabozho is a shape-shifter, changing his own form, as well as the form of the world around him. In *Trickster Makes This World*, Lewis Hyde claims, "in spite of all their disruptive behaviour, tricksters are regularly honoured as the creators of culture."[65] Indeed, the claim is reiterated on the concluding page of the ASO website: "Nanabozho is the custodian of culture in a world that he created."

In a single room of the Grange house, Häussler alludes to one of the oldest creation myths told by the Anishinaabe alongside a photograph by one of Canada's pre-eminent contemporary photographers, with many stories held in between. Although there is the concern of appropriation in Häussler's use of an Anishinaabe myth, the allusion to Nanabozho is used, I believe, as an attempt to honour and acknowledge the stories of the inhabitants of the Grange site lifetimes before the British colonization of Ontario, the formation of the city of Toronto, or the Boultons' possession of the Grange land. Häussler's inclusion of Nanabozho in her work endeavours to recognize yet another overlooked or unmentioned story from the Grange site—the appropriation of Indigenous land—an aspect of history that is often elided due to the colonial holdover of many Western museums. Understanding issues of appropriation and respecting Indigenous protocols around who has the right and honour to tell Indigenous stories is imperative in scholarship and in everyday Canadian culture. The work of Indigenous activists and scholars, as well as their allies, is helping settlers better understand these protocols, as we move toward becoming communities that uphold Indigenous resurgence and decolonization. A decade after *He Named Her Amber*, Häussler too recognizes her errors of appropriation in the inception of this work. When I shared this manuscript with Iris to request final permissions for her images to be printed, she responded to this paragraph particularly: "It's interesting what you write about the cultural appropriation problematic with

the Nanabozho figure I integrated into the work. Now, today, in 2018, I would be sensitive enough to 'not just do that' but to get in touch with as many people from local Indigenous groups to find out their thoughts and opinions first!"[66] She also responded by acknowledging that a genocide has taken place in Canada against Indigenous people, and that the stories and histories of any group who has experienced genocide must be treated with particular care, sensitivity, and respect. She admits, "I also should have been much more in touch with the Irish and the Korean communities when I developed my Amber-narrative."[67] Whatever the circumstances in which one first encounters Häussler's work—walking through the archeological dig in the basement of the Grange in 2008 or reading about it now over a decade later—the cultures, histories, and stories included in *He Named Her Amber* are multiple, layered, and complicated: a trickster story belonging to the Anishinaabe mingles with the stories of two female settlers—one Irish, one Korean—coming to Toronto over a century apart, and then these stories mix with an image taken on Stó:lō land in the Pacific Northwest. Together, these allusions span centuries of history and art history taking place on land that is now called Canada. If, as viewers, we come to be initiated into these stories and images, to share in these diverse perspectives, the constellations of our historical contexts also expand.

Past the containers of dirt watched over by Nanabozho, and along the pathway to the pantry, visitors—split into smaller groups of one or two, in order not to crowd the walkway or damage "sensitive scientific equipment"—observe the largest wax object of O'Shea's found on the tour: Object 17. Acoustic equipment that ASO has used to locate the hidden larder and workshop of O'Shea is on the left as tour-goers pass through a cramped passageway. The delicate and sensitive device of the "fibrescope" is in fact constructed of hunks of wood and metal, glued together and spray-painted black—tricks reminiscent of those by a props department for film and television (such as the electric razors that magically become "communicators" once in the hands of Captain Kirk's crew on the starship *Enterprise*). As tour-goers are led further into complicity with Mary O'Shea's story and simultaneously given further responsibility—such as traversing unsupervised pathways that house expensive equipment—a personal investment in the story further develops. Tour-goers, subconsciously, tend to want to live up to the trust that is being bestowed upon them by their guides. Yet, afterward, with revision, the physical thresholds walked also become conceptual thresholds. Questions arise in the re-seeing: How was my trust in

the historical narrative formed? How did unchecked belief hinder my skills of observation and attention? How did the intrigue of the story prevent me from seeing that a "fibrescope" was actually a spray-painted piece of wood, and that I was actually walking along a stage set? Kingwell describes this moment of haptic conceptual art, and his experience of *The Legacy of Joseph Wagenbach*, to be a time when a viewer is "constantly shifting the frame, inside and outside, going over and back on the threshold."[68] Once a viewer attends to her previously held beliefs and her revised experiences—once she goes over and back on the thresholds of her thinking—the complexities and contradictions of belief, display, trust, and power inherent to any historical tour, any museum experience, are made visible.

Dr. Lee's office is another threshold that must be crossed—a private space that tour-goers surreptitiously enter. The movement from the more public enclosures of the library and basement kitchens into the sequestered sphere of Dr. Lee's office is meant to solidify a kind of complicity between guide and tour-goer, and to instill a discomfort in the act of the public entry into,

Figure 12. Dr. Lee's office in the basement of the Grange.
Photograph by Iakub Henschen.

and disturbance of, a private, "authorized-only" space. *"Refocus the group after splitting them up in the previous room. Make them complicit in a 'transgression.' Establish a connection to the historical past through the physical presence of Chantal Lee and her passionate work,"* Häussler's script to tour guides reads under the section "Researcher's Office."[69] Further instructions for the staged blocking of this scene on the tour follow: *"As you reach Chantal's office, knock and wait, hesitate, then slowly open the door to the office instead of turning towards the larder. Look around to reassure yourself that there is nobody inside, step in and beckon your visitors to follow."*[70] Once inside this forbidden space, viewers *trespass*—in the sense both of intruding where one does not belong and of committing an offence against a person or set of rules. In trespassing, tour-goers, ever so subtly, begin to become a part of the breakdown of the propriety and convention typically required of museums that *He Named Her Amber* is trying to unsettle. In Dr. Lee's office the most common edict of museum etiquette given to children—"don't touch, only look"—is transgressed, and by the tour-guide (with all of her invested authority) no less. As further outlined in Häussler's script for her guides: *"You may rummage curiously through Dr. Lee's notes while leaving the visitors in a somewhat awkward position. After a while, explain that you should really not be in here and guide visitors out."*[71]

Yet, despite, or because of, the transgression of entering Dr. Lee's private office space without her permission, Dr. Lee's office encourages in gallery-goers a sympathetic connection to the researcher. The messy, energetic feeling in Dr. Lee's office of a person having just stepped out from engaged and thoughtful work invites a sense of wonder coupled with care in the viewer: look how hard she is working, look how much this story matters to this young dedicated professional woman. She is sleeping here? I hope she is getting enough rest, enough food to eat.

For an example of a viewer's sympathetic engagement with and connection to Dr. Lee, one needs only to turn to the book of Korean poetry inscribed to Chantal that rests on her desk. An elderly patron of the AGO sent Dr. Lee this book after going on the Grange tour: a book of his own poetry, written in his first language, as an acknowledgement of their shared cultural history and as fortification to her during long stretches of concentrated labour. Iris Häussler had to write the man back—with the help of a Korean friend—to clarify that the woman to whom he had sent his gift did not in fact exist.[72]

Before leaving Dr. Lee's office, we encounter another allusion that hints at the excavation's artifice. The close resemblance to Eadweard Muybridge's locomotive camera work in the diagrams of the undressing maid on Dr. Lee's

Figure 13. Dr. Lee's office, including a view of object #17, recreated by Dr. Lee. Photograph by Iakub Henschen.

Figure 14. Dr. Lee's research library and workspace, where a sleeping area is set up for long days of excavation and assessments. Photograph by Iakub Henschen.

Figure 15. Dr. Lee's re-enactment of the creation of object #17, 2008.
Photograph, 62 × 84 cm. Photograph by Iakub Henschen.

wall is a deliberate allusion to the man first responsible for capturing live motion to film. Muybridge's reputation in the art world and with the general public for his use of the zoetrope machine for displaying moving images was on the rise at the same time that the fictive Mary O'Shea would have been keeping house for the Boulton family. Robert Taft notes of Muybridge's photographs in *The Human Figure in Motion*, "His pictures startled artists, physiologists, and many others, for they showed that the conventional representations of motion such as a horse running, a man walking, or an athlete vaulting were composites on the brain of the observer."[73] Indeed, Muybridge's photography did as much for physiologists and motion pictures as it did for our understanding of indexical interpretation in the human mind. Due to Muybridge, an understanding of indexicality was born: the cinematic illusion wherein singular still images are, through the brain's connection of composites into a whole, interpreted as seamless movement. Häussler's allusion to this particular moment in art history is apt when one considers how the illusion of the Grange excavation is not dissimilar to cinematic illusion. The story of the excavation exists as a whole due to an indexical interpretation between viewer and author, as Gillian MacKay notes:

In hindsight, of course, it was implausible that an archaeologist would be sleeping in the Grange. Even more illogical was that a servant could have single-handedly plastered and walled off a secret workshop in the basement, to be discovered 150 years later.... Reflecting back, all of us [participating as patrons on the tour] marveled at the audacity of the ruse, at the brilliance of its execution, and, most of all, at our eagerness to believe.[74]

Despite implausibility, we as viewers project our own imaginings and probabilities onto the meticulously created objects and into the gaps left open in the narrative in order to create a composite whole that is seamless, believable, and real. Upon the reveal, our assumptions are also revealed to us.

Next, upon exiting Dr. Lee's office, we notice, with "open eyes," how the passageway to the last stop in the larder is also theatrical, almost filmic, in its conception. A boardwalk has been placed over a perfectly stable brick floor and lit beneath by blue lights. There is no structural reason for the boardwalk; Häussler placed the boards and lights in this walkway simply for the sake of giving viewers the feeling of being on a journey, passing by bridge over mythical waters onto a different perch of land.[75] Once across, we note that the window in the back room that houses the larder is unnecessarily covered over with cardboard from a box. The darkness of the last room, coupled with the need to shine a flashlight onto the wax-poured mask that ends the tour's narrative, leaves tour-goers with the intimate feeling of pleasure one can also find from a good ghost story told around a fire. Indeed, it was in the darkness of the last room—as myself and my fellow tour-goers crowded, spellbound, around the flashlight's beam—that we did our most collaborative speculating upon the story of O'Shea, Whyte, and Lee.

Yet even in this, the final moment of the tour, Häussler is making yet one more allusive reference to prod us toward understanding the artifice of Mary's story within which we find ourselves physically immersed. Dr. Lee's plaster mask, made in an effort to identify the woman behind the wax-slab impression that ends the archaeological tour, resembles the sculptural work by Marcel Duchamp, *With My Tongue in My Cheek*. The piece is simple: a sly impression of Duchamp's tongue into the musculature of his face that physically illustrates the idiomatic expression of speaking with intentional irony: a doubling of meaning, a kind of mask in language.

The last image of Häussler's mask, with its allusions to Duchamp's mask, offers a final reflection upon authorship and the viewer's role in the work's

Figure 16. Imprint of a woman's face in beeswax. Photograph by Iris Häussler.

Figure 17. Iris Häussler, *Untitled*, 2008, plaster shard on drawing,
24.8 × 15.0 × 3.8 cm.

creation. Drawing a connection between Duchamp's *With My Tongue in My Cheek* and another plaster cast of the artist, *Marcel Duchamp Cast Alive*, Dalia Judovitz speculates that the work "celebrates a new idea of authorship understood as the assumption of a mask, a transitional role or position whose meaning is determined through interaction and play."[76] Judovitz believes that through Duchamp casting himself, he assigns "agency to the work's reception and consumption" and "recasts the logic of authorship and artistic production in the modality of interactive play."[77] This reimagining of authorship and artistic production could be seen to mirror Kingwell's reimagining of artistic praxis in his eleventh category, which he identifies in Häussler's haptic conceptual artwork, where "the image economy of the artist collapses, and the artist actually disappears."[78] The tour guides, along with the masks of her characters, are the ways in which Häussler can be seen to "disappear" herself as artist; however, I do not agree with Kingwell that Häussler's artwork maintains this disappearance. Instead, I believe that Häussler's work—with these hidden allusions to other artists' work, and through the act of the reveal—draws attention to the artist as a persona, a figure who can be conceived of as yet another part of the artwork. The persona of the artist is yet another paratext that creates and interacts with the viewer, the museum, the narrative, the objects, and the characters to collectively produce the work of art.

Häussler's artwork, like Duchamp's, does not ultimately indicate the death or disappearance of an author. In looking at Duchamp's casts, Judovitz argues that the masks in fact challenge "the myth that the birth of the spectator must in some sense entail the death of the author," suggesting instead that "the life of a work resides not in the effigy of its author but in the dynamics the work sets in play."[79] Häussler's artwork and its allusion to *With My Tongue in My Cheek* gestures not toward the author's death or disappearance, but to a reallocation and re-conceptualization of authorship—narrative as collaboration between spectator and artist, listener and storyteller. Moreover, when one rethinks authorship as collaboration, it is even conceivable that the role that an author plays in the creation of a work can be intersected and transformed by the role of her *characters*. Häussler alludes to Duchamp's masks physically in the wax mask that Mary O'Shea has made (the final object examined by patrons on the tour) and the plaster recreations that Dr. Lee is experimenting with as she tries to uncover O'Shea's story, but Häussler's allusion is also theatrically taken up in the multiple masks or masques that she creates in the "biographies" (as she calls them) of her characters.

As MacKay notes, Häussler describes the making of her sculpture for *He Named Her Amber* as having been completed through "a demanding process that involves a kind of channelling of her characters."[80] Häussler claims, "My characters demand all sorts of attention, thoughts, research, physical work, and resources. I depend on their shamelessness, and willingly become their servant."[81] Häussler suggests that "the strategy [of creating art from the persona of her characters] releases her from the 'burden of influence'—the inhibition engendered by too much art history: 'It's like taking off a corset. These characters give me permission. You allow yourself to play, then things come up.'"[82] The "permission" that Häussler notes her characters have given her is not dissimilar to the freedom authors may feel upon loosening the grip of their given names from the covers of their books. After all, Genette reminds us—as I will explore in further detail in the third section of this book—"to sign a work with one's real name is a choice like any other."[83] Häussler identifies the collaborative relationship between an author and her characters—a relationship that many fiction writers have described. Yet the difference between a fiction writer and her characters and Häussler and her characters is that, for a brief while, the masks are understood to be made not by Häussler at all, but by two other artists and thinkers—Mary O'Shea and Dr. Lee. The hoax of Häussler's artwork thus also holds a family resemblance to an act of pseudonymous authorship.

Mary O'Shea, Dr. Lee, Henry Whyte: all can be seen as masks for Iris Häussler. All can be read as her pseudonyms. Or, taken further, the characters become Häussler's heteronyms, those types of pseudonyms that are brought beyond the name on a book into a fully fleshed-out life of their own. Genette describes pseudonymity as "imagining the author."[84] Pseudonymity, whether in literature or in art, can often be, like a mask, an invitation to discovery. Yet, "whose face this is a mask of," the guide reminds us at the end of the tour, "we don't yet know." Along related lines, Genette claims that "the use of a psueudonym unites a taste for masks" with "delight in invention, in borrowing, in verbal transformation, in onomastic fetishism."[85] The characters Häussler creates become artists. The library books and Post-it notes adrift on Dr. Lee's desk become a kind of sculpture, as do the cot and sleeping bag where she apparently takes naps. Henry Whyte's hand-drawn map becomes an artistic sketch. Dailiness and vocation become forms of art. The wax globes are both Iris Häussler's and Mary O'Shea's. Without her characters' help in creating the story and context of the excavation at the Grange, the wax globes—on their own, tagged with Häussler's own name—would hardly be

noticed in the glass display cases of a gallery and would garner little, if any, interest from passersby. It is O'Shea's fictive hands as much as Häussler's real ones that make these pinch pots and waxen slabs art.

The art does not solely reside in Mary O'Shea's waxen sculptures, Henry Whyte's handwritten diaries, or Chantal Lee's Post-it notes. Kingwell speculates that Iris Häussler's artwork "is not the house, still less the contents thereof, it is not even the experience of visiting the house. It is, rather, the entire field of meaning opened up by the installation plus the revision ... the work begins anew with each visitor, each tour, each moment of the reveal."[86] Whether it is Dr. Lee's multi-voiced letter at the end of the tour, the strange ambiguities and improbabilities in the narrative given by the guides, or the allusions to other forms of trickster art that trigger a reveal for the tour-goer, it is the conceptual disorientation experienced as part of a hoax that is its most powerful epistemological thrust: "The project is a sustained, unnerving and moving meditation on the importance of art, and of life, which can only achieve its ends by means of the basic deception *plus the reveal*."[87] Only in doubling back and travelling through the excavation again, whether physically or imaginatively, only in the twoness required of a hoax—the doubled story, the double take, the re-vision—does He Named Her Amber most richly begin to exist.

MISTAKENNESS AND DISORIENTATION: RESPONSES TO IRIS HÄUSSLER'S HOAX

During the Grange exhibition, Kathryn Blaze Carlson reported in the *National Post* Arts column that "Häussler's He Named Her Amber has polarized gallery patrons, AGO staff, and the art world at large, pitting those who cherish the revelation as part of the art experience against those who feel outright duped by the unusual exhibit."[88] Yet the dichotomy often presented in theories of hoaxes that viewers and readers are either victims or accomplices does not describe the complexity of the lived experience of being hoaxed. A response upon the reveal of a hoax is not always immediate, nor is it necessarily permanent, nor is it clear-cut. As time passes, a viewer's reaction may begin with delight and end in anger—or vice versa. Even in a single reader, a complex network of reactions is possible over a short span of time. The range and complexity of responses to Häussler's work demonstrate the aesthetic and ethical complexity of He Named Her Amber and of hoaxes generally.

Iris Häussler and the Art Gallery of Ontario received over 250 emails, handwritten letters, gifts, notes, and telephone calls from visitors who took

part in *He Named Her Amber.*[89] In their correspondence, tour-goers identified physical sensations, emotions, and theoretical reflections provoked by the exhibit. Viewers' affective responses to their own mistakenness, the disruptions of their expectations, and their experiences of disorientation provide insight into ideas of trust and ease, experiences of error and untruthfulness, and the exploration of a more muddied middle ground of near-truth or "truthiness." While each response to *He Named Her Amber* can be read as a personal aesthetic reply to a singular piece of art, the experiences of the respondents also have ethical reverberations that move beyond the walls of galleries, or the pages of books, to comment on authorities, narratives, and habits in which society commonly, and often unquestioningly, places its trust.

Readers and spectators of realist novels, plays, paintings, or sculpture generally maintain awareness of the mimetic nature of the artworks they are reading or viewing no matter how taken in by a work's near-perfect semblance to reality. In part, this lack of delusion comes from an agreement, through the pact of the work, that a reader or viewer will suspend disbelief for the sake of enjoyment. For example, this tacitly agreed-upon suspension of disbelief is demonstrated earlier in the Grange's history when tour-goers came across "maids" baking bread in the downstairs kitchens. Children and adults alike suspended their disbelief in the possibility that a nineteenth-century maid in full historic dress could somehow time-travel into the future twentieth century in order to bake them bread. Instead of inciting delusion, this "realistic" detail helped tour-goers deepen their understanding of history through a "re-enactment," a theatrical flourish that engaged senses usually inaccessible through textbooks and historical narratives: those of smell, taste, and touch.

Despite a feeling of authenticity instilled in viewers by the presence of these actor-maids, one could also argue that the actual realities of a maid's life in the nineteenth century were not realistically represented in the historical re-enactments. The drudgery, dirt, heat, exhaustion, homesickness, illness, and despair that often accompanied lower-class existence in nineteenth-century Toronto were not a part of the act that the historic tour of the Grange permitted visitors to observe. After all, at the end of her shift, the "maid" could simply untie her apron strings, change out of her petticoats into her blue jeans, get into her car or onto public transit, and return home to the conveniences and freedoms of her own twentieth-century life. Yet, despite an erasure of the very real hardships facing female servants during the Georgian and Victorian eras, despite any historical inaccuracies or elisions perpetrated

on the part of the Grange, the actors playing bread-baking maids were a publicly celebrated aspect of the property's historical tours. Never were these composite representations of a joyful nineteenth-century servant intended or understood to be a deliberate deception enacted against patrons.

Mary O'Shea of *He Named Her Amber*, on the other hand, differs from the Grange's previous bread-baking maids in that observers have no chance to make a pact beforehand to suspend their disbelief for a fiction. Rather, they believe Mary to be historically real and therefore experience what Abramson describes as a "fictional narrative that incites a reader to an authentic 'methectic' or participatory response" (*methectic* meaning immersive—an experience felt as though "real"; by contrast, in a *mimetic* experience, one observes rather than physically, emotionally, and intellectually participates in the theatre unfolding). This methectic response, then, with the reveal, "alters the very nature of reality and skews the oppositional relationship of fact to fiction."[90] To have the "very nature of reality" skewed and altered is an inherently disorienting incident. The viewer is physically, emotionally, and rationally immersed in an experience of what she believes to be reality, only to realize, upon the reveal, that this event was a fiction. Rather than leaving a tour at the Grange holding a real piece of bread freshly baked by a fake maid, the tour-goer participating in *He Named Her Amber* emerges encountering their own disorientation.

In "Bodily Disorientation and Moral Change," philosopher Ami Harbin writes that "the bodily ease of felt orientation is like this: we can be most likely to notice that we were at ease only when we become partially or seriously disrupted, when we are no longer able to recognize or interact with objects, people, or occasions in ways that were once habitual."[91] The unease felt by museum visitors—experienced as "dizzying"[92] and as a form of "discomfort"[93]—is a sign of disruption to our habitual gallery experiences. This discomfort is articulated by commentators through resentment, anger, disappointment, and a diminishment of faith. One anonymous commentator writes, "The AGO has behaved and continues to behave disgracefully in continuing to present a fictional narrative as an actual discovery. In the face of upset patrons, the AGO is an arrogant schoolyard bully."[94] Another respondent asks of Häussler, "Am I stupid for not assuming that someone might be lying to me because the story was so eccentric? Is this an exercise in proving how gullible people are?[95] Another writes, "We lost our time, our faith in human interaction, our attention to worthier aspects of the AGO."[96] As Carrie Lambert-Beatty notes of parafictions (a term she chooses in order

to describe hoaxical works, just as Abramson has chosen "mystifications," Ruthven "supercherries," and McHale "mock hoaxes"): "Being taken in by a parafiction after all, is not just epistemologically destabilizing. It is humiliating.... Parafiction is an antidote to vanity. It changes you, leaves you both curious and chastened."[97] Realizing that our loss of comfort is deliberately being performed against us can be humiliating.

Yet, disorientation does not always result in inarguably negative experiences. Some emails to Häussler indicate a complex range of responses that defy binary categories of accomplice and victim. Paul Roorda writes that he felt "duped, captivated by a fiction, a trust betrayed," yet he also acknowledges the ability to "step above all of that to admire your creative work as art, and the process of my belief, the challenge of reinterpreting my strong response."[98] Krys Goldstein writes of the experience of the reveal she and her daughter felt upon reading Chantal's letter: "Things became unclear, hard to comprehend ... then whoa ... we felt betrayed ... sad that [Mary O'Shea] did not exist—pissed off ... then so enthralled with the genius and elaborateness that we wanted to do it again."[99] These respondents express dismay or discomfort at the experience of being hoaxed alongside feelings of challenge and/or enthrallment. In all cases, the experience of the hoax is felt physically, emotionally, and sensorily, potentially allowing for questions of history, art, ethics, and trust to (haptically) be felt as well as intellectually analyzed.

For some respondents the experience of mistakenness and unease even resulted, as it did for Lynne Kenneith Brogden, in various reported pleasures: "I have not had such a wonderful thing happen to me in a long time. I keep revisiting the experience. Just thinking about it fills me with a grand feeling of awe again.... It is emotional splendour."[100] For others, the experience of mistakenness evoked wonder or astonishment. Mistakenness—both in a gallery setting, and in "real life"—need not be thought of negatively. As Canadian poet Anne Carson observes in the poem "Essay on What I Think about Most:" "Lots of people including Aristotle think error / an interesting and valuable mental event."[101] Carson's poem examines the emotions that come when we make a mistake:

On the brink of error is a condition of fear.
In the midst of error is a state of folly and defeat.
Realizing you've made an error brings shame and remorse.
Or does it?[102]

Carson's poem argues that attending to our experiences of assumption, error, and mistakenness has tremendous potential to be, as Aristotle himself noted, a "valuable mental event." If, as Carson suggests, we "look into this,"[103] we may find that our experiences of disorientation and mistakenness—such as the disorientation and mistakenness of believing Häussler's artwork to be a factual example of history—help us to discover more deeply what enlivens and troubles our daily inhabited epistemologies. Carson, referring to Aristotle's *Rhetoric*, suggests that when "the mind experience[s] itself / in the act of making a mistake," a "surface breaks or complicates" and "Unexpectedness emerges."[104] While at first the unexpected experience "looks odd, contradictory or wrong," through our shock we come to realize that "things are other than they seem" and that "such mistakenness is valuable."[105] Paradoxically, moments of mistakenness or disorientation often permit new aesthetic and ethical insights and alert us to habituated thoughts and concretized beliefs. As Harbin claims, "we are often most able to recognize our orientations when we become disoriented."[106] To be disoriented permits us to see as new what has become routine and to thus understand our held beliefs, actions, and orientations more clearly.

Orientations are generally considered useful in our daily directional and social navigations, providing comfort and ease in interfaces and interactions. As Edward Casey notes of orientation, "The main function of orienting is to effect familiarization with one's surroundings. To be disoriented, or even simply unoriented, is to find these same surroundings unfamiliar, *unheimlich*.... Getting oriented is to learn precisely which routes are possible, and eventually which are most desirable, by setting up habitual patterns of bodily movement."[107] Orientations can, along with habitual patterns of bodily movement, include confidence in one's beliefs, comfort with one's surroundings, and/or a firm grasp of social customs and behaviours. Casey goes on to note that with "the development of body memory, we find that less thought and effort is required in order to feel oriented."[108] Harbin adds that body memory "leads to felt orientation by making some embodiments so intuitive we do not (because we need not) notice ourselves or others enacting them."[109] It is when we begin to rely heavily on habitualizations that we may, unconsciously, take for granted the positions and relationships we have become oriented to: we may carefully roll up a nylon stocking before placing the gathered fabric onto our pointed toe without noticing the learned competence of our action, nor the learned gendering of the garment itself. In being oriented we may falter at noting the beauty in a partner's freckles or blue eyes. Because we see

him daily, our familiarity over time may cause inattention within a precious relationship. We may drive each morning from a home in Hamilton to our workplace in Toronto on a well-travelled route without consciously remembering the mechanics of operating the vehicle (Did I stop at that light? Did I signal for that left turn?). From habit, we might neglect to reflect upon our environmental impact of choosing to drive our own car each day rather than carpool or take public transit. Orientations consist of bodily, emotional, and cognitive habits. When we become disoriented, the experience is total. We don't just *think* we are disoriented, or rationalize it through a Cartesian method of our minds overcoming the experiences of our bodies. When disoriented, all aspects of ourselves are jolted out of the expected.

The Russian Formalist Viktor Shklovsky noted the effects of habitualization in his 1917 aesthetic treatise, "Art as Technique": "If we start to examine the general laws of perception, we see that as perception becomes habitual, it becomes automatic. Thus, for example, all of our habits retreat into the area of the unconsciously automatic."[110] Shklovsky claimed that one only need think of a repetitive action to feel the dampening work of habit: "If one remembers the sensations of holding a pen or of speaking in a foreign language for the first time and compares that with his feeling at performing the action for the ten thousandth time, he will agree with us."[111] Shklovsky felt strongly that when perception becomes habitual our lives are "reckoned as nothing."[112] "Habitualization," he wrote, "devours works, clothes, furniture, one's wife, and the fear of war. If the whole complex lives of many people go on unconsciously, then such lives are as if they had never been."[113] Just as orientations can offer us comfort and ease, entrusting ourselves completely to habits or routines without conscious awareness can, over time, deaden our experiences of life and prevent us from asking important questions about our own thoughts and actions, and those of the society to which we belong.

The disruption that *He Named Her Amber* instills in the gallery-going public ought not to be considered a flippant gesture. For despite the work being considered lighthearted tomfoolery or "bullshit" by some,[114] Häussler's hoax is what psychoanalytic scholar Jonathan Lear would call "a peculiar form of *committed* reflection" on history and authority.[115] The work examines the roles of the gallery, artist, and spectator, as well as the often unspoken and unexamined pacts connecting all three players. The work in no way suggests the meaninglessness of art's role in society, nor is *He Named Her Amber* an act of devaluing or dismissing the importance of history, gallery, or patron, so much as a reflection upon these values. Lear writes about an experience of

disorientation he felt during the middle of his career as a teacher in the class-room. He notes that "it is because my life as a teacher matters to me that I am disrupted."[116] Likewise, it is because the roles of museum-goer, artist, patron, curator, historian, and so on matter that Häussler chooses to disrupt them. *He Named Her Amber* allows the viewer to live as a habituated museum-goer without interruption for the duration of the tour. But, upon the reveal, the viewer is then called to pay attention to the role of the museum, the work of the artist, and the viewer's own role as spectator to the art—to question why and how truths, histories, and authorities are established. Through the deception and reveal of Häussler's work, our experience of the gallery becomes not just "one more possibility" that we can "simply add to the established repertoire" of museum going, of placing trust in authority, or of understanding art's purpose in our lives: "It is a disruption of the repertoire—and in the disruption, it brings to light that the established repertoire is just that."[117] This is why the strength of responses to *He Named Her Amber* shows that the ori-entations being disrupted are often deeply valued and deeply entrenched. The hoax reveals patrons' commitments to history, aesthetic value, and accuracy, which are entrusted to the authority of a museum to keep. Yet the hoax also asks if there are aspects of these institutional or personal commitments and habits that ought to be carefully re-examined or that are ready to be let go. For Häussler, "the museum is a central metaphorical predicate that requires a critical view."[118] *He Named Her Amber* "treats the museum (the edifice, idea and daily operation of the institution) as a proscenium, a frame into which the viewer enters ... [in order to] fulfil a time-honoured criterion of art—to encourage visitors to test their convictions."[119] The testing of viewers' con-victions through a sustained and relational medium of art arguably makes *He Named Her Amber* an ethical as well as an aesthetic event.

The extended duration of a viewer's engagement with the excavation at the Grange performs what Shklovsky describes as "the technique of art": "to make forms difficult, to increase the difficulty and length of perception because the process of perception is an aesthetic end in itself and must be prolonged."[120] The tour at the Grange requires, at first, a commitment of a minimum of half an hour of each viewer's time, after which, upon the reveal, a visitor then immerses herself in revising and revisiting her experiences after the frame of the excavation is broken. The prolonged temporal response of viewers to Häussler's work is, in part, enactive of the type of sustained and binding attention between beings that ethics requires. Emmanuel Levinas's philosophy that ethics arises before ontology—that we are beholden ethically

to an other, before we know what that other will bring—is at play in the rela-
tionality and sustained attention inherent to Häussler's art. Indeed, Häussler
herself has stated that the "conceptual dimension" of He Named Her Amber
"focuses on questions of self and other, on the nature of art and how art
relates to other facets of life."[121] Shklovsky ultimately claims that "art exists
that one may recover the sensation of life; it exists to make one feel things,
to make the stone *stoney*."[122] Along these lines, the form of He Named Her
Amber requires viewers to sustain their attention to the simple physical prop-
erties of their environment: stones, dirt, earth, and wax. Simultaneously,
Häussler's artwork asks viewers to sustain their attention to history and to
story, to the narratives we create about our physical world. Upon the reveal,
viewers are asked to re-see the museum and the truth it houses. Not only do
patrons re-examine their faith entrusted to the institution of the gallery, but
He Named Her Amber has the capacity for viewers to "recover the sensation of
life" through seeing anew—whether through discomfort or delight—daily
objects and activities that are, at first, expected, cursory, and habitual.

The questioning of institutional authority inherent to He Named Her
Amber has been read by some patrons as a vigilance to truth and by others as
an erosion of trust. Yet it is at this edge that hoaxes are conducted: "The fact
that parafictions are queasy-making is key to what they are and what they
do."[123] Hoaxes are, as Lewis Hyde states in the context of trickster narratives,
"radically anti-idealist; they are made in and for a world of imperfections."[124]
Hoaxes deal with aesthetic and ethical questions in the realm of what sound
technicians call "dirty conditions": conditions for recording that are not pris-
tine or flawless. Lambert-Beatty writes that artistic practices that play with
ideas of truth and fiction interest her as an art historian "because they are
so powerfully and uniquely appropriate to our historical moment—which
is to say, powerfully and uniquely troubling."[125] The world is frequently a
troubling, imperfect, and flawed place. We live in a cultural landscape where
it is commonplace for consumers to be manipulated by corporations into
purchasing consumables beyond our needs, where the environment is defiled
for monetary profit, where politicians in charge of countries and cities do
not lead with trustworthiness, and where history is written by upper-class
and racially dominant groups. Lambert-Beatty suggests that in "experi-
encing most parafiction—where the fictional hangs on the factual—one is
evaluating not only whether a proposition is fictional, but what parts of it
are true.... Parafictions train us in skepticism and doubt, but also, oddly,
in belief."[126] Hoaxes can remind us that in keeping careful watch we will

encounter not only danger and difficulty, but the clarity and possibility that is also inherent to risk.

He Named Her Amber is a relatively safe space in which to experience, respond to, and examine feelings of misplaced trust, as well as the feelings of surprise and contingency that an "other" can bring to our lives. Art, theatre, and story—all of which are foundational components in *He Named Her Amber*'s creation—become a means of play, practice, and imagination, so that we might consider our responses to further circumstances outside of a gallery or a book wherein we may need to rely on our developed awareness and attention. *He Named Her Amber* asks that we as participants be alert: whether to the embodied experience of comfort or mastery; to the ethics of a given situation; or to an examination of our own unique and individual beliefs in relation to the received stimuli of places, circumstances, information, and people. To be alert to our surroundings and the intentions of others can protect us from harm, but it can also open us to richer lived experiences wherein we fully listen, smell, touch, feel, and take in the environments, objects, and people around us. When we become so comfortable with our circumstances as to slip into boredom, we also risk, according to Levinas, slipping into unethical engagements with others: "The unknown is immediately rendered familiar and the new habitual. There is nothing new under the sun ... not due to sin but to *ennui*. Everything becomes absorbed, engulfed and immured in the Same.... Except the other who, in all this *ennui*, one cannot abandon."[127] Because of our unconditional responsibility for the other—that person or circumstance outside ourselves that interrupts our expectations and calls us to attention—we are prevented from using, cannot under any circumstances use, our ennui as an excuse for abandoning the other. The other requires us to practice vital engagement, even if that "other" is a made-up maid, a fictional anthropologist, a non-existent butler, or the authority of the museum itself.

(PISSING?) ON THE MUSEUM'S AUTHORITY

The foundation of *He Named Her Amber*'s hoax relies upon the inherent trust that gallery-goers bestow on the authority of the museum. The tools used to protect ideas of authenticity in an institutional context are turned into the props of an elaborate stage set under Iris Häussler's hand. Glass display cases and museum labels deliberately misinform us of the origins and significance of the artifacts inside. The dress and technology of science—lab coats, white gloves, microscopes, scalpels, and official-looking nametags—are convincing

markers of authority. The comfort and solidity of numeric accuracy, such as birthdates and death dates, act like nails, hammering down facts to create a seemingly solid piece of history. Even the building's historic and cultural designations are exploited for the ruse: built on decades of criticism and taste, the institutions of the art museum and National Historic Site determine, by what they house, what art and history *are*. As Lambert-Beatty has noted of parafictions, "institutional authority is a crucial ingredient in plausibility."[128] In this sense, a niggling hypocrisy remains in hoaxes performed by museums and artists: because Häussler has worked in collaboration with the AGO, it is ultimately from the museum's authority that the questioning of authority comes.

Toronto gallerist and former AGO curator Jessica Bradley notes of *He Named Her Amber* that "playing games of trust and challenging the authority of the museum is *de rigueur* in the art world … but it takes courage and commitment on the part of the AGO to acknowledge that they are not sacred or untouchable."[129] While I agree with Bradley that a gallery taking a risk to get patrons questioning the status of a museum is brave, the museum and artist are still complicit as curators to the visitor's reading of the artwork: the power and authority of the museum and the artist have not entirely disappeared, as Kingwell hoped. Those who delight in a hoax's subversive nature are often thrilled at the ability of a hoax to "disturb the societies in which they are produced … in ways resented by the guardians of cultural institutions,"[130] yet the "guardians of cultural institutions"—the AGO, David Moos, and the tour guides—are, in the case of *He Named Her Amber*, collaborators in the visitors' deception.

The pact made between gallery, artist, and viewer in the formation of a piece of art becomes especially exclusive when two parties of the pact work together to misinform the third. However, with any kind of pact, there is no guarantee that the interpreter will *get* or *make* the meaning of the hoax in the same way that an artist or institution intends. Viewers can thwart as much as realize an artist's intention, making meanings artists or institutions did not plan upon or predict. The third party of the pact—the viewer or reader—still has power in how an artwork is read, perceived, and publicly discussed. Certainly a viewer's reaction can involve hostility toward the affront of the hoax, as evidenced when patrons who were upset with their experience of *He Named Her Amber* revoked their AGO memberships and thereby their financial support to the institution.[131] However, there is also a kind of thwarting that Häussler and the AGO's collusion might inspire in viewers that remains closer in kind to the thwarting of authority *He Named Her Amber* attempts to

perform. For instance, upon completing a tour of *He Named Her Amber* with a friend, I insisted that we read the letter together. Her response was not to be offended, or even especially delighted, but to immediately think of ways she could hoax Häussler back: writing a letter to Häussler from Chantal Lee; finding a Korean actress to sneak into Dr. Lee's basement office, hide in the sleeping bag, and surprise the tour guide and audience by yawning and getting out of the cot, upset at the group's intrusion.

To intervene with regard to an artwork is not a new idea. Artistic interventions involve interactions with previously existing artworks or artistic venues, as well as interactions with sites and situations outside of the art world, in an attempt to change the existing aesthetic, political, and/or economic conditions of a given institution, group, or person. Artistic interventions have implications of subversion, although they are often performed with the endorsement of those in positions of authority, as is the case with *He Named Her Amber*. Unendorsed interventions are still common, however, and often blur distinctions between art and vandalism or trickery.

One of the most famous artistic interventions of the twentieth century has itself been the recipient of further artistic interventions. In 1917 Marcel Duchamp anonymously submitted *Fountain*, one of his early ready-made sculptures, to the Society of Independent Artists in New York for an exhibition. The Society had proclaimed that it would exhibit all submitted work. However, despite the Society's promise, *Fountain*—a urinal signed "R. Mutt"—was hidden from view during the show (and then subsequently lost). The New York Dadaists protested *Fountain*'s exclusion in the second issue of their publication the *Blind Man*: "Whether Mr. Mutt made the fountain with his own hands or not has no importance. He CHOSE it. He took an article of life, placed it so that its useful significance disappeared under the new title and point of view—created a new thought for that object."[132] *Fountain* intervened with regard to prevailing notions of what a work of art was, shifting the focus of art from the physical craft of an artwork to its conceptual interpretation and context. Perhaps, then, it is fitting that in the spring of 2000, performance artists Yuan Cai and Jian Jun Xi honoured the spirit of Duchamp's work and critiqued the current state of Modern British art with an intervention of their own. Xi claims that, "Modern British art is getting worse and worse. They haven't taken any risks. The mainstream are caught in a circle, and we are outside that circle—pissing in."[133] Yes, you guessed it: Cai and Xi went to the newly opened Tate Modern and urinated on the artist-approved copy of the *Fountain*.[134]

Cai and Xi were in fact prevented from soiling the sculpture directly by a Perspex case that surrounds the work, erected due to other artists' and visitors' previous attempts to pee in the *Fountain:* "In the last decade of the twentieth century" alone, attempts were made by "Brian Eno at the Museum of Modern Art in New York in 1990; Kendell Geers at the Palazzo Grassi in Venice in 1993; Pierre Pinocelli at the Carré d'Art in Nîmes in 1993; Björn Kjelltoft at the Moderna Museet in Stockholm in 1999; and Yuan Cai and Jian Jun Xi at the Tate Modern in London in 2000."[135] The year before Cai and Xi urinated on Duchamp's sculpture, they "intervened" in Tracey Emin's installation *My Bed,* shown at Tate Britain during a 1999 exhibition honouring artists nominated for the prestigious Turner Prize. *My Bed* consists of a bed made with dirty unkempt sheets littered with condom wrappers, vodka bottles, tissues, and other detritus that implies a sexually active, alcohol-swilling lifestyle. As the title of their work *Two Naked Men Jump into Tracey's Bed* explains, Cai and Xi took off most of their clothing and jumped on her artwork.

However, Cai and Xi are certainly not alone in performing interventions at/against established works of art. The palimpsests of interventionist art are perhaps endless, as evidenced by cases of artistic interventions intervening into artistic interventions. In the spring of 2003, an unidentified man intervened with Cornelia Parker's *The Distance: A Kiss with Added String.* The sculpture—"nothing more than Rodin's sculpture *The Kiss* wrapped in a [mile's] length of twine," which, "according to the artist is 'a comment on the claustrophobic nature of relationships'"—was freed of its ties after the twine was snipped with scissors.[136] *Telegraph* Arts reporter Mark Blacklock suggests that out of the recent artistic interventions that have been made upon/into artistic interventions, the freeing of *The Kiss* from its string was "the most eloquent" and worked "to advance the original piece, bringing to it a sense of completion."[137] Blacklock speculates that the scissoring may, in fact, have "offered a ray of hope to the artist," for if "the artist finds relationships claustrophobic, shouldn't she find the cutting of her string metaphorically at least, a liberation?"[138] He concludes his commentary by suggesting that the artist and the vandal get together for a dinner date over "a bowl of spaghetti."[139] Indeed, as Blacklock's humorous reportage suggests, artistic interventions can spiral into absurd navel-gazing acts, deserving only of witty rejoinders. Yet, the humour and creativity of these interventionist responses to art—not withstanding their violent, disobedient, and certainly, at times, criminal behaviour—have a spirit of participation about them that ought not to be completely overlooked.

In the case of *He Named Her Amber* there have already been creative responses to the artwork that did not require the disruptive vandalism of pissing on works of art. Along with the emails expressing wonder, Häussler also received a message from "Neil Hollands" who claims to have been "born in 1961 onboard the marine research vessel HMS *Jack Russell* while stationed ten miles off the Larsen G shelf in Antarctica."[140] Hollands asserts that his mother, "Dr. Grace Wilson, an endocrustaceanist, was recovering from a diving accident inside a hyberbaric chamber when she gave birth to me."[141] He explains that the accident "grossly enlarged posterior canals within my inner ears" and "somehow allowed me to discern complex harmonic overtones inaudible to others."[142] Further, Hollands' email tells Häussler, "I feel I can trust you," and, because of this trust, Hollands goes on to warn her of "robot-ized drummers" whose "frequencies are siphoned off and fed into innocuous looking 'domestic glass jars'" in the Grange basement: "YOUR EARS MAY BE IN SERIOUS PERIL!" insists Hollands.[143] He concludes by inviting Häussler to participate in a scientific experiment "disguised as a house party."[144]

Hollands' response to the fiction of *He Named Her Amber* with fiction lightheartedly questions the authority of Häussler and her artwork, just as she and her artwork questioned the museum's authority. Hollands' fiction plays with elements of Häussler's art, but subverts them into his own imaginative narrative response, a literary equivalent, perhaps, to pissing on (or taking the piss out of) Häussler's narrative. Hollands ironically brings up the trust of a viewer that Häussler engages with: "I feel I can trust you," he says, to the woman who has just fooled him with her art. A key element of *He Named Her Amber*—scientific work being a mask for playful artistic invention—is mimicked in Hollands' email, wherein a scientific experiment becomes a house party and reference is made to a "marine research vessel" preposterously named after a breed of dog rather than a lauded scientist. The fabrication of an elaborate story based on a simple object found in domestic areas of the Grange home is also subtly and hilariously parodied in Hollands's response: the dangerous noises are coming from "domestic glass jars." Just as Cornelia Parker's intervention into Rodin's sculpture *The Kiss* was performed with her mile of string in *The Distance*, and just as the interventionist snipping of Parker's strings added to the history of both Rodin's and Parker's works of art, Hollands's response to Häussler's response to the history of the Grange adds to the palimpsest of events and interactions that have occurred through the existence of this singular Toronto home.

Award-winning Toronto novelist Martha Baillie has also responded to Häussler's artwork with reciprocal creativity. For *Brick* magazine's Summer 2007 issue, Baillie wrote "An Encounter with Joseph Wagenbach," a personal essay describing her experience of Häussler's earlier work at 105 Robinson Street. Baillie's essay questions the ethics of Häussler as an artist, and admits to her sadness and frustration at being duped: "For a full five minutes, I felt indignant—and then a sense of hollowness set in. I was losing Joseph. I felt a new anger, one born of loss rather than hurt pride."[145] Baillie's response to *The Legacy of Joseph Wagenbach* inspired Häussler to ask Baillie whether she would agree to write an essay about *He Named Her Amber*. Baillie decided to go through the training required to pose as a guide at the Grange in order to see what the experience of Häussler's work might be from the other side. In "Memoir of a Tour Guide," published in the catalogue for *He Named Her Amber*, Baillie outlines her training as a volunteer and her memorization of the various details she was expected to include for her tour group, along with the mixed feelings she had as a "traitor" to her fellow gallery patrons as she led them through the house: "'It's not true,' I wanted to shout. 'It's all a fiction.'"[146] Baillie concludes her personal essay on *He Named Her Amber* by continuing what she began in "An Encounter with Joseph Wagenbach," namely to contemplate the ethics and purpose of Häussler's work of art: "The early twentieth-century Russian philosopher Lev Shestov wrote that anyone seeking truth stands like a drunkard on ever-shifting ground and must be prepared to fall down repeatedly. *He Named Her Amber* pulls the rug out from under our feet. On the other side of this disagreeable sensation, what remains?"[147] Baillie, like Neil Hollands, responds to the ever-shifting ground of truth seeking that Häussler's work has inspired her to think about with a further creation of art, a fictive monologue that gives close third-person omniscient voice to the voiceless Amber of Häussler's creation:

> Where is she to hide her little waxen planets? The house is her sole ally. It knows all about secrecy; its walls and floors harbour abundant rumour. Pry up a loose floorboard, remove a brick, or tap at a crack in the plaster. She inserts her treasure, then returns everything to its proper place. Now when she enters a room, the walls and floor speak to her, in a language only she can comprehend.... She suffers from headaches. Yet she must continue at all costs. Secret knowledge is privilege. She is heaping privileges upon herself.[148]

By giving Häussler's Amber a voice, Baillie is adding—without permission from the artist or the gallery—to the body of work that is *He Named Her Amber*. The artwork—even after it is no longer on display in the museum—continues to be improvisational in that it changes and transforms with the interpretations and interventions of viewers. To respond with thoughtful critique or with creative flourish to *He Named Her Amber*, as both Hollands and Baillie have done, means that the meaning (and meaningfulness) of the artwork does not rest with the authority of the gallery as an institution or with the artist's intention. The artwork's meaning and life in the world are manifested through the truly collaborative and contingent actions and reactions of the reader or viewer. There is an authority that an artist and a gallery cannot ever claim, and that is the authority over the unique felt responses of patrons to works of art. Honesty and notions of truth persist in our society for the sustainability of trust in our communities. It is not my intention to argue that the art gallery ought not to have authority or trust bestowed upon it by society to care for and house important works of art and cultural artifacts. My claim, in bringing the antics of artists and/or vandals like Chai and Xi into the conversation is to note that gallery, artist, and viewer are all bestowed with authority, and what Häussler's art asks, and what interventions and responses to works of art also have the ability to ask, is just how that authority is chosen, distributed, and conducted, and whether, ethically, there are occasions where the authority of the museum certainly needs to be questioned by both artists and the public.

The epistemology of revision toward established norms of curation and display that *He Named Her Amber* can inspire in viewers is transformative, and it is curatorially connected to Frank Gehry's architectural renovations to the Art Gallery of Ontario, named "Transformation AGO." As Gehry's architectural renovations transform the *physical* space of the gallery, *He Named Her Amber*—the opening of which deliberately corresponded with the gallery's reopening—transforms the *theoretical* space of the AGO by reimagining the foundations and practices of the gallery and the context of its history, and by asking basic questions about what *is* and what *makes* a work of art. The combination of this architectural and theoretical transformation allows for a deeper contemplation and connection to *all* works of art and *all* gallery experiences encountered thereafter.

Häussler's *He Named Her Amber* is not a practical joke or a malicious act. It is not a lie made to undercut the seriousness of art or the importance of the art gallery in housing, protecting, and displaying treasured and singular

works of art. *He Named Her Amber* is, paradoxically, an act of faithfulness to the practices of art, curation, display, and patronage through its very disruption to the expectations and common practices of artists, galleries, and museum guests. The disruption disorients habituated and inattentive practices of creating, curating, and consuming art so that both individuals and institutions remain self-aware, alert, and adaptive to the change that art can instill in our perspectives, our relationships, our daily lives, and our understanding of the human histories that take place on this land.

Unsettling Images

Decolonizing Ethnographies in the Artworks of

Brian Jungen, Jeff Wall, and Rebecca Belmore

ETHNOGRAPHY, ART, AND COLONIAL THINKING

The entire time I was enrolled in my public education, from kindergarten in 1984 to the start of my graduating year of high school in 1996, federally and religiously run residential schools, whose chief aim was "aggressive assimilation," and which, over the course of their history in Canada, forcibly removed over 150,000 First Nations, Inuit, and Métis children from their communities, were in full operation.[1] At these schools, children's bodies were buried by priests and teachers under the lawns, less than a half-day's drive from my own school grounds.[2] At these schools, Indigenous children were subjected to medical experiments and deliberate malnutrition, with federal consent.[3] Children experienced physical and sexual abuse at the hands of their teachers, principals, and priests.[4] Children were physically punished for speaking their Native languages, for dancing, for singing, or even for smiling at their siblings.[5] In over twenty-seven years of public, undergraduate, and graduate education in Canada, the history of residential schools was not once taught to me in a classroom—yet, *twice*, I was taught about Indigenous history using the fake ethnographic paintings of Paul Kane: once in Grade 1 at my

elementary school in Regina, Saskatchewan, with a viewing of the 1972 film *Paul Kane Goes West* produced by the National Film Board (NFB), and once through my Grade 10 social studies textbook while I attended high school in Vancouver, British Columbia.

It is the realities and the contemporary repercussions of Canada's colonial history which, for generations of Canadians including my own, were deliberately missing from classroom education that Brian Jungen's *Sketches Solicited for Wall Drawings*, Jeff Wall's photograph *Fieldwork*, and Rebecca Belmore's *Wild* and *Vigil* critique. These contemporary artists use a technique known as "reverse ethnography" to illuminate the ways in which anthropology, ethnography, and museological display buttress the erroneous myths of the "peaceful settler" and the "vanishing Indian" that still exist in contemporary ideas of Canadian history and identity, and which "create the myth of the country we now call Canada."[6] In "reversing" the ethnographic and museological practices that many of us have experienced as children on museum field trips and in classrooms, it is the viewer's habits of colonial thinking, often learned throughout early education, that become foundational materials to Jungen's murals, Wall's photograph, and Belmore's performance art. Before I examine the reverse ethnography of Jungen's, Wall's, and Belmore's art, I want to give two examples of dubious ethnographic encounters that demonstrate the need for artistic disruption to Canada's cultural institutions that have historically produced, and often continue to perpetuate, harmful colonial thought. One is the example of encountering Paul Kane from my own early education, and the second brief example comes from the more recent opening in 2012 of the Canadian Museum of History.

In my elementary school in Regina, watching a film meant that the reel-to-reel projector and screen were set up in the gymnasium and all the classes gathered together to watch whatever had been selected and shipped to our school in the silver circular metal film canisters. After we'd been seated in rows, collectively counted down the projected numbers, and made shadowy shapes with our fingers in the dusty beam, the green-eyed logo of the NFB appeared on the projection screen. *Paul Kane Goes West* begins with quotes from Kane's journals as he sets off from the muddy streets of Toronto for a cross-country painting tour that takes him from Lake Ontario all the way to Puget Sound and back again. In a voice-over, we hear passages from Kane's journals describing the disappearance of the "red man": "all traces of his footsteps are fast being obliterated from his once favourite haunts, and those who would see the aborigines of the country in their original state, or seek

to study their native manners and customs, must travel through the pathless forest to find them."[7] The film shows a large collection of Kane's paintings while describing the arduous journey he took, forty years before the rail lines crossing Canada were completed, of a Métis buffalo hunt, a traversal of the Saskatchewan River, lodging in Fort Edmonton, climbing the Rocky Mountains, and descending into the Columbia River to Fort Vancouver in early December of 1846.[8]

Watching the film again as an adult, it occurs to me that the story of Kane's treacherous journeys that precipitated his rise as a painter and ethnographer in Canadian history have been made so mythic that Paul Kane could be a character made up by Iris Häussler: an intrepid Victorian explorer-artist in a fur-lined parka, sketchbook in hand, a distant relation of the Irish scullery maid with a penchant for beeswax who was, during the very same year of history that Kane was setting off on his voyages west in 1845, stockpiling candle wax and creating her mysterious objects in the Grange home. Kane's travails embody a particular lore of exploration and expansion prevalent in the mythology of Canadian settler history: the lone explorer besieged by a hostile environment, traversing empty landscapes by canoe and snowshoe, his feet "cut by large cakes of ice that would form every day in his moccasins."[9] The film describes how Kane travelled and painted due to his firm belief that the Indigenous population of Canada was disappearing and needed to be captured on canvas before this annihilation took place. It is also quite likely the case that Kane recognized how this timely ethnographic capture would, once he returned to Toronto, bring him fortune and fame: which it did.

The public's response to Kane's first exhibition solidified his position as an ethnographic authority on North American Indigenous populations. Within a month of returning to Toronto, Kane mounted an exhibit that included paintings, sketches, and Indigenous cultural "souvenirs." Patrons and citizens who encountered Kane's work back in the city did not just deem him "Canada's foremost painter of the West"; they also considered him a scientist, an ethnographer, and an archaeologist. Kane's work was cited in ethnographic texts such as Daniel Wilson's *Prehistoric Man*.[10] Kane's field sketches were regarded as field studies. His portraits doubled as data collection. Kane was praised for the authenticity of his drawings and paintings. The *British Colonist* newspaper claimed that a "striking characteristic of Mr. Kane's paintings is their truthfulness" and that "nothing has been sacrificed to effect—no exaggerated examples of costumes—no incredible distortions of features."[11] Scholars lauded his paintings as realistic graphic representations

of the ordinary activities Indigenous people conducted in naturally occurring settings: the quintessence of ethnographic method.[12] Kane was known for meticulously "seeking out testimonials to assert his faithful renderings of landscapes and portraits in the field."[13] He had his subjects and his fellow travelling companions sign documents and the images themselves to assert the accuracy of his depictions of the people and places he visited and documented along his journeys. Yet, despite these safeguards for factuality, Kane cheated in his realist depictions by, once returning to his studio, reflecting Eurocentric attitudes in his compositions, and adding culturally inauthentic clothing and artifacts in his depictions of Indigenous subjects.[14] In erasing specific cultural practices in favour of an ahistorical amalgam of traditions, Kane's work perpetuates a quiet yet undeniable form of violence toward First Peoples through misrepresentation and erasure.

Now that I know Kane's predilection for fakery, the two "historical" images I recall from my Grade 10 social studies class during our unit on "Western Expansion" appear to me as harmfully dehumanizing stereotypes. *Kee-a-kee-ka-sa-coo-way, The Man Who Gives the War Whoop* and *Flathead Woman and Child, Caw-wacham*—are examples of how Kane frequently mixed and matched tribal objects in his paintings—depicting arrows, fishing hooks, blankets, masks, and garments out of their geographic, historic, and ethnographic context.[15] Kane's field sketch of *Kee-a-kee-ka-sa-coo-way, The Man Who Gives the War Whoop* is noticeably different from his studio painting. In the field sketch, Kee-a-kee-ka-sa-coo-way wears a wolfskin fur draped over his left shoulder. His face is painted red at his eyes and on his chin. He holds nothing and wears no headdress on his head.[16] In the studio painting, Kee-a-kee-ka-sa-coo-way is wearing a buffalo-skin shirt with fringe, beading, and embroidery work. He wears a headdress with red feathers. He holds an elaborate ceremonial pipe adorned with a fan of white feathers and the head of a black bird.[17] In *Flathead Woman and Child, Caw-wacham*, Kane combines a sketch of a Chinookan baby having its head flattened by being strapped to a cradle board with a later watercolour field portrait of a Cowlitz woman living in a different region: "In the studio oil, Kane attached the Cowlitz woman's head to a fur-robed torso, placed the Chinook child in her arms, and set them both against a romantically atmospheric background of billowing clouds and darkly arching trees."[18] The composition of Caw-wacham creates the effect of a "New World version of a European Madonna and child,"[19] an aesthetic decision that inflects the painting with Christian iconography, muddying the ethographic imperative to "collect data in a systematic manner but without

meaning being imposed on them externally."[20] Kane's artistic decision to remove a baby from its mother's arms and pictorially place that child in the care of someone who has no relation to the child is hauntingly indicative of the disregard for family and cultural connection that took place in the forcible removal of Indigenous children to attend residential schools, a removal from family and community that continues to take place in Canada's current foster care system where "52.2% of children in foster care are Indigenous, but account for only 7.7% of the child population."[21]

By erasing particularity and nuance from his portraits in favour of the popular European sentiments of his clients, Kane's works solidify culturally erroneous depictions of Indigenous populations in public consciousness as historical documentation. To set the same problem in a hypothetical contemporary context, notwithstanding the dynamics of race and power present in Kane's artistic capture of Indigenous people on his travels: Kane's practice of swapping significant cultural dress and traditional objects and claiming his work is ethnography would be as erroneous as Kane deciding to make himself known for painting Canadian hockey players, only to depict famed Edmonton Oiler Wayne Gretzky wearing a Calgary Flames jersey and holding a curling broom. Regardless of his deliberately deployed cultural inaccuracies, I am not the only student to go through a public education in Canada learning "history" from Kane's fake paintings. Up until the late twentieth century, Kane's images were included in Canada's public-school curricula as accurate renderings of early Indigenous existence.[22]

The unquestioning acceptance of Kane's distorted "documentary" portraits and landscapes as truthful representations of Indigenous populations throughout generations of public-school teaching means that current understandings of Canada's history continue to be filtered through a colonial, imperial, and Victorian sensibility. What Kane's artworks "accurately" or ethnographically realize is not an Indigenous historical reality but a nineteenth-century urban European projection of how Indigenous communities living in Canada's "wild west" looked, lived, and behaved, devoid of the very context and consequences of colonial "contact" for which many of these patrons were responsible. Never once, for instance, does Kane indicate—in his writings or his artworks—that he had seen Indigenous populations ravaged by the illness and alcoholism introduced by explorer and settler populations. Never does Kane allude to the conditions of what contemporary artist Sonny Assu has described as "the world's forgotten genocide ... the largest in our Western history."[23] And if Assu's choice to use the word genocide in

association with the acts of settler populations on First Peoples in Canada seems too extreme, a review of the legal definition of genocide found in Article 2 of the 1948 United Nations Convention on the Prevention and Punishment of the Crime of Genocide, an article and definition still upheld today, supports his claim. The convention defines genocide as "any of the following acts committed with intent to destroy, in whole or in part, a national, ethnical, racial, or religious group, as such: killing members of the group; deliberately inflicting on the group conditions of life, calculated to bring about its physical destruction in whole or in part; imposing measures intended to prevent births within the group; [and] forcibly transferring children of the group to another group."[24] "Any of the following acts"—a definition that can be seen to apply to the treatment of Indigenous populations in Canada by settlers, particularly when considering the violence and injustices of the legal banning of potlatches, unjust and unceded treaty negotiations, and the federal residential school system, which ran between 1876 and 1996 and forcibly removed children from their families in order to instigate cultural and religious assimilation to a strictly European and Christian way of life, including cruel punishment for children caught speaking in their Indigenous language. None of Kane's subjects are depicted in non-traditional dress, in ill health, or alongside European figures or industrialized landscapes, despite the fact that European "contact" has happened and has influenced the Indigenous populations and that, at the time of Kane's voyage, signs of colonization and industrialization would have been clearly evident.

Kane's work does not illuminate the genocide of Indigenous cultures taking place in Canada at this time, nor does it illuminate the cultural inventiveness, sophistication, survival, resistance, and resilience of Indigenous people in the face of colonial violence—entire populations who, by the time Kane was painting, had not just kept their own cultural practices alive despite state-legislated suppression and violence but had also helped keep settler populations alive by teaching methods of survival and offering healing; had influenced Canada's forms of governance; had incorporated European and Indigenous materials, tools, and loan words into daily practices of living, no matter the difficulties or distress that these acts and negotiations required, for the sake of their own cultural survival. Rather than acknowledging either the dying or surviving of Indigenous populations at the hands of settlers, Kane chose to erase European "contact" from his images altogether, focusing instead on images of "untouched" Indigenous populations he knew would be popular with his clientele, hoping for an "authentic," unmarred capture of Indigenous

culture, yet still relying on the myth of the "vanishing Indian" to help him sell his work to urban, wealthy, settler patrons. When used in textbooks and in museums, what these images teach children to believe is that Indigenous and Métis lives are a far, distant part of the land we live on, when, in reality, this history did not occur in some distant past, after which Indigenous people "vanished," but is a complex history that is still unfolding in the present.

The second example of colonial thinking I want to highlight is from the My History Museum public engagement project that was launched on October 16, 2012, with the announcement by then Heritage Minister James Moore that the Canadian Museum of Civilization would become the Canadian Museum of History. I first heard of the My History Museum public engagement project from museum scholar Marc-André Fortin, who spends much of his research time in the caverns of museum archives examining the paperwork, files, reports, and collections data created by museums about the operation of museums themselves. The public engagement project, according to the government report, was launched in order "to learn more about how Canadians think about history and what about Canadian history matters to them"[25] One such public engagement activity was the Museum's "timeline" of Canadian history, produced through "interactive 'kiosk' activities." A base timeline was created to which users could add events, ultimately leading to the construction of an online timeline of history.

There was, however, a major problem with the project: the earliest dates on the base timeline set by the Museum began in the 1600s, such as "1608: Samuel de Champlain Founds Quebec City" and "1670: Establishment of the Hudson's Bay Company." At some point, earlier additions to the timeline were added by participants, but as Fortin describes:

When I first came across the timeline, the first thing I did was to try to find where the timeline began. Starting at the present day, I scrolled back until large already filled-in sections thinned down to isolated events. In 1497 Jean Cabot arrives in Newfoundland; in 1000 L'anse aux meadow. I scroll and scroll, absolutely nothing. I arrive before the common era, and continue for a while, but the timeline does not scroll very quickly, and there is nothing there anyway. It is possible that there was one further entry, as listed in the final report: 10500 BC: The First Canadians Enter the New World, but I don't make it there, and it seems that this was added later. Melody McKiver, Anishinaabe, pointed out that the physical timeline that she saw at the opening day of the public consultation at the museum began at 1670, and the online timeline at 1608.[26]

Centuries of Indigenous history that had taken place on the land was disregarded in this nationally funded public history project. Further, Fortin points out, the very idea of linear time through the use of a "timeline" forces participants to consider history through an undeviating "Western" conception of time and prohibits forms of public participation that consider time and history non-linearly. As Mark Rifkin notes in *Beyond Settler Time: Temporal Sovereignty and Indigenous Self-Determination*:

> Settler colonialism produces its own temporal formation, with its own particular ways of apprehending time, and the state's policies, mappings, and imperatives generate the frame of reference (such as plotting events with respect to their place in national history and seeing change in terms of American [or, in this case, Canadian] progress). More than just affecting ideologies or discourses of time, that network of institutionalized authority over "domestic" territory also powerfully shapes the possibilities for interaction, development, and regularity within it. Such imposition can be understood as the denial of Indigenous *temporal sovereignty*, in the sense that one vision or way of experiencing time is cast as the only temporal formation—as the baseline for the unfolding of time itself.[27]

However, if one accepts the public timeline as a means of gauging the public's sense and sentiment of Canadian history, the narrative choices in determining a starting point—whether beginning quite apart from a timeline altogether with the stories of Glooscap, Skywoman, Nanabozho, or Raven, or beginning a few hundred years ago when thousands of acres of land were stolen from Indigenous communities in the name of King Charles for the Hudson's Bay Company; whether Samuel de Champlain is a key protagonist in the narrative, or whether the thousands of unnamed Indigenous women who have fed babies and created matriarchal communities for centuries on this land are the key protagonists to the foundations of a nation—it becomes clear how much the origin myths of a country can come to shape the kept and venerated objects, knowledge, and believed histories of a place.

If the purpose of the timeline was to "learn more about how Canadians think about history and what about Canadian history matters to them," the timeline demonstrates much about the colonial myths that Canada continues to consider formal history. The timeline's bias also reflects the biases the nation has been taught about its history through nationally and provincially funded educational institutions, such as public schools and publicly

funded museums. The timeline leaves out much complexity, sophistication, and diversity of history on this land. The timeline's colonial focus excludes the knowledge, culture, survival, and political intricacies settler peoples have learned from Indigenous communities that were established well before 1608. However, the timeline does give the public the opportunity to have an honest look at what is not included: where our historical blind spots lie as a public when we are given the chance to engage and reflect on our history. The timeline suggests how much more work Canadians must do, and certainly museums and governments must do, to expand our notions of history beyond the common, expected, and ultimately damaging figures of colonial myth.

Two such figures evoked in Canada's colonial myths are identified by Paulette Regan in *Unsettling the Settler Within* as "the peaceful settler" and "the vanishing Indian,"[28] which, given the inclusions and exclusions of Paul Kane's "ethnographic" paintings and the Canadian Museum of History's interactive timeline, are still clearly present in our ethos and thinking of Canada's history. Regan argues that images of the peaceful settler extol the "virtues of the 'pioneer spirit' and the practices of 'civilizing new frontiers' and 'settling empty lands,'" while Indigenous peoples are displayed as either inevitably "vanishing" due to European expansion or as "noble savages" untouched by the corruption of civilization.[29] Regan observes that these stereotypes are "deeply ingrained in the Canadian national psyche, reinforced by popular culture and the media."[30] Particularly, the peaceful settler and the vanishing Indian are myths re-inscribed through practices of capture and display used by museums for their collections of Indigenous artifacts. These myths, through the authority and reputation of the museum, become, over time, what patrons believe to be the history, the facts, of the various peoples on the land. Yet, the practices, historical and current, of archaeological and ethnographic documentation often limit a fuller understanding of Indigenous realities, deny academic recognition for Indigenous collaboration, or erase Indigenous histories altogether for the sake of preserving the domestic traditions or civic institutions of wealthy and powerful settlers. In practice, then, what is on display in many museums is as much colonizing myth as cultural history. As Thomas King writes, "Most of us think that history is the past. It's not. History is the stories we tell about the past."[31] It is important, then, to examine what stories we are telling about Canada's past—stories that also inevitably reflect our present ways of thinking—so that we might better understand and acknowledge the complexity of our stories, and the ways they are told and not told through images and objects on display.

Just as it is easiest for us to form our own cultural views through personal histories and habits, museums tend to root their institutional practices of display with an inward gaze to the history of the institution itself, with its roots in sixteenth and seventeenth European practices of ethnographic collections, rather than outwardly to the much earlier histories and stories of the people whose objects museums house. Brian Jungen's *Sketches Solicited for Wall Drawings*, Jeff Wall's photograph *Fieldwork*, and Rebecca Belmore's performances *Wild* and *Vigil* consider the art history that precedes their artistic practices, while also highlighting the history of collections and museums where artworks and objects of cultural value are accessioned, preserved, stored, and displayed. These three artists respond to depictions of indigeneity rooted in nineteenth-century traditions of ethnography and anthropology historically and presently found in Canada's museums: the stereotyped portraits of ethnographic painter Paul Kane, the salvage anthropological techniques used by Franz Boas to collect and display West Coast Indigenous artifacts at the American Museum of Natural History, the settler-centric narratives of historical house museums, and the violent ramifications that occur when the perpetration of the myth of the "vanishing Indian" is sustained outside of the museum with the continued "vanishing" of Canada's murdered and missing Indigenous women, girls, and 2SLGBTQQIA people. Through "reverse ethnography," Jungen, Wall, and Belmore use contemporary art to critically engage with museums' colonial histories so that the unexamined trust that both institutions and patrons place in ethnographic practices becomes the culture under scrutiny.

REVERSE ETHNOGRAPHY

The term "reverse ethnography" was first coined by Cuban-American interdisciplinary artist Coco Fusco in connection to the visual arts in her 1994 essay "The Other History of Intercultural Performance," where she discusses her collaborative performance piece with Guillermo Gómez-Peña, *Two Undiscovered Amerindians*. First performed in Columbus Plaza in Madrid at the Edge '92 Biennial, *Two Undiscovered Amerindians* then toured across the globe to public locales and private museums as diverse as Covent Garden and the Smithsonian's National Museum of Natural History. Fusco and Gómez-Peña lived "in a golden cage for three days," presenting themselves "as undiscovered Amerindians from an island in the Gulf of Mexico that had somehow been overlooked by Europeans for five centuries."[32] The work—often confused by

gallery-goers to be a real anthropological display rather than a contemporary piece of art—was as much about observing viewers' reactions to the caged "Natives" as it was the performance of "Nativeness" that Fusco and Gómez-Peña presented, partially in response to the quincentenary of Christopher Columbus's "discovery" of America. "Fusco explicitly called what she and Gómez-Peña did 'reverse ethnography,' as they noted the behaviour of the people responding to their cage"; Fusco and Gómez-Peña placed themselves in a position of observation—albeit simultaneously as object—previously reserved for anthropologists.[33]

Fusco and Gómez-Peña's *Two Undiscovered Amerindians* speaks directly to the history of the display of Indigenous people that occurred in connection to the voyages and collections of explorers from the fifteenth century through to the seventeenth century: the Arawak woman brought back from the Caribbean by Columbus in 1493 who is "left on display in the Spanish Court for two years until she dies of sadness"; the "Eskimos" exhibited in Bristol England in 1501; the display in 1788 of "Arabanoo of the Cammeraigal people of North Sydney, Australia" who is "captured by Governor Phillip" then "chained and guarded by a convict" and later shown off to Sydney society before dying of smallpox.[34] While Fusco and Gómez-Peña expected these histories of ethnographic capture to resonate with their audiences, "when they put on the grass skirt, the Mexican wrestler's mask, and the dog collar, the artists were not thinking they'd be taken for members of a newly discovered tribe of Amerindians."[35] As with patrons of Iris Häussler's *He Named Her Amber*, the observations and conjectures made by viewers of *Two Undiscovered Amerindians* became a decolonizing feature of the work of art. Fusco and Gómez-Peña, albeit initially unintentionally, hoaxed audience members, destabilizing the trust patrons put in ethnographic display and the authority of the museum, as well as highlighting the colonial ideas of "Nativeness" still present in contemporary North American society. Jungen's *Sketches*, Wall's *Fieldwork*, and Belmore's *Wild* also destabilize viewers' trust in ethnographic display, be it archeological collection, documentary photography, or historical preservation. Through trickery, each of these artists draws attention to viewers' entrenched, and often unquestioned, colonial ways of thinking, such that the stability of archaeology and ethnography as objective and unbiased disciplines is disturbed. Their trickery and disturbance are crucially reliant on the artists' knowledge of the artistic, ethnographic, and museological practices historically employed by Canadian cultural institutions.

Recent publications in art history have noticed intersections and exchanges between ethnography and contemporary art. Hal Foster, in his essay "The Artist as Ethnographer," argues that there is a "particular prestige of anthropology in contemporary art."[36] He ascribes this prestige to the fact that ethnography takes "*culture* as its object, and it is this expanded field of reference that post-modernist art and criticism have long sought to make their own."[37] Foster also argues that the disciplines of ethnography and anthropology have, in turn, a kind of "artist-envy" where "the artist becomes a paragon of formal reflexivity, sensitive to difference and open to chance, a self-aware reader of culture understood as text ... the anthropologist as collagist, semiologist, avant-gardist."[38] Indeed, both the disciplines of ethnography and art at first appear to offer promises of "cultural readability, cultural translation, and cultural understanding."[39] Art and ethnography endeavour to communicate connectedness across difference. Both disciplines "translate" one culture to another culture through visual mediums, sounds, stories, music, and handiwork in order to see the commonalities of humanity shared beyond the disparities of geography, ethnicity, and race.

However, as much as readability, translation, and understanding are desirable qualities in these disciplines, one must not forget that, historically, both ethnography and art have, at times, also promoted stereotypes and alienated cultures from one another. As much as they have instilled understanding, ethnographic research, artistic depiction, and museological display have also continually constructed "cultural differences rather than reflecting or recording them."[40] While ethnography and art may be recently intertwining as disciplines, thereby offering a kind of formal exchange, the pairing alone does not automatically make art more culturally aware nor make ethnography more avant-garde. Neither discipline is immune to the influences of hegemony or capital, and both are examples of disciplines where "privileged authorities could routinely 'give voice' (or history) to others without fear of contradiction."[41] Ethnographers risk misrepresenting the cultural groups they are endeavouring to understand due to bias, security, power, and comfort lent to them by racial or cultural dominance and academic authority. The artist, art critic, and art historian risk being inhospitable to a public seeking an appreciation of culture through the disciplines' histories of privilege and cultural elitism. Given both art's and ethnography's freighted history of colonization and cultural dominance, Jungen's, Wall's, and Belmore's artworks engage with the disciplines of archaeology and art history in order to redress and decolonize practices of collection and display that have previously promoted or

justified cultural dominance, violence, racism, and cultural misunderstandings between settler and Indigenous people in Canada.

It is the colonialism inherent to classification and collection—metaphorically and physically manifested, for instance, in Fusco and Gómez-Peña's gold cage—that contemporary artists Jungen, Wall, and Belmore aim to complicate and contradict in their works. A sense of control, mastery, or even understanding is thwarted in the viewer when encountering the artists' drawing, photography, and performance through the instability they create about what facts can be determined to be "truthful" or scientific and which elements of their art are fabricated and make-believe. These artists disrupt the stereotypes of Indigenous cultures—such as the traits of savagery, nobility, or vanishment—which result from the desire to contain and classify peoples and cultural objects into tidy categories for intellectual or social consumption.

The social consumption of ethnographic data and a feverish desire to collect and classify began with the private "cabinets of curiosity" as early as the twelfth century,[42] where European citizens of financial or political means, with ties to those who could afford to travel abroad, would house botanical and ethnic objects "discovered" in other regions of the world. This feverish desire to collect—often as a means of demonstrating one's sophistication and social advantage—heightened with European colonial expansion to the "New World" alongside the Enlightenment culture of seventeenth- and eighteenth-century Europe, which introduced the development of "learned societies," such as the Royal Society in London (1660), the Academy of Sciences in Paris (1666), and the Society of Antiquaries of London (1707), and by the nineteenth century had become a discipline founded on the "urgency of collection for the sake of preserving data whose extinction was feared,"[43] wherein the collections were no longer just accessible in private homes but were made publicly available through the institutions of museums. The early infrastructures of the major museums in North America relied on salvage anthropological practices that attempted to document the rituals, practices, and languages of cultures believed to be facing extinction from dislocation or modernization. Salvage anthropology involved rigorous ethnographic data collection alongside the removal of objects from Indigenous communities with the intention of scientific analysis and preservation. As European colonization spread across the globe and museums were built or expanded to house the growing collections of materials and data gathered during colonial enterprises, the same governmental bodies and learned societies that were

creating these museums began to acknowledge that the destruction of cultures was concomitant with imperial expansion.

An 1837 parliamentary report from the British Select Committee of Aborigines observed that the colonial policies and attitudes of Great Britain toward Indigenous cultures "are apt to class them under the sweeping term of savages, and perhaps, in so doing, to consider ourselves exempted from the obligations due to them as our fellow men."[44] The report acknowledged that the colonial policies of Great Britain "had already affected the interests, and, we fear we may add, sacrificed the lives, of many thousands."[45] The report included incidences from across the globe where Indigenous populations had been negatively affected by British contact: "The Caribs are gone, the inhabitants of new Holland have been made even more wretched than they were, the Tasmanians have been resettled and virtually destroyed ... murders, misery, and contamination have been brought to the islands of the South Pacific."[46] The introduction to the report's section on North America begins with an account by a Chippeway chief: "We were once very numerous, and owned all of Upper Canada, and lived by hunting and fishing; but the white men, who came to trade with us, taught our fathers to drink the fire waters, which has made our people poor and sick, and has killed many tribes, till we have become very small."[47] Apparent in the Select Committee's observations is the idea of the dying Indian and the paradoxical desire to save the remnants of the very civilizations, cultures, and communities that European expansion was in the process of depleting.

The museum's history in North America is inextricably linked to the idea of the "vanishing Indian." The American Museum of Natural History (AMNH) states of its North American Ethnographic Collection:

> Fieldwork among North American Indians was driven by two main concerns. There was a sense of urgency about collecting artefacts, as well as other information, for it was thought that the material culture of the Indians was on the verge of disappearing. Moreover, professional ethnographic reports of tribal cultures were needed both as an empirical base for the construction of theory and for the preparation of accurate and informative exhibitions.[48]

The wording from the AMNH is significant here: professional ethnographic reports were needed for the construction of archaeological theory and "for the preparation of accurate and informative exhibitions," suggesting that ethnographic collection was directly linked to the readying of exhibition

displays, museum labels, and presentable data. This explanation produces a chicken-and-egg question of whether artifacts in need of preservation came first, or whether expanding museums in need of artifacts were precedent. It can be argued that, in the nineteenth century, the demand of expanding museum infrastructures drove archaeological and ethnographic collection in the field in order that the grand museum halls of booming industrial cities could be filled. The institutional desire to preserve was a mechanism toward cultural destruction.

The oldest hall of the American Museum of Natural History, which opened in 1899, showcases the collections and research of the Jesup North Pacific Expedition. Museum curator and prominent anthropologist Franz Boas, often called the father of anthropology, led this expedition from 1897 to 1902. The hall showcases the collections that Boas and his team of anthropologists salvaged on these tours from "the Native peoples of North America's northwest shores from Washington State to southern Alaska, including the Kwakiutl (known today as Kwakwaka'wakw), Haida, Tlingit, and others."[49] The team on the Jesup expedition under Boas's supervision removed over four thousand artifacts from the Indigenous peoples of these regions and transported the items—from bowls, knives, pipes, and canoes to entire totem poles and house posts—4,390 kilometres overland to America's capital. Boas's techniques of salvage and display are directly addressed in Jungen's and Wall's works through the artists' own documentation of fieldwork on West Coast sites where Boas himself once worked.

THE REVERSE ETHNOGRAPHY OF BRIAN JUNGEN'S
Sketches Solicited for Wall Drawings

Brian Jungen's *Sketches Solicited for Wall Drawings* had four incarnations between 1997 and 2006: each was different in its conception, yet all were engaged directly and subversively with the curatorial techniques used by museums to display anthropological collections, as well as the traditions of ethnography found in Kane's paintings and the salvage anthropological practices used by Franz Boas. In each instance, the academic methods of the nineteenth-century ethnographer are redrawn and the artist examines—with subtle and illuminating variations—the collisions of ethnic prejudice and ethnographic collection that are a part of art's history in Canada. Reversing the ethnographer's tools, impressions, and beliefs about Indigenous identity and art become the object of study; the stereotypes of warriors, savages, and

squaws found in Kane's nineteenth-century paintings, which remain a part of conceptions of indigeneity in Canada today, are put under scrutiny.

Sketches Solicited for Wall Drawings premiered in 1997 at Calgary's Truck Gallery in Jungen's first solo show, entitled *Half Nelson*. The Truck show included Jungen's own early drawings, which often engaged in stereotypes of Indigenous art and identity through naked, cartoonish, bobble-head figures, and *Sketches*, which involved Jungen soliciting the "help" of an unsuspecting public using the classic data-collecting method of questionnaire and survey. "I set up the work as a kind of loose ethnographic survey," Jungen notes in an interview, "only in reverse: where I was no longer the 'subject' but instead was both observing and collecting images from the public."[50]

In order to produce his various versions of *Sketches*, Jungen recruited non-Indigenous volunteers to traverse the streets, malls, markets, and indoor gardens of the cities where *Sketches* was exhibited. These social anthropologists asked citizens to draw their associations with the idea or term "Indian" or "Indian Art." The images on display when *Sketches* was exhibited, therefore, are not in any way drawn or sketched by Jungen himself, but have been "solicited" by him, as the work's title suggests, using ethnographic fieldwork typically employed in cultural anthropology. Being a kind of ethnographic collection, *Sketches* changes depending on where the images are exhibited; the artwork is contingent upon the people of the cities in which the murals

Figure 18a. Brian Jungen, *Anonymous Drawings (Discourse)*, 1997 latex paint on wall, 98 × 118 in. (250 cm × 300 cm). Installation view, Half Nelson, Truck Gallery, Calgary, AB, 1997. Courtesy of Catriona Jeffries, Vancouver.

Figure 18b. Brian Jungen, *Anonymous Drawings (White Bird)*, 1997 latex paint on wall, 98 × 118 in. (250 cm × 300 cm). Installation view, Half Nelson, Truck Gallery, Calgary, AB, 1997. Courtesy of Catriona Jeffries, Vancouver.

Figure 18c. Brian Jungen, Installation view, Charles H. Scott Gallery, Vancouver, BC, 1999. Courtesy of Catriona Jeffries, Vancouver.

or carvings are shown. Because the artwork is based on the collected data of Jungen's ethnographic surveys, the images created by the artist's unsuspecting collaborators will shift every time the survey for *Sketches* is undertaken and the results are reproduced by Jungen on the gallery walls.

In the 1997 show, *Sketches* adorned the Truck Gallery's walls in cheerful hues reminiscent of watermelon bubble gum, the salmony coral of Floridian sunrooms, chocolate milk, the dusty green of fake potted ferns, lemon sherbet, the powder blue of suburban bathrooms, and Pepto Bismol. Arrayed against this palette of "bourgeois home decorating,"[51] the murals consisted of crudely drawn totem poles; birds in flight; headdresses; a tepee and lodge amongst fir trees; a large feather; a bottle labelled *beer* and a can labelled *Lysol*; and, in the only mural to offer human forms, two powder-blue men standing in profile, facing one another on a coral coloured background: "An 'Indian' signified by long hair crowned with a feather and a 'white man' signified by a hat and gun enact a history of colonial contact, in which the 'Indian' figure reaches out to receive (or give?) a bottle marked xxx."[52] Jungen notes: "In a way I wanted to set up a kind of visual paradox: between images that were violent or derogatory and these cheerful colour-fields."[53] Indeed, the contrast between the softness and approachability of Jungen's colour palette and the unpalatable

racism of the collected images from the street is part of what jars viewers into re-evaluating, reconsidering, and re-seeing images that seem, at first glance, blithely or whimsically presented. Viewers are unwittingly engaged in a visual instability: patrons are viewing the collected visual expression of deeply embedded, often highly racist, stereotypes of "Nativeness" drawn by non-Indigenous citizens, yet framed, through the authority of the gallery and the label of the artist's name, as the work of artist Brian Jungen, who is of Swiss and Dane-zaa background.

In their generic and formal conventions, the four incarnations of Jungen's *Sketches* rely not just on the lineage of anthropological fieldwork, but on the common curatorial practice of accompanying wall illustrations, drawings, cultural impressions, and depictions of Indigenous life connected to the salvaged objects on museological display. For instance, along with Kane's paintings, the artist would display Indigenous artifacts gathered on his journeys to heighten the "authenticity" of his sketches and portraits. Likewise, along with salvaged Indigenous artifacts, Boas and his team took testimonies, stories, and drawings from the communities they encountered, so that, along with the physical objects removed from the communities, displayed primarily in vitrines and behind silk ropes, galleries such as the Hall of Northwest Coast Indians include in their museological displays informative wall plaques, illustrations, village maps, dwelling floor plans, and ethnographic commentary on the cultural relevance of the objects.

Jungen's contemporary reversal of nineteenth-century colonial ethnographic projects lies in his ability to mimic and then thwart the authenticity strived for by salvage anthropologists in their collection and display. *Sketches* plays into viewers' previous experiences and preconceptions that illustrative images found on gallery or museum walls will help to illuminate characteristics of Indigenous populations in meaningful ways. Instead, Jungen displays drawings by random passersby, collected by untrained volunteer ethnographers. What Jungen's wall drawings illuminate is, in fact, viewers' habits of believing that museological displays will illuminate an idea of authenticity at all; Jungen uses "ethnographic methods to expose the limits of ethnography."[54] *Sketches*, in its sketchiness, in its tenuous connection to accuracy and truthful depiction, points out the gaps and fallibilities inherent to consuming anthropological information in sites such as galleries and museums since Kane first displayed his collected portraits and objects in Toronto in 1848 and Boas's Hall of Northwest Coast Indians first opened at the beginning of the twentieth century.

Each of the four incarnations of *Sketches* exhibited by Jungen over a nine-year history displays subtle yet significant shifts that illuminate museological practices of display and the history of ethnographic collection differently in each exhibit's iteration. Two years after the colourful premiere of *Sketches* at the Truck Gallery in Calgary, *Sketches* was exhibited again, with slight modification, in an eponymous solo show at the Charles H. Scott Gallery in Vancouver. To display *Sketches* at Charles H. Scott, Jungen painted the gallery walls in brightly coloured squares once more, placed vinyl decals overtop, added a final coat of black paint, and then pulled away the vinyl shapes to reveal the collected images of "Nativeness"—a breaching orca, an eagle's head, a childishly drawn thunderbird—once again solicited from non-Indigenous passersby, this time at Vancouver's popular Granville Island. The palatable pastel colour palette of the first incarnation of *Sketches* was still present in this second exhibition of the murals, yet Jungen's choice to over-lay the hues with black added dramatic contrast. The cheerful colours are, this time, set against all of the inscribed metaphorical resonances inherent in *black*: darkness, uncertainty, confusion, impurity, and non-whiteness. The cheerfulness stands precarious, sore-thumbish, against the wash of dark. Despite location and colour changes between the first two incarnations of *Sketches*, what is surprisingly similar are the survey results: in both Calgary and Vancouver the images are stereotypical, oftentimes racist, either stemming from a shallow understanding of Indigenous arts and culture, or else reflecting the difficulties survey-respondents encountered trying to express complex understandings of Indigenous culture in Canada through the spontaneous action of a sketch—difficulties that are inevitably a part of ethnographic collection and display.

But how does one distinguish a work of "authentic" Indigenous art from an inauthentic work? "Authenticity" is most often determined by correctly identifying the work's inarguable connection to the cultural-designation and name of a particular artist. Given that Jungen, listed as the artist of *Sketches*, is Indigenous and he has made these strange, callow, offensive images floating brightly before the viewer, are not the images, no matter their content, "authentic Indigenous art"? The potential, therefore, exists for viewers to mistake a randomly collected series of racist images, drawn by an unnamed non-Indigenous public for their opposite: authentically produced Indigenous images created by an Indigenous artist. Partly these misconceptions of attribution are due to the fact that—as with Kane's ethnographic art—stereotypical images of Indigeneity produced by non-Indigenous people

are what patrons of Canadian art have become accustomed to consuming over centuries, such that the inauthentic has become trusted as "true." The orca, the totem pole, the mask, the dream catcher: are not these, patrons might observe, "Native" images no matter their creator or context?

It is this very confusion, this grey area of identity and authenticity, that Jungen's *Sketches* affirms and contemplates. Cuauhtémoc Medina argues that Jungen's artworks "are located at the crossroads of a number of racial and cultural mirages" wherein Indigenous imagery has entered the capitalist realm of spectacle and consumption: "Rather than merely repudiating that process, Jungen amplifies the marketing and stereotyping of Indian culture that allows First Nations peoples to participate in the current economy and symbolic landscape and to transform their heritage into capital."[55] If patrons of galleries expect stereotypical, consumable, Indigenous art, and if these images are a means of gaining capital for Indigenous artists from settler or tourist patrons, why not get those patrons working for the Indigenous artist? "Why not have non-Indigenous patrons produce the images of 'Nativeness' that they expect to see?" is the question *Sketches* seems to propose. What results is a blurring of clearly delineated cultural markers. The images are and are not produced by an Indigenous artist. The hand of someone who likely identifies as Indigenous did not draw the originary images. Jungen—who is Indigenous and who did then paint, silkscreen, decal, and carve the images onto and into gallery walls—appropriated the images for his use. The images are, in a sense, "found," they are *objets trouvés*, making *Sketches* reminiscent of multiple moments in art history: the unusual objects collected in cabinets of curiosities; Duchamp's ready-mades, such as *Fountain* (discussed in the first section of this book), in which "existing objects, manufactured or of natural origin" are used in works of art "without mediation" or "as raw material in an assemblage, with juxtaposition as a guiding principle"; and Dadaist art practices, such as using "damaged and reclaimed materials as a potent image of futility."[56] It is through Jungen's process and conceptual framing, in placing the collected images in the gallery with his name as artist attached to their display, that he then reuses the objects for his own purpose. Jungen is employing the techniques of anthropologists and ethnographers—like Kane's field sketches that he modified and stylized for his Toronto patrons—except Jungen is "reversing" these traditions so that the very difficulties and futilities of trying to solidify the complexity of an entire culture into an indicative image or trope is troubled.

Figure 19. Brian Jungen, *Bush Capsule*, 2000. Plastic chairs, plastic, fluorescent lights. Dimensions variable. Courtesy of Catriona Jeffries, Vancouver.

In 2000, Jungen's ethnographic data were exhibited at Toronto's Pearson International Airport in another variation of *Sketches*, this time with a different title, which more openly concedes the artwork's lineage of ethnographic methodology: *Toronto Field Work 2000*. In the field surveys completed in Toronto, participants were asked to depict "their knowledge of Native culture in British Columbia."[57] For *Field Work*'s display at the YYZ Artists' Outlet in Canada's largest international airport—a liminal space of travel and global exchange—bright hues were replaced by "faint traces of luminous yellowy-white paint" on the white walls of the small gallery space.[58] With the images retraced by Jungen in semi-gloss latex paint, the viewer is able to catch the faint images of survey-respondents only at an angle, in the reflected light of an accompanying sculptural work, *Bush Capsule*.

Bush Capsule, a tent-like dome, emits an electrical glow through its shrink-wrapped igloo-shaped skin, evocative of the nomadic, yet also offering the hope of shelter. In this incarnation, the display of the wall drawings in conjunction with Jungen's sculptural work suggests ethnography's connection to movement: between cultures, between places, caught while in transit. The low-lit display of Jungen's *Field Work* alongside *Bush Capsule* on-site at YYZ

highlights how the socially constructed imaginings of indigeneity solicited in the city are here intermittently seen and unseen, nearly walked past. The vibrancy of the colour palette of the Truck and Charles H. Scott shows is replaced with ghostly traces in *Toronto Field Work 2000*. If viewers see the assertiveness of Jungen's earlier colour choices as being a forceful clash of racist assumptions with a cheery palette of suburban decor—"employed by Jungen near the peak of the home buying and home renovating frenzy that has just abruptly deflated"[59]—the nearly invisible images in *Toronto Field Work* suggest how assumptions about Indigenous culture are also not always so boldly drawn into the spotlight of conversations; at times cultural assumptions go unnoticed, are rushed past, and are seen only indirectly. The ghostly quality of *Sketches'* incarnation in *Field Work* is subtler and more insidious. One must stop and dwell for a moment in a softer light and in focused concentration to see the stereotypes on the wall. Stereotypes, by their nature, often occur without conscious awareness and become visible only when viewers or readers pause to reflect. It is the unconscious and subtle containment of stereotypes that Canadian society also carries (like the carry-on baggage of passengers rushing through the corridors of the airport), which is differently embodied in *Toronto Field Work 2000*, as compared to the more overt images of stereotype and racism displayed in Jungen's 1997 and 1999 shows. The tensions of suburbia are not as present in *Toronto Field Work 2000* so much as the hurried nature of contemporary lives, the connections lost in the human rush to globalize, the almost-not-seen and therefore almost-forgotten cultural assumptions between Indigenous and non-Indigenous people (nomadic verses settled, origi- nary verses landed) with which Canadians continue to dwell: unquestioned, glanced at, and then walked away from, on the way elsewhere, unresolved.

In the fourth incarnation of *Sketches* at the Vancouver Art Gallery (VAG) in 2006, for Jungen's first large-scale retrospective solo exhibition (sponsored and circulated by the VAG between 2005 and 2007, with further exhibitions at New York's New Museum of Contemporary Art, the Musée d'art contem- porain de Montréal, the Witte de With in Rotterdam, and the Museum Villa Stuck in Munich), the solicited drawings changed shape and form once more for the Vancouver portion of the tour. Now entitled *Field Work, 1997–1998 (remade 2006)*, this time the solicited imagery of "Indian art"—inuksuk, dream catcher, totem pole—was carved by Jungen into the Vancouver Art Gallery's walls. Jungen's choice to carve into the very structure of the gallery directly, rather than overlaying his salvaged images on drywall left whole, shows a kind of violent inscription of these commonly held stereotypes of

Indigenous identities into the physical structure of the museum. The act of carving into the walls of the VAG, as Leigh Kamping-Carder notes, also alludes to "the carving tradition of the coastal nations of British Columbia, especially the low-relief designs on bentwood boxes,"[60] and echoes the tradition of petroglyph carvings, carved at various locations across the province, which denote ancient sacred sites and gathering places. Unlike an incision into stone or wood, "the incisions in the walls reveal layers of paint left from other shows at the museum, giving them a geological quality that calls up archaeological digs."[61] If Jungen's carvings are an archaeological dig into the history of previous displays, the viewer is placed in the position of both art patron and archaeologist, observing Jungen's findings of the history of the gallery's past exhibitions in each gash of the wall.

The fact that Jungen has repeated *Sketches* at numerous points in his career in a variety of locations across Canada is also an important part of the artwork's power. Cultural critic Homi Bhabha observes that the repetition in Jungen's artworks mimics the rhetorical form of stereotype: "Stereotype itself is a trope of repetition."[62] He argues that Jungen's work "importantly brings to people's attention the stereotype as a form of perception and then undermines the very material and signifying process by which stereotypes create their own hegemony or unquestionable authority."[63] Jungen draws attention to the repetition of stereotype by displaying, repeatedly, viewers' stereotypes, revealing the cultural assumptions that linger and repeat, often unexamined, in Canadian consumption of artistic and ethnographic display. *Sketches* reveals how "the idea of *Indian*" has been repeatedly represented in Canadian culture without sufficient institutional critique or complex analysis on the part of those purveying these ideas and images: "The crudity of the drawings signifies the crudeness with which First Nations culture is imagined in the public sphere."[64] Jungen states that in presenting *Sketches*, "I guess I was partly interested in the idea that these stereotypes were shared by everyone," and that the artwork "was really a way of developing and questioning notions of identity as a more socially constructed reality."[65] The images are not "an ethnography of white culture,"[66] but rather a fieldwork into how stereotypes of Indigenous identity and art invariably reflect a shared colonial history, from which "concentrations of ethnic prejudices" continue to exist for all who encounter Canadian culture.[67] Paulette Regan argues that "reassessing our shared history in light of new understanding invites us to work with complexity, intersubjectivity, and multiplicity in ways that avoid binary thinking."[68] The image of two powder-blue men from *Sketches Solicited for*

Wall Drawings, standing in profile, facing one another on a coral-coloured background—the "Indian" with long hair and a feather, the "white man" with a hat and a gun, and, between them, an exchange of poison, the bottle marked xxx—is an opening into renewed intersubjective discussion, a way of reassessing Canada's shared and stereotyped history. Paradoxically, it is the simplicity of the images that calls for complexity in our response. Now that these stereotypes have been revealed through Jungen's ethnographic display to the public, whether splashed in bright and unavoidable hues, hidden in shades of white on white, or sharply carved into gallery walls, viewers "begin a process of 'unlearning' whereby they begin to question received truths."[69] The racism that is a part of Canadian history, and which continues to reside firmly in a present-day Canadian collective unconscious, is revealed in *Sketches* as the proverbial writing on the wall. Yet I believe that Jungen's *Sketches* are, ultimately, a hopeful gesture. He displays racism museologically, as if these assumptions are precariously verging on vanishment. Colonial dominance is petrified as if it is an ancient trope of Canada's past. Perhaps one day, *Sketches* seems to posit, the prejudices that produced this artwork will be on their way to extinction, will, in fact, vanish altogether, rather than, as was once thought, the Indigenous populations in Canada.

THE NEAR-DOCUMENTARY PHOTOGRAPHY OF JEFF WALL

Photographer and art historian Jeff Wall has documented West Coast Canadian landscapes and people for over five decades. With the documentary style of Wall's work, his images invoke an ironic play between the real and the imaginary, often leaving viewers uncertain of what is real and what is staged. His work especially draws attention to performances and cultural instances of power, privilege, and authority, but particularly through images of persons on the margins of this power. Over his career, for instance, he has produced several photographs that have the institutions of galleries and museums as their subject; however, these images primarily focus on those who often go unrecognized for their labour, construction, data collection, curation, janitorial services, and stories—those who support institutions of cultural production "behind the scenes." For instance, *Outburst* (1989) addresses issues of sweatshop labour and material production; *Restoration* (1993) highlights the physical labour of keeping and preserving historical and artistic collections;

Adrian Walker, artist, drawing from a specimen in a laboratory in the Dept. of Anatomy at the University of British Columbia, Vancouver (1992) demonstrates the scientific and artistic skills needed for reproductions; *Vancouver, 7 Dec. 2009. Ivan Sayers, costume historian, lectures at the University Women's Club. Virginia Newton-Moss wears a British ensemble c. 1910, from Sayers' collection* (2011) examines the intersections of collectors, academic institutions, and the historical roles of women; *A woman consulting a catalogue* (2005) addresses the publication and proliferation of exhibition catalogues as a means of accessing art; *Morning Cleaning, Mies van der Rohe Foundation, Barcelona* (1999) acknowledges that someone must be the one to mop a gallery's floor; *The Storyteller* (1986) recognizes that Indigenous stories are not relics salvaged by anthropologists, but are alive parts of contemporary Indigenous life, told when stories need telling, even if urban spaces for Indigenous traditions are marginalized by settler societies and property developers so completely that these stories end up being told under bridges or beneath highway viaducts; and *Fieldwork. Excavation of the floor of a dwelling in a former Sto:lo nation village, Greenwood Island, Hope, B.C., August, 2003. Anthony Graesch, Dept. of Anthropology, University of California at Los Angeles, working with Riley Lewis of the Sto:lo band* (2003), the image on which this section will focus, illustrates the site-specific realities of an active anthropological dig. Yet, while many of Wall's photographs that depict the labour of cultural collection can be considered political, it is not his chosen subjects alone but his photographic method of "near documentary" that most aligns his work with the practice of "reverse ethnography."

At first glance, many of Wall's photographs that focus on cultural production have the appearance of being candid portraiture. The bodies of his subjects often appear relaxed and unselfconscious; they seem unaware of the camera's presence; oftentimes they are performing absorptive tasks that prevent them from noticing any outside observer, or the subjects are involved in private gestures, rituals, or moments of thought that could not easily be captured on film without the subject's unawareness or obliviousness to the presence of the photographer. There is a privacy to Wall's photography. Yet this privacy often feels somehow uncanny. Partly, this uncanny feeling is due to Wall's choice to display these intimate images of private moments as large-scale photographs, often mounted as cibachrome transparencies on light boxes, similar to the impersonal backlit advertising pervasive in contemporary cityscapes. But, more so than the size or brightness of Wall's images, the uncanniness of his

photographs is in large part because, despite the seeming spontaneity of the moments captured, most of Wall's photographs involve staged actors, weeks of cinematic production, and further post-production digital distortion and collage. These techniques result in an overall effect that has been called, over his career, "cinematographic," "staged-realist," and "near-documentary."[70] This "near-documentary" form imparts an ironic way of seeing upon the viewer: observers of Wall's photography take on the strange position of becoming an audience member to a stage set originally perceived to be reality.

This practice of "near-documentary" employed by Wall engages with the idea that "nothing could be more remarkable than seeing someone who thinks himself unobserved engaged in some quite simple everyday activity" as if one were to "imagine a theatre, the curtain goes up & we see someone alone in his room walking up and down, lighting a cigarette, seating himself etc. so that suddenly we are observing a human being from outside in a way that ordinarily we can never observe ourselves; as if we were watching a chapter from a biography with our own eyes."[71] This aesthetic premise of a staged kind of realism, described by the philosopher Ludwig Wittgenstein to his friend and correspondent Paul Engelmann, would surely, Wittgenstein imagined, "be at once uncanny and wonderful."[72] In fact, the philosopher goes on to claim, witnessing reality within a theatrical frame would be "more wonderful than anything that a playwright could cause to be acted or spoken on the stage. We should be seeing life itself—But then," he notes, "we do see this every day and it makes not the slightest impression on us! True enough, but we do not see it from *that* point of view."[73] Wittgenstein's observations, likened to Wall's work by art critic Michael Fried in *Why Photography Matters as Art as Never Before*, very much describe what is essentially Wall's "near-documentary" photographic techniques, albeit, in Wall's case, through still photography rather than the experience of live theatre that Wittgenstein imagined.

Like Jungen's *Sketches* or Fusco and Gómez-Peña's *Two Undiscovered Amerindians*, Wall's "near-documentary" technique employed in *Fieldwork* creates a precarity between what is "real" or "authentic" and what is "staged" or "faked." Wall's blurring of fiction and the genre of documentary normally associated with realist analogue photography asks ethical and aesthetic questions about the role of photographer, subject, and viewer. In *Fieldwork* especially, these questions also turn to, as Wall's lengthy title of his photograph signals to the viewer, the ethnographic observation and collection of artifacts by Anthony Graesch, from the Department of Anthropology at the University of California at Los Angeles, as he works with Riley Lewis,

of the Stó:lō Nation, on an excavation of the floor of a dwelling in a former Stó:lō village in S'olh Temexw, the traditional territory of the Stó:lō people, in August of 2003. While this is the longest title Wall has given to one of his photographs, Fried observes, it still "doesn't quite say everything."[74] What the title "doesn't quite say," and the instances where Wall's photograph "isn't quite" real and "isn't quite" fake are where his work begins to create questions in viewers' minds about the trustworthiness of documentary images and, specific to *Fieldwork*, the depicted practices of anthropology as a discipline.

Compared to earlier works of Wall's, *Fieldwork* differs slightly in its technique, adopting a new approach to image capture for this particular picture, which, at first, appears more ethnographic and "true" to reality. The new technique is described by Fried as a turn from Wall's earlier work to a new form of photographic representation which he calls "near-near documentary," noting that this form of photography prevalent in Wall's most recent works is closer to documentary than his earlier staged and manipulated images, but that they cannot be considered completely "straight" documentary photography.[75] In *Fieldwork*, because the form is so much nearer to documentary photography, and because viewers now familiar with Wall's previous staged photographic techniques will immediately view Wall's image skeptically, with an eye toward staging, the questioning of truth is directed more at the subject matter of the photograph—anthropological collection—than at the immediate veracity of the image itself. *Fieldwork* is a kind of ethnographic document on the practices of ethnography. It works to decolonize ethnographic practices by observing anthropologists in the field, in private moments of collection, generally not publicly seen in galleries and museums. Yet *Fieldwork* is also problematic as an ethnographic document, as were Kane's paintings, because Wall's field images are manipulated once the artist returns to his studio. In analyzing *Fieldwork*'s composition and production, in assessing how ethnographic and anthropological collection is displayed in *Fieldwork*, and through interviewing the remaining living human subject of the photograph, Dr. Anthony Graesch, it is questionable whether Wall's "near-near-documentary" photograph can be considered ethnographic in its own right, whether *Fieldwork* achieves decolonizing ethnographic practices such as those found in the reverse ethnography of Jungen's *Sketches*, or whether *Fieldwork* re-inscribes colonial hierarchies, such as those found in Kane's problematic portraits.

Fieldwork, rather than being a rehearsed dramatic tableau typical of Wall's earlier near-documentary photographic techniques, is a document of

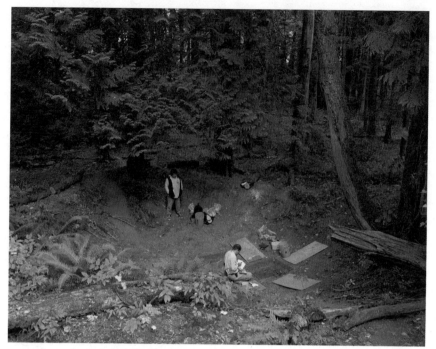

Figure 20. Jeff Wall, *Fieldwork: Excavation of the floor of a dwelling in a former Sto:lo nation village, Greenwood Island, Hope, B.C., August, 2003. Anthony Graesch, Dept. of Anthropology, University of California at Los Angeles, working with Riley Lewis of the* Sto:lo *band.* 2003. Transparency in lightbox 2195 × 2835 mm. Courtesy of Jeff Wall.

lived experience produced in a fairly traditional documentary photographic form—or at least it appears to be at first. Fried notes, "Unlike Wall's previous ventures in the 'near documentary' mode, *Fieldwork* is not a re-enactment of an actual event but rather a depiction—I do not quite wish to say a straight photograph—of a scene that took place just as it appears."[76] However, Fried's description is decidedly inaccurate: the scene is *not* precisely a "depiction of a scene that took place just as it appears," despite markers of documentary that Wall is sure to include in the presentation of his photograph. For instance, the title reveals the date, the site, the identity of the two protagonists in the image, the circumstances under which Graesch and Lewis have come to work together, and the object of archaeological research that is being undertaken. The precision of the title points to Wall's conscious ethnographic approach to his subject matter, and to the precision of the tasks Wall has captured being performed by Lewis and Graesch.

The picture is taken from what in cinema is called a long shot, from a slight aerial angle. The two men are seen in full within their surrounding environment: a clearing in a coastal rainforest where two square holes have been dug into the ground—"the product of meticulous excavation"[77]—and cordoned off with fluorescent orange flagging tape. A bespectacled Caucasian man—whom most viewers would assume to be the Anthony Graesch of the Department of Anthropology introduced in Wall's title, although neither subject is definitively identified—sits cross-legged in running shoes, khaki pants, and a light-blue long-sleeved Oxford shirt, making field notes on a clipboard. Beneath the canopy of a nearby tree stands Riley Lewis, overseeing Graesch's work. It is this standing figure of Lewis whom most viewers would assume to be, as Wall's title describes, "of the Sto:lo band." The Stó:lō, translated into English as "People of the River," are Coast Salish peoples of the Fraser River Valley who are Halkomelem speakers and who "take their name from the river that is central in their territory and integral to their identity."[78] Lewis wears running shoes, a pair of worn blue pants (perhaps blue jeans or sweatpants), a grey hooded sweatshirt with a logo that is unreadable from the distance at which the photographer stands, and a casual black vest with pockets, where Lewis keeps his hands while he, in this captured moment, oversees the proceedings. In Wall's image, the more neutral browns and greens of the forest are punctuated dramatically with the clothing of the photograph's protagonists, various demarcations made by the brightly coloured orange flagging tape, the matching orange buckets, a plastic yellow case that looks like it could be a tool box, and a blue dustpan. The title, clothing, and brightly coloured plastics in Wall's photograph indicate a contemporary moment. Wall is not interested in portraying the trope of the "vanishing Indian," as previous settler artists had been, for, despite the remnants of the Stó:lō settlement that is being unearthed, there stands Riley Lewis in the photograph, wearing blue jeans and a hoodie, very much alive as Wall takes his photograph, contemplating the dig before him. Five plywood sheets rest at the lip of the square holes. Fried notes that "the wooden 'mats' that radiate outward from the hole for practical reasons—to keep workers from disturbing the excavation—serve the pictorial function of directing the viewer's attention to the central motif."[79] "The overall effect," Fried claims, "is calm, contemplative, absorptive."[80] The men in the photograph are at a significant enough distance from the viewer that it is difficult to see distinct facial expressions or to connect intimately with either figure. The viewer is positioned as an observer, emotionally removed from the proceedings through distance and height.

In *Why Photography Matters*, Fried first describes the process involved in the on-site production of *Fieldwork* and then speaks to some of the post-production digital distortion Wall completed in the studio once he returned to Vancouver:

> Wall spent three weeks at the site, first erecting a scaffolding from which to take pictures and then photographing more or less continually, the idea being that the men digging the hole and examining its contents would become so accustomed to his presence that they would come to discount it and behave naturally, that is, as they would if he were not present. There is no reason to doubt that this is more or less what happened, but nevertheless Wall was there (and taking pictures).[81]

What is particularly interesting about Fried's description of the nearly month-long photo shoot on Welqámex (anglicized as Greenwood Island) is the idea that the subjects would become so accustomed to Wall's presence that they would come to discount the camera and "behave naturally." In ethnography, one goal of fieldwork is to collect data of "ordinary activities" in "naturally occurring settings" in such a way that the research imposes a minimal amount of the ethnographer's own bias on the data.[82] Fried's description of Wall's on-site technique is similar to the idea of participant observation, a methodology in anthropology originated in North America through Boas and his students when conducting research in the field. The idea behind participant observation is that the ethnographer or anthropologist spends so much time with the persons and communities being studied that eventually their presence is not strongly felt by participants so that the actions of the communities will be as naturally occurring as possible.[83] Not only is Wall's subject matter ethnographic in *Fieldwork* but so, ostensibly, is his photographic method. Just as archaeologist Anthony Graesch and the team of researchers to which he belongs have cultivated long-standing relationships over time with the Stó:lō Coast Salish people of the Upper Fraser River, so too does Wall stay for a lengthy period of time in Graesch and Lewis's presence in order to "take part in the daily activities, rituals, interactions, and events" during Graesch and Lewis's archaeological fieldwork.[84]

Fried also points out, however, that in post-production Wall has used a technique of digital stitching that produces an equally sharp focus across the entire plane of the photograph, which, upon a viewer's first glance at *Fieldwork*, may go unnoticed:

For Wall, the resulting image is closer in feeling to ordinary vision, in which one is never normally conscious of objects nearer or further away being blurred relative to those being focussed on, as is often the case in photographs. Yet there is no equivalent in ordinary vision to such evenness of focus across objects at varying distances from the viewer.... To achieve such evenness of focus required the use of a computer to combine multiple images, which is why I did not want to characterize it as an instance of straight photography.[85]

The photograph cannot be deemed "straight photography" by Fried because it is not a single photograph capturing a single image and a single moment in time, but rather many photographs taken over the span of Wall's month of shooting, then manipulated into one digital image from a series of composites. After shooting *Fieldwork*, the final project is an image of a moment that never in fact existed, a moment digitally stitched together from hundreds of photographs taken over many weeks. In this way, it is not a precise reality that *Fieldwork* depicts, but rather a curated composite of reality, a fabricated moment of documentary, that Wall presents as realistically as possible.

To understand more about the process of *Fieldwork*'s own fieldwork, and in order to assess more deeply the links between Wall's digitally manipulative photographic techniques and the techniques and practices of ethnographic documentation used by the anthropologists on Welqámex, I turned to the anthropological data thus far published by the collaborative research groups responsible for the archaeology that Wall documented (the project, known as the Fraser River Valley Project, is a collaboration between scholars at the University of California, Los Angeles; Simon Fraser University; the University of British Columbia; and the Stó:lō Nation). Further, in April 2014, I also contacted Graesch, one of the anthropologists under scrutiny in Wall's photographic study, to speak with him about being a photographic subject in *Fieldwork*. Lewis, who was working with Graesch extensively during the summer of 2003, when Wall was present on Welqámex, has since passed away, so, in order to gather a sense of Lewis's work as an anthropologist on this dig, I spoke instead with a long-time colleague and friend, Dr. David Schaepe, in the fall of 2018. Schaepe was also the anthropologist working on the Fraser River Valley Project who connected Wall to Graesch and Lewis's work.

Dr. Schaepe first met Riley Lewis in 1997 working on an inventory in the Chilliwack River watershed thirty kilometres west of the site where Wall took the photographs of Lewis and Graesch for *Fieldwork*. Schaepe worked

closely with Lewis and two other Stó:lō Nation members on the watershed project and then continued to work with Lewis on a number of archeological digs over the next decade until Lewis shifted his professional life from a regulator—a steward and protector of Stó:lō culture on archeological projects taking place on S'olh Temexw, traditional Stó:lō territory—back to his roots as a fisheries biologist, working closely with his band. Dr. Schaepe recalls, as Dr. Graesch also mentions, how important Riley Lewis was to him as a teacher and mentor, particularly in educating fellow archeologists about Stó:lō heritage and spirituality. Schaepe recalls that what Lewis taught him in the field was a totally different perspective than what he had learned in his traditional Western education at the University of British Columbia and Simon Fraser University at the time: "Riley was a spiritual person," Dr. Schaepe explained over the phone. "He was able to anchor everything we were doing in a context of spirituality: the connection between our work, the sites we were working on, aspects of Stó:lō heritage, and the relevance, meaning, and impact our work had spiritually for all involved."[86] Dr. Schaepe describes how Lewis was cautious about the archeological work that was being done and how Lewis taught him "the importance of cultural protocols, so that we brought no harm to others or to ourselves" as archeologists.[87] I asked Dr. Schaepe if he had been taught any of these protocols during his university studies, and he explained that cultural protocols were not a part of his archeological education at UBC, SFU, and NYU during the time that he completed his schooling: "It was outside of common knowledge at that time in archeology. There were few Indigenous people working directly in archeology; the Stó:lō Nation was one of the only Nations at that time who had Stó:lō archeologists on their Nation's staff."[88] Like David Schaepe, Anthony Graesch also mentions the profound impact the Fraser River Valley Project had on his life as an archeologist, and he describes in detail his memories of the summer that Wall took the photographs of Graesch and Riley Lewis at work in the field.

Wall's photograph *Fieldwork* was taken early on in the fieldwork for Graesch's doctoral research toward his dissertation, "Archaeological and Ethnoarchaeological Investigations of Households and Perspectives on a Coast Salish Historic Village in British Columbia." The summer of 2003 was the first full season Graesch spent in the field on Welqámex. According to Graesch's recollection of that summer, Wall had been scouting for a photogenic archaeological site in British Columbia, and, through David Schaepe, Wall ended up contacting Graesch and Lewis about the possibility

of photographing them as they proceeded to assess the Welqámex settlements near Hope, British Columbia.[89] Wall ended up spending thirty days ("over a month of Mondays to Fridays") in the woods with Graesch and Lewis: "Wall and his assistants built a stand for elevation—a solid eight to ten feet off the ground, and about four feet or so in diameter. There was just enough room for Jeff and his tripod. He was using a large-format camera.... He would come across the river on a boat every day."[90] The work that Graesch and Lewis were undertaking was an initial investigation into "the primarily Historic-era Stó:lō (Coast Salish) village of Welqámex in southern British Columbia. Comprising at least five semi-subterranean houses and one above-ground cedar plank structure."[91] Graesch's doctoral work included collaborative research on Stó:lō households on sites that "span the period from 4200 cal B.C. to the late A.D. 1800s and include settlements with semi-subterranean houses of different forms as well as aboveground plank houses."[92] Graesch's research examined "slate artefacts recovered from Welqámex houses," analysis of which "shows that the production and use of slate knives clearly persisted after the arrival of Europeans in the Fraser Valley," and he outlined "a new classification scheme by considering the cognitive underpinnings and material implications of a range of knife-makers' activities."[93] Graesch's doctoral thesis addresses habitats quite different from those researched on Welqámex as well; his dissertation also examines "contemporary U.S. households" in urban Los Angeles, "and the relationship of household wealth to house size."[94]

When speaking with Graesch about being the subject of scrutiny while contemporaneously scrutinizing his own data in the field, I asked whether he was cognizant of Wall's presence: "Did you ever stop realizing that he was there?" Graesch answered with a reflection on the discipline of anthropology, and on the effects of observance upon human behaviour:

> This is an important question in anthropology—in anthropology we are both observing and participating. Which is why methodologically anthropologists try to become a part of the community as much as possible, and to spend as much time with the community as possible; the longer the better because then people are likely to be less aware of your presence. Really, though, people are always aware of a presence that isn't a family or a close relation. We never act exactly the same when someone else is there observing us. So, to answer the question, we always knew Jeff was there. For instance, even if we became engrossed in the work, there would be a click from his camera.[95]

Graesch also mentioned that sometimes Wall verbally made his presence known when he would "occasionally yell down from the platform so that we would freeze for a moment. This was to do with the lighting of the forest."[96] Graesch also described the dynamics of participant observation more broadly, both from the perspective of one who is an observer, and, in the case of being the subject of Wall's photograph, as one who has been observed: "Earlier on in the process of being observed, we generally try to posture ourselves, or are aware of how our bodies are placed, or are aware of our actions. The longer Wall was there, definitely the more we just did our work."[97] Graesch mentioned his Los Angeles household research as an example: "When we went into L.A. households we entered into people's homes to look at double-income earners and of course people notice that you're in their homes. But it's really difficult work to be something you're not and we can't really pretend to be something we're not, and so eventually we relax back into being ourselves."[98] It is this relaxed self, this proximity as much as is possible to natural human behaviour, that Wall sought from his subjects in *Fieldwork* with his lengthy method of observation and image capture.

Wall has commented on his aesthetic movement toward near-near documentary photography, such as the choice, later in his career, to hire models who are not professional actors but the people, especially with regard to their vocations, whom they are portraying. The device has roots in Italian neo-realist cinema, an influence that Wall acknowledges in a *New York Times Magazine* feature: "'One of the things I liked about Italian neo-realism was just using people as they were, in situations similar to their real situations.' ... 'If you're interested in the actual, it's the closest to the actual.'"[99] Arthur Lubow notes that in later years Wall "has tried to elide the distinction to the vanishing point, engaging actual art restorers in *Restoration*, field anthropologists in *Fieldwork* and day laborers in *Men Waiting*.... The performers are playing themselves."[100] Lubow's argument once again recalls Wittgenstein's observation that "nothing could be more remarkable than seeing someone who thinks himself unobserved engaged in some quite simple everyday activity."[101] But Wall's subjects cannot forever think themselves unobserved. Participant observation inevitably changes his subjects' behaviour, even when they have a duration of time to relax back into themselves. Also, Wall's near-near documentary photographs are still digitally manipulated after being shot. So, the documentary moment is still tampered with, is still made unnatural, in post-production. Just because the "actor" in one of Wall's cinematographic photographs happens to be playing himself,

or at least playing his profession, the final, edited depiction is, ultimately, not any more truthful or faithful to life.

Midway through our conversation—after richly describing the process of the photo shoot, meeting Wall, and how their August of 2003 unfolded—Graesch admitted, "All that said, I don't particularly care for the photo. It's a great shot of the field, of what it looks like to be working with residential architecture, but I don't like how the relationship between Riley and me is depicted."[102] When asked to elaborate, Graesch again spoke eloquently about his discipline as an anthropologist and how he sees the discipline's history and its current directions before describing why he disliked the depiction of Lewis and himself in Wall's composite photograph:

> Our research groups have a long cultivated relationship with the Stó:lō Nations. Anthropology is deeply rooted in colonial history. It was built upon white entitlement, elitist entitlement; an idea that here, we're going to come in and then tell your history for you. The history of the discipline has been a situation of take: people lose pieces of their history. People's ideas are taken. But there are a lot of contemporary scholars who are trying to define a new era of archaeology and anthropology: one of collaboration. A different kind of relationship than has happened in the past. When we work with the Stó:lō, we ask for their permission, and the area of our research is partly chosen by the Nation; something that their community is interested in.[103]

Graesch elaborated that it was "the positionality" of Wall's photograph that he disliked:

> Riley was working very closely with me, sitting, taking notes, excavating. He did all the same work that I did. We would be lying there on our bellies covered in dirt, but Wall chose to put together composites—out of anywhere from about three hundred to maybe a thousand shots he took—that, whether consciously or unconsciously, depicted a particularly colonial power dynamic; a moment when Riley was on a break, watching what I'm doing. The Stó:lō are collaborators with us. More traditional and deeply colonial archaeology involves Natives standing aside and watching. But that's not what our research group is about.[104]

When I asked Graesch if the work of his research group was as entirely collaborative with the Stó:lō Nation as he claimed, why Riley Lewis's name

was not listed on any of the research group's co-authored papers, Graesch replied, "Because the discipline is slow to change. It's taking a while. But there are a lot of spectacular scholars who work in Indigenous archaeology who are trying to change the ways scholarship happens.... I think there will be major shifts in the discipline over the next decade as new scholars emerge and begin to teach."[105] When I asked the same question of Dr. Schaepe, why Riley Lewis was not listed as a co-author on the papers when he worked as an archeologist researching Stó:lō sites, Dr. Schaepe's response was slightly different from that of Dr. Graesch:

> When I write a research paper, and I feel like this is a distinction in our field, a co-author is a person who sits down together with other collaborators and colleagues to write out the reports. I acknowledge Riley's work in what I write, commemorating his involvement, commemorating him as a friend and colleague, but there hasn't been a moment where we've sat down and written a piece together.[106]

As a co-editor of *Towards a New Ethnohistory: Community-Engaged Scholarship among the People of the River*, and co-author of the introductory chapter, "Decolonizing Ethnohistory," Dr. Schaepe has practised (and one could quite literally say has collaboratively "written the book on") long-term, trust-building, collaborative, mutual, and *relational* ethnographic and archeological practices in the field—protocols taught to him in part by Riley Lewis.

Graesch attributes his commitment to decolonization—and his awareness of the history of colonial issues in field research, ethnography, and archaeology—to his time spent on the Fraser River Valley Project photographed by Wall. In our phone interview, Graesch described to me how his entire approach to teaching North American archaeology has changed because of his work on the dig with Lewis. He says he used to start his courses at the earliest date in North American history—from the Pleistocene era—then teach forward toward the present moment, but he has "completely redefined" his approach. "I now start in the present. What is it that we know about Indigenous cultures in North America? *How* do we know what we know? Then we do a lot of work deconstructing these American and often Romantic ideas of Native culture."[107] Graesch also discussed how, in his classroom and when instructing individual students in the field, he specifically addresses the erroneous myth of the dying Indian, so prevalent in nineteenth-century North American ethnography: "We recognize that these people are still here, which a

number of students—often students of great privilege—don't necessarily even know. We do this by talking about what contemporary reservation life looks like, and how colonialism is still present, is still a project that is underway."[108]

The question of whether Wall's photograph can be considered "reverse ethnography" is complicated. *Fieldwork* may at first seem to unsettle colonial narratives, but the photograph also elides decolonization in the repetition of expected and stereotypical power dynamics in Indigenous-settler relationships. If Wall's photograph were to be considered not just visual art, but also ethnography, the work would most likely fall into the sub-field of anthropology known as visual anthropology: "The field may be conceptually wide-ranging, but in practice visual anthropology is dominated primarily by an interest in pictorial media as a means of communicating anthropological knowledge, that is, ethnographic films and photographs and, secondarily, the study of pictorial manifestations of culture."[109] When I asked Graesch whether he would consider Wall's *Fieldwork* to be an ethnographic or anthropological document, he mentioned the work of another artist: Peter Menzel's *Material World: A Global Family Portrait.* In this work, the photographer toured the world, asking families in fifty different cultures and geographic locations to take all of their possessions and place them outside their homes for a family portrait. "Menzel stages these photographs," Graesch notes, "and the staging shapes behaviours. The work is extremely valuable, but I'm not entirely sure it's ethnographic. It demonstrates, in part, our relationship to stuff, but it's not typical of everyday life. It's not *in* life, within the context of use. It does not depict a relationship with the stuff."[110] Fried has beautifully described *Fieldwork*'s "larger meaning" to be "above all an attempt to represent, to make visible, the historicalness of the everyday ... the way in which material traces are deposited day by day."[111] Graesch describes Wall's work as "a slice of time," and qualifies that *Fieldwork* could not be considered visual anthropology because "visual anthropology will show a lot of different photographs taken over time, an abundance of data."[112] Wall's work, like Menzel's, is only representative: "One image can never be demonstrative as data."[113] Context is needed in order to understand the stances of bodies, the habits and meanings behind human behaviours, the relationships between people, places, objects, and our stuff.

When I first contemplated using Jeff Wall's *Fieldwork* for this section, I felt as though his photographic depiction of the process of anthropological study, fieldwork, and archaeological data collection, especially given his history of near-documentary photography that has the capacity to unsettle

viewers, was as decolonizing a project as Jungen's *Sketches* or Fusco and Gómez-Peña's *Undiscovered Amerindians*. However, I am left wondering whether *Fieldwork* is also a complicated mixture of "reverse ethnography" coupled with remnant colonial art-historical techniques found in Paul Kane's ethnographic portraits. One could argue, for instance, that Wall's choice to use an image in post-production of Lewis with his arms crossed in a detached stance on the sidelines of the dig could be interpreted as body language indicative of holding power: that Wall places Lewis on the sidelines, rather than working in the dirt, to show a reversal of settler-Indigenous colonial hierarchies. In this reversal, Lewis is clearly in charge while Graesch, under Lewis's supervision, does the dirty work. However, one could equally argue that Wall's final image, chosen during the artist's last stage of post-production collage—an image presumably representative of the entire collection of days spent in Lewis and Graesch's company—is indicative, instead, of a body language and stance of passivity in the figure of Lewis, rather than an image of power. Lewis can equally be depicted, as was Graesch's concern, as being "on the sidelines" of the dig, which denies recognition for the Indigenous collaboration necessary and vital to the project's academic research. Seeing Lewis as non-participatory in the collaborative academic work of the Fraser River Valley Project between UCLA, SFU, UBC, and the Stó:lō Nation sets aside the academic labour of the Stó:lō people in order to continue harmful stereotypes founded on the erroneous colonial belief that settler knowledge systems are superior and more central to academic insight than Indigenous knowledge systems, or that Western-trained academics carry more wisdom than Indigenous knowledge keepers. Interpreted this way, Wall's image re-inscribes the erroneous and harmful colonial beliefs of Kane's time, which posited that the use of "benevolent settler" ethnography is necessary in order to carefully preserve Indigenous traditions before the "vanishing Indian" is eradicated completely.

This second interpretation of *Fieldwork* positions the photograph as a re-inscription of colonizing beliefs, rather than working to decolonize viewers' remnant colonial assumptions, and does not, according to Graesch, depict the true collective labour indicative of his and Lewis's working relationship as field partners during the dig on Welqámex. Because Graesch and Lewis were, as Graesch has described, truly collaborators on the initial exploratory archaeological dig of Stó:lō houses and settlements in the summer of 2003—were both on their bellies together in the dirt excavating soil samples and discovering slate knives and early indications of semi-subterranean

houses—Wall's final choice of image for *Fieldwork* limits a viewer's sense of Lewis's anthropological labour and Lewis and Graesch's substantial academic collaboration. Wall has taken the images gathered in the field—like Kane's field sketches—and, once returned to his studio in urban Vancouver, has modified the collected images to depict a relationship between Graesch and Lewis most suited to Wall's own aesthetic point of view, which also, whether consciously or unconsciously, depicts a political point of view on settler and Indigenous relationships in an anthropological context. If this final image depicts an inaccurate portrayal of Lewis's professional engagement in the dig, then it is difficult to see Wall's digital manipulation as any more decolonizing than Kane's aesthetic choice to attach a Cowlitz woman's head to a fur-robed torso and place a Chinook child in her arms upon returning to his Toronto studio.

And yet, as with all of Wall's work, it is not the created image alone but his collective practices and contexts as a "near-near documentary" artist that come into play in a viewer's understanding and interpretation of *Fieldwork*. Wall has a history of creating "fake" documentary photographs that capture a staged reality. It is thereby through the viewer's knowledge and expectation of Wall's famed technique of staging the real that she observes and interprets the images he presents. Kane, on the other hand, repeatedly claimed to be offering a "straight" documentary truth about Indigenous people living on land that is now called North America, while deceptively and deliberately erasing and eliding distinct tribal traditions and ignoring the devastating effects of colonization in his "ethnographic" portraiture. Part of the unsettling nature of Wall's "near-documentary" artworks is the viewers' disturbed and disrupted encounter with what reality is perceived—so often casually, habitually, or unquestioningly—to be. Like in Wittgenstein's theatre-that-is-life, the viewers of Wall's "near-documentary" photographs are observing "life itself," and yet, as Wittgenstein noted, "we do see this every day and it makes not the slightest impression on us!"[114] Wall ensures that reality has "the slightest impression" on the viewer by causing her certainty with a seemingly "real" documentary image to no longer be reliable. Wall's "near-documentary" technique allows the viewer to perceive life as "at once uncanny and wonderful" because, through the act of framed attention and sense of precarity with reality, one begins to "see it from *that* point of view," as Wittgenstein imagined. *Fieldwork*, when known to be both real and not real, encourages the viewer to notice the fragmented collections of moments that make up reality, and to attend to that reality carefully, noticing what she might otherwise not inspect: which body

stands by and watches at this archaeological site? which body digs? whose stance holds power? how do the two men work together? what is this image's relationship to art and to archaeology? what is real about the image and what is fabricated? Therefore, it is as much the conceptual work of Wall's photographic technique as it is the image alone that, while admittedly complicated, skews my understanding of *Fieldwork* toward a decolonizing image rather than an intentionally harmful stereotype. Kane, it seems clear, wanted to make history. Yet, as Paul Chaat Smith writes in *Everything You Know about Indians Is Wrong*: "no history is complete without knowing the history of the history"[115] In *Fieldwork*, Wall is much more engaged with trying to figure out "the history of the history" than with presenting history "straight" through his work of art. The questioning of perceived reality is essential to Wall's art. In *Fieldwork*, as with other works of reverse ethnography, the instilled colonial markers of what makes up our ideas of archeology, the collection and study of Indigenous artifacts, and the complex act of an archaeological dig itself become the objects of the viewer's scrutiny.

The stories behind the making of Wall's *Fieldwork* remind viewers just how much is left out when we try to capture a culture, how much of the context and creation of an object lies beyond the galleries and museums in which art and artifacts are held. As with Häussler's *He Named Her Amber*, it is not only the objects but the collecting and framing of these objects and the institutions housing and protecting these objects that become scrutinized in Jungen's *Sketches* and Wall's *Fieldwork*. The works, by destabilizing viewers' trust in ethnographic display—be it archeological collection, historical preservation and re-enactment, or the practice of documentary photography—draw attention to the myths of the "peaceful settler" and the "vanishing Indian" still existent in Canadian culture today. The work of the last artist discussed in this section, Rebecca Belmore, continues the traditions of reverse ethnography found in Jungen and Wall but extends a critique of settler-centric narratives found in cultural institutions, such as the Grange house museum, outward, beyond the walls of the museum and gallery, into the city street. Belmore's work asks viewers to physically, intellectually, and emotionally understand how the settler-centric narratives of historical house museums, and the institutional practices that perpetuate the myth of the "vanishing Indian," are sustained outside the walls of the museum with the continued "vanishing" of Canada's murdered and missing Indigenous girls, women, and 2SLGBTQQIA people. Her work asks viewers to make connections between what is remembered and celebrated in the memorial halls and manicured historic rooms of the

nation's museums, and what other kinds of vigils must be kept to remember names that could otherwise violently be lost in history's timelines.

UNSETTLING ACTS OF REMEMBRANCE: REBECCA BELMORE'S *Wild* AND *Vigil*

For five days in the master bedroom of the historic house museum of the Grange in Toronto, an Anishinaabe woman reclines in the master's bed. Her shoulders are bare. Her black hair spreads its tendrils across the white map of pillows beneath her head. Before inserting herself beneath the bedclothes, she redecorated. The Georgian four-poster bed had a new canopy made of beaver pelts. The bedspread glistened with red sateen fabric and swaths of black hair that undulated with the breath and movements of the woman in the bed.

Across the country, six months later, this same woman, with bucket and scrub brush, washed the sidewalk near the intersection of Gore and Cordova in Vancouver, then, once she had implored a passerby in the neighbourhood to light votive candles, she screamed out women's names she had written on the skin of her body, and, for each name, stripped a rose of its leaves, petals, and thorns by running the flowers through her clenched teeth and closed lips.

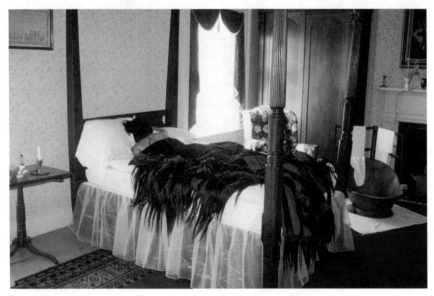

Figure 21. Rebecca Belmore, *Wild.* Performance, installation: hair, fabric, beaver pelts. *House Guests: The Grange 1817 to Today.* September 15, 2001–January 27, 2002. Toronto, Art Gallery of Ontario. Courtesy of Rebecca Belmore.

Figure 22. Rebecca Belmore, *Wild*. Performance, installation: hair, fabric, beaver pelts. *House Guests: The Grange 1817 to Today.* September 15, 2001–January 27, 2002. Toronto, Art Gallery of Ontario. Courtesy of Rebecca Belmore.

She then donned a red dress and repeatedly nailed the dress to the wood of an electrical pole, and to a nearby fence of plywood, and struggled—nailing, thrashing, nailing, thrashing—to tear herself free, until her dress hung in shreds and the woman remained: sweating, out of breath, standing on the street corner in her underwear.

This woman's name is Rebecca Belmore, an Anishinaabekwe artist originally from Sioux Lookout, Wana-na-wang-ong, in northern Ontario. Both her work *Wild* (performed between September 15, 2001, and January 27, 2002, as part of the exhibition *House Guests*, celebrating the centenary of the Grange, one of Toronto's historical colonial buildings) and her work *Vigil* (a commemoration of sixty Indigenous women who had gone missing over the previous ten years from the Downtown East Side, which she performed on June 23, 2002, as part of the inaugural Talking Stick Festival) are acts of memorializing that question who is included in history and in a nation's collective memory. Through inserting her body into unexpected spaces where other bodies like hers have disappeared, Belmore ensures that the lives and the deaths of Indigenous women, girls, and 2SLGBTQQIA people, those whom sociologist Avery Gordon describes as "the lost subjects of history," are not forgotten by contemporary onlookers.[116] Belmore's art engages in acts of reverse ethnography in that the museum patron's or bystander's response becomes a part of the artist's work. The uncanny surprise of encountering Belmore's living body abruptly dislodges viewers out of any comforts and habits they have come to associate with the histories taught in the traditional spaces of a museum or the typical encounters they might have on a sidewalk or a street. The unasked-for encounters that Belmore's performances produce echo unasked-for encounters of violence experienced by Indigenous women, girls, and 2SLGBTQQIA people. In spaces meant to preserve history, in neighbourhoods that ought to protect women from harm, Belmore's work calls attention to the violent erasure of Indigenous female bodies and their stories that historically and presently takes place across Canada.

Belmore's work of inserting herself into unexpected places, which engages viewers in startling, often disorienting, experiences of re-learning and re-membering history, has a lineage in other Indigenous performance artists, whom she names as mentors and whose work also aligns itself with the practice of "reverse ethnography" that Fusco and Gómez-Peña established and named as an art practice, and that Jungen and Wall employ in their sketches and photographs. One such mentor that Belmore acknowledges is James Luna, a well-known Payómkawichum performance artist. His work,

Figures 23, 24, 25. Rebecca Belmore, *The Named and the Unnamed*, 2002, video installation. Collection of the Morris and Helen Belkin Art Gallery, The University of British Columbia. Purchased with the support of the Canada Council for the Arts Acquisition Assistance program and the Morris and Helen Belkin Foundation, 2005. Photos by Howard Ursuliak.

The Artifact Piece, first performed in 1987, also works to "reverse" the ethnography of object and observer inherent to museums. Wearing only a towel breechcloth, Luna "installed" himself in an exhibition case filled with sand in the San Diego Museum of Man in a section filled with mannequins and props showing the "ways of life" of the Kumeyaay First Peoples. Surrounding Luna were testimonials of his own life: his diploma, his divorce papers, a Jimi Hendrix cassette tape, a toy model Volkswagen Beetle. Signs positioned within the showcase indicated his name and commented on the visible scars present on his body. In *The Artifact Piece*, as was done in *Two Undiscovered Amerindians*, Luna presents his own living body as an artifact, to mimic, disrupt, and question the techniques of vitrines, dioramas, and wall plaques used in museums' ethnographic displays, which erroneously visualize the lives of Indigenous societies as vanished or extinct.

In *Wild*, Belmore, through the act of live performance, observes the responses to her presence in the four-poster bed of the Grange's master bedroom. *Wild* asks viewers to question their trust in the accuracy of historical house museums: how "truthful" a history is shared with visitors of a preserved colonial mansion when non-colonial, non-white, and non-wealthy lives are vanquished, unnamed, and unmentionable in the home's lavishly decorated rooms? Belmore writes in the exhibition catalogue for *House Guests*, "By occupying a place as personal as this bed I am making a connection between myself and the history of the Grange. It is a way of asking, 'Where is my history?'"[117] Part of the work of memorial that Belmore performs, through the startling proximity and physical intimacy of her naked body in a bed, is to ask patrons whose lives and histories we have ignored. Just as Thomas King reminds us that "most of us think that history is the past. It's not. History is the stories we tell about the past,"[118] Belmore's presence in *Wild*—like the stereotypes collected from passersby in Jungen's *Sketches* or the collaged positioning of bodies in Wall's *Fieldwork*—asks us to examine what stories we are memorializing about Canada's past—stories that also inevitably reflect our present ways of thinking.

For instance, one possible story from Canada's past that *Wild* examines is the myth of the colonizer's "Indian lover." Belmore asks whether her Indigenous woman's body in the master's bed from 1817 is a probable image: "If I was alive back then, I would never be in the master's bed. Or, my question is, would I? ... I [am] thinking of the history between European settlers and Aboriginal peoples, specifically of the so-called master taking an Indian lover or a wife."[119] Indeed, the presence of an Indigenous lover is primarily absent in historical house tours—faithful, often religious, monogamy being an important trait to maintain for the continued myth of the peaceful settler. As Helene Vosters's work on embodied memorial performance asserts, commemorative and memorable practices act as frames that inscribe only certain events and losses into social memory, while casting other events and populations beyond the realm of our dominant collective memory.[120] But Belmore's naked body in the master's bed cannot help but draw a viewer's mind to an alternate story: the possibility of a sexual relationship between this unidentified Indigenous woman and the "master" (or perhaps the mistress) of the house.

However, if present at all, the narrative of the "Indian lover"—that image of the helpful Pocahontas "squaw"—has become prevalently accepted by settler cultures as a colonially palpable figure of helpful, sexualized female indigeneity. She is just taboo enough to enter at the margins of possible socially acceptable colonial thought, while still maintaining an order of dominion: her body, like

the other beautiful objects adorning the room, *belongs* to the colonizer. Further, when looking at this myth of the lover in a comfortable bed, we realize this narrative does not resemble remotely the horrifying treatment that settlers historically showed female and queer Indigenous bodies during the nineteenth century. Law and education scholar Sherene Razack argues that "sexual violence towards Aboriginal women was an integral part of nineteenth century settler technologies of domination."[121] "Spatial containment, along with a practice of limiting rations to Aboriginal families, was exploited by settler agents who would exchange rations for sexual acts from the women." The effect of this practice was the "universal conflation of Aboriginal woman and prostitute and an accompanying belief that when they encountered violence, [they] simply got what they deserved."[122] Our collective memory, history, and storytelling about the past primarily, as King asserts, consists of what we can palpably and willingly believe about ourselves now. Razack argues that "a quintessential feature of white settler mythologies is ... the disavowal of conquest, genocide, slavery, and the exploitation of the labour of peoples of colour."[123] One can begin to see why, until Belmore's disruptive insertion, the Indigenous female body has been wilfully erased from the colonially preserved Grange home. To look realistically and honestly at settler relationships with Indigenous women's bodies (and, even less historically documented or publicly discussed, Indigenous queer bodies), is to see violence, rape, starvation, and murder—not an encounter with Canadian history that tourists to the Grange who are looking for a long-weekend cultural activity may be prepared to attend between catching a street-hockey game and gathering for a Victoria Day picnic. The violence inflicted upon Indigenous female and 2SLGBTQQIA bodies is a part of Canada's history and present reality that is difficult to acknowledge, let alone to memorialize and consider through the public institution of a museum. Yet we must acknowledge the truths of our history, we must be honest in the stories we tell about ourselves, if we want the violence against Indigenous women, girls, and 2SLGBTQQIA people to stop.

What is compelling about the Indigenous lives that Belmore, Luna, Fusco, and Goméz-Peña create and insert in the context of museums is that they puncture a facade of history that these museums work so hard to create. The fabricated and fictive creations of these artists allow us to see the realities of history that have been left out. History without honesty is an illusion. It is a dream of what we wished we were, but not a representation of where we actually come from. And this dream is often beautiful: it is silver cutlery and fancy hat stands, china tea services and the crisp sheets of canopied four-poster beds. The dream, as imagined by Ta-Nehisi Coates, in the context of black lives and black

history in the United States, "smells like peppermint but tastes like strawberry shortcake. And for so long," he realizes, "I have wanted to escape into the Dream, to fold my country over my head like a blanket,"[124] but, he knows, "this has never been an option because the Dream rests on our backs, the bedding made from our bodies,"[125] not unlike the masses of roiling black hair Belmore has sewn for her bedclothes. The preservation of the myth of a peaceful colonial past as found in the Grange, if continued, unnoticed and uninterrupted by artists like Belmore, directly damages our ability to reconcile our present.

This direct connection between unrealized historical erasure and violence and the present-day erasure and violence toward Indigenous female and 2SLGBTQQIA bodies is unquestionably disturbing when considering the links between Belmore's act of affective memorial in the early-nineteenth-century colonial context of the Grange and the remembrance Belmore makes on the streets of contemporary Vancouver in *Vigil*. Belmore claims that it was not, in fact, spiteful, ignorant, or racist comments that were the strangest ethnographic observations made during *Wild* while she pretended to sleep in the Grange's master's bed: "The most extreme reaction to the work was for people to enter and observe the 'historical beauty' of the room, discussing all the objects in the rest of the room, while ignoring me in the bed."[126] As art critic Kevin Griffin notes, "Belmore recalled how people described an object just beyond her head but deliberately ignored her, the Aboriginal woman in the most intimate room in the house. Her invisibility was a metaphor for the unseen history of Aboriginal people and the way Native women are often taken to bed but never named or talked about."[127] Belmore's ethnographic work reveals not just the *historical* exclusion of Indigenous women from the Boulton's pristine colonial mansion but the deliberate acts of erasure performed on the bodies of Indigenous women, girls, and 2SLGBTQQIA people in the *present*. A simple gesture of erasure, of deliberately disregarding a woman's body that is there, if one takes a look, right in front of one's eyes, is arguably connected to the 1,017 Indigenous women, girls, and 2SLGBTQQIA people who have been murdered between 1980 and 2012 and the at least 105 Indegenous women, girls, and 2SLGBTQQIA people missing under suspicious circumstances, according to a report issued by the RCMP in November of 2013—a homicide rate roughly 4.5 times higher than that of all other women in Canada.[128] How else, except for an unexamined systemic disregard for particular bodies, are 1,017 Indigenous women, girls, and 2SLGBTQQIA people murdered before an (arguably faulty and provisional) official inquiry takes place? It is these women, girls, and 2SLGBTQQIA people, and in particular the 60 Indigenous women who went

missing from the Downtown East Side of Vancouver between 1980 and 2002, whom Belmore's *Vigil* is in remembrance of.

A vigil is a period of keeping awake during the time usually spent asleep, especially to keep watch or pray. And it is ultimately an act of waking that both of Belmore's works ask of their viewers. Belmore's body moves from a reclined position of rest, sleep, dreaming, sex, or death in *Wild* to one that is alert and loud and publicly visible in *Vigil*, but both require the viewer for their labour as decolonizing memorials. That both *Wild* and *Vigil* are surprising and unexpected to viewers insists on viewers' engagement. Both memorials are neither passive statuary nor national remembrance in the form of the naming of cities and streets after naval captains and settler profiteers. These colonial forms of remembrance in Canada have largely left out the histories of Indigenous women, girls, and 2SLGBTQQIA people, and so new forms of remembrance, like Belmore's, must take their place. When Belmore lies down for *Wild*, her act of remembrance is in the paradox of her body's presence. And the simple act of a body's presence—as one can see repeatedly in the tradition of performance artists' work—for instance, Marina Abramović's intensely popular *The Artist Is Present*—can also be a form of endurance.[129] When Belmore shouts the names of women who have gone missing and been murdered in *Vigil*, people from the neighbourhood shout back and become part of the work of naming the women, girls, and 2SLGBTQQIA people who have, for decades, gone unnamed. And as Vosters notes,

> Belmore's use of a labour aesthetic is not artifice, her performance not a representation of labour as a symbolic device—she is labouring. She is scrubbing the streets, her knees are pressed into concrete; she is driving nails through fabric into wood; she is struggling to tear herself free. And through her labour we who bear witness also must labour.[130]

The labour of witnesses to Belmore's work is to look and to feel, to affectively respond to the past and its consequences in the present. Turning again to Coates's work, he reminds us that

> all our phrasing—race relations, racial chasm, racial justice, racial profiling, white privilege, even white supremacy—serves to obscure that racism is a visceral experience, that it dislodges brains, blocks airways, rips muscle, extracts organs, cracks bones, breaks teeth. You must never look away from this. You must always

remember that the sociology, the history, the economics, the graphs, the charts, the regressions all land, with great violence, upon the body.[131]

Along with this violence, in Belmore's grappling, physically labouring, and enduring presence with her body in *Wild* and *Vigil*, in her irreverence in the rooms of the museum and her reverence in the street, the confrontation of this *felt* memorial, of absence, loss, violence, and erasure, is also met with her body's strength, spirit, endurance, and vigilance. It is this vigilance, this reverent and irreverent spirit, by which acts of reverse ethnography ensure that museum-goers do not forget Canada's varied and complex histories. It is the body—the physical presence of muscles, bones, teeth, hair, and brains—whose physical presence paradoxically disrupts typical historical timelines to remind viewers whose bodies and lives have been made absent through the colonizing forces of the galleries and museums so often explored during school field trips.

It is hard for me to know what learning Canadian history feels like, even though I was taught Canadian history every year of my education. I never had the chance to know the surprising, bracing, complex, and difficult colonial history of my country throughout elementary school, high school, and university. Never once in a classroom was I told about the genocide of Indigenous bodies on this land, nor of the resilience and resurgence of Indigenous communities in the face of cultural annihilation. For most of my formal education the difficult and violent parts of my country's history were kept from me by my educators. Given what was missing from the Canadian Museum of History's interactive timeline, given the stereotypical responses to the reverse ethnography of Jungen's wall drawings, and given the silence and disregard toward Belmore's presence in the master's bed at the Grange, it appears that my contemporaries were not taught about the complexities of Canada's colonial history either. If the Canadian Museum of History's interactive timeline was indeed established "to learn more about how Canadians think about history and what about Canadian history matters to them," the unruly artworks of Jungen, Wall, and Belmore complement this national task by asking further questions of the museum and gallery-going public: What are the stories we are telling ourselves about the past? What stories do we avoid telling because of our discomfort? What happens when we destabilize linear notions of historical time, disrupt traditions of ethnography and archeology, and upset the firmly held understandings of mythical settler and Indigenous identities? Through the reverse ethnography of Jungen, Wall, and Belmore, the answer I have come to is paradoxical: through encountering the lies that art reveals to us, we come closer to knowing the truth of who we are.

Imagining the Author

The Heteronyms of Fernando Pessoa,

Erín Moure, and David Solway

THE HETERONYMS OF FERNANDO PESSOA, ERÍN MOURE, AND DAVID SOLWAY

AS WRITER ERÍN MOURE TELLS THE STORY, "IT STARTED ON MARCH 20, 2000. In Providence, Rhode Island, I decided not to read anything for five days and just think."[1] Yet, despite her self-imposed ban on reading, she found herself in a bookshop, and, having forbidden herself from opening the covers to read the words inside, purchased a copy of Alberto Caeiro's *O Guardador de Rebanhos*, "because it was red."[2] Upon returning to Toronto for a writing residency, a most wonderful surprise occurred. Moure opened the book and suddenly realized she could read not just the English translation of Caeiro's poems but also the original Portuguese on the facing pages: "What startled and elated me was the Portuguese. I'd only expected to view the original language as markings, as *traits*, but because of my studies in Galician, I could read it. It was a sudden, unexpected gift. Felicity! To suddenly know a language!"[3] With her new gift, and with time to write ahead of her, Moure began to create "an altered but true translation" of *O Guardador de Rebanhos*, a work by the modernist Portuguese poet Fernando Pessoa attributed to

one of his heteronyms.[4] Heteronyms, in the context of authorship, are an extreme kind of pseudonymity: an authorial mask wearing. Gérard Genette describes the practice of heteronymic writing as "imagining the author."[5] For example, Eirin Moure's *Sheep's Vigil by a Fervent Person* is a translation of Alberto Caeiro's *O Guardador de Rebanhos*, but Alberto Caeiro is a heteronym imagined into being (fervently) by Fernando Pessoa.

Moure's translations of Pessoa are not the only instance of heteronymic writing in contemporary Canadian literature. The personhood, the poetics, and the translational practices found in Moure's translations of Pessoa's heteronym Caeiro in *Sheep's Vigil by a Fervent Person*; Moure's own heteronym Elisa Sampedrín, particularly as manifested in *Little Theatres*, *O Resplandor*, *Expeditions of a Chimæra* (co-authored with Oana Avasilichioaei), and *The Unmemntioable*; and David Solway's heteronym Andreas Karavis in *Saracen Island: The Poems of Andreas Karavis* and *An Andreas Karavis Companion*—all impede inattentiveness to commonly held ideas of authorship, translation, and remnant colonial ideas of what constitutes Canadian literature. These heteronyms are able to confront habituated perceptions of authorship, language, and literature through, quite simply, make-believe. These real and imagined authors engage in cultural and ethical questions of *what could be* in Canadian literature. They ask readers to wonder why more imaginative and inclusive Canadian authorial and translational cultural practices do not yet exist. It is through an ethics of imagination that these heteronyms do important work in reimagining what Canadian culture and literature have the potential to include and to be.

Like many fictional characters we encounter as readers, Moure's and Solway's creations, the heteronyms Sampedrín and Karavis, require readers' empathy in order to exist, yet these works do not allow readers to rest comfortably in such empathy. The heteronyms interfere with and disturb constituted and established realities. Yet, in the disruption, this foregrounding of how reality can be transformed by the imaginary gives us permission to change our own established realities and, thereby, even in small and subtle ways, transform injustices. Specifically, Sampedrín teaches us that, in order to transform established realities, meaning needs to be sought not just in the communicative functions of language but also in the poetic, with its fierce metaphorical abilities to discomfort and complicate our expectations and our reliance on the habitual. Solway's creation of the heteronym Karavis demonstrates how difficult it can be to overcome a stuckness of the self. Karavis's presence embodies Solway's—and undoubtedly many other authors'—fear of

inferiority and anger regarding a fame-driven literary marketplace in Canada. Karavis's and Sampedrín's disruptive behaviours in translation present an "identity correction" that draws readers' attention to current translational practices in Canada. These characters demonstrate how inextricably connected our uses of *language* are to the creation of *culture*.

WHAT IS A HETERONYM?

Heteronyms operate on linguistic, translational, and authorial levels—all of which Caeiro, Sampedrín, and Karavis pester and complicate. At the linguistic level, heteronyms are words that are identical in spelling and pronunciation but entirely different in etymology and meaning (such as *agape*—both to have one's mouth open and a theological term for love; or *invalid*—both a person who is infirm from sickness or disease and the state of not being valid). As Natalee Caple describes it, a heteronym is "a group of words that look identical on the surface but can be used to embody multiple meanings."[6] It is thereby not equivalence that heteronyms primarily embody, but difference. There is multiplicity and complexity in what at first may seem to be a single and seamless surface of language.

The definition of heteronym is also linked to translation: "a name of a thing in one language which is a translation of the name in another language,"[7] such as *grandmother* in English to *grand-mère* in French to *abuela* in Spanish, or *eggplant* in English to *aubergine* in French, to *berenjena* in Spanish. Translators might describe this kind of heteronymic relationship as the relationship between a word in a source language and the word in a target language. Most translators, however, would also agree that to translate heteronymically, word for word, source *mot* to target *palabra*, is not a sound method of translation. (Anyone who has attempted to use Google Translate to communicate with an acquaintance in a different language has likely discovered the difficulties presented by heteronymic translation.) A translational technique focusing primarily on word-by-word equivalency means that meaning is lost, an author's distinct style and voice are lost, the context and grammatical considerations of the original are lost, and the poetry and enjoyable surprises of language are lost. Susan Sontag argues that translation is not the "finding of equivalents" but is an "exalting" in language's complexities and "a valuable cognitive—and ethical—workout."[8] Canadian translator Oana Avasilichioaei asserts, "To my mind, translation is impossible because there are no equivalences between languages, the bodies that utter them

and their contexts, only counterparts and digressions."[9] The complexities, counterparts, and digressions of linguistic and translational heteronyms are embodied and amplified in the poetic counterparts of Pessoa's, Moure's, and Solway's authorial heteronyms.

When "heteronym" is applied not just to the function of words but to the broader functionality of texts, to the relationships between authors and readers—a relationship that is often mitigated by how publishers choose to classify, market, and distribute texts—a heteronym is also not an equivalency but an alternative, a digression, an "unexpected gift" to our conceptions of what a book can be. Alberto Caeiro is a gifted alter-poet to Fernando Pessoa, with a unique linguistic style that differs from that of his creator. It is Caeiro's difference from Pessoa rather than his equivalence, his alterity rather than his sameness, that is primary to the act of "imagining the author."

In Michel Foucault's 1969 lecture "What Is an Author?" he acknowledges that the author's name is not "just a proper name like the rest" but instead acts as a "classificatory function. Such a name permits one to group together a certain number of texts, define them, differentiate them from and contrast them to others."[10] Or, as Mark Rose interprets Foucault's author-function, "the name of the author becomes a kind of brand name, a recognizable sign that the cultural commodity will be of a certain kind and quality."[11] Foucault's essay recognizes that an author's name and persona are distinct from an empirical person, and that these names and personas can circulate in discourse quite separately from a physical counterpart. The author-function is itself a creation, whether deliberately groomed by an author or publisher or imagined by a readership. Robert Griffin notes that an author's name can circulate separately "because the author-function describes precisely a function that may be fulfilled by a name but does not require one. It is first of all an empty function, a structural blank space, which may be signed or unsigned depending on the circumstances. And when signed, of course, the name may just as easily be a pseudonym."[12] Or, as in the case of Alberto Caeiro, Elisa Sampedrín, and Andreas Karavis, the name may be a heteronym.

According to Genette, a heteronym is a category of pseudonymity, the practice of "imagining the author," wherein "the real author attributes a work to an author who, this time, is imaginary but provided with some attributes."[13] While a pseudonym is typically a pen name—an authorial label placed on a text with no further information given to the reader beyond that name—a heteronym is a fictional author who comes with a past and

preferences that tend to differ greatly from the author's. The author might be a young existentialist, write sonnets, have red curly hair, and be adorned with a tattoo of swallows across her shoulder blades; however, the heteronym she creates might have dark brown eyes, be seventy years old, know Arabic, read Derrida in cafés, smoke Gauloises cigarettes, and listen to "What a Wonderful World" by Louis Armstrong on his stereo while writing sestinas. With heteronyms there are two, or perhaps even three, layers of creation: the creation of the text by the heteronym/author, the creation of the heteronym her-, them-, or himself, and the recreation of the author's own self that occurs in the course of writing as a persona. For example, Pessoa—to whom has been attributed the invention of the practice, the coining of the definition, and the creation of over seventy heteronyms in his lifetime[14]—creates the poetry of his heteronym Alberto Caeiro, he creates Caeiro himself, and, in these acts of creation, Pessoa reconsiders and reconfigures the fashionings of his own authorship and selfhood, ultimately altering his own identity. Moure identifies the shift that occurs to her own identity while translating Pessoa's poems through an altered spelling of her name. She becomes Eirin Moure in her translation of *Sheep's Vigil by a Fervent Person*, another spelling of Erín and Erin that is used in Galicia, and one that inserts a little "i" into the name—a new first-person self, nestled into the habitual.

In order to do the work of "imagining the author," Genette observes, the author of a heteronym must "supply the whole paratextual apparatus that ordinarily serves to substantiate (seriously or not) the existence of the imagined author."[15] The heteronym authors the *peritext*, those words printed inside a publication—the poetry, the titles, the notes—and becomes substantiated through the author's manipulation and use of the *epitext* of a book: those aspects of authorship "located outside the book, generally with the help of the media (interviews, conversations) or under cover of private communications (letters, diaries, and others)."[16] We may read in a newspaper, for instance, about what a heteronym wore to a party, just as we can read the poetry that a heteronym has written in a book. Heteronyms are "complete poetic personalities—characters with different bodies of work, biographies, horoscopes, educations, professions, and aesthetics."[17] While the presence of the heteronym likely confounds conventional expectations of authorship held by readers, heteronyms also frequently surprise the authors creating them, complicating the idea that an author is the sole authority in the creation of a text. In this surprise, heteronyms likewise offer a reflection on whether we can be

considered the sole authors or agents of our selves. Heteronyms help to remind us of the contingency, creativity, and fluidity of our very existence—our lives' capacities for wonder, loss, pain, and unexpectedness through our encounters with others—which can derail and undo the expectations we hold of our own personalities and life paths. Heteronyms—as with fictional characters whose lives unfold solely within the boundaries of a fictional narrative—allow us to imagine alternate realities and new possibilities for ourselves.

The heteronym amplifies Foucault's distinction between the circulating author-function and the empirical author by playfully filling that "structural blank space" with a name that becomes imaginatively embodied. The "empty function" of the author's name takes on its own physical existence and seeming agency (through rich and believable physical description, through reporting that a heteronym was physically seen in a real place at a real time, or, sometimes, through the use of an actor), highlighting the complex gap between the ontology of an author and how an author exists in the perceptions of a reading public and the publicities of the literary marketplace. Quite separate from the author herself, the heteronym shows up at parties, the heteronym runs avant-garde theatre companies, the heteronym is born in Lisbon and dies of tuberculosis after living most of his life in the country with an aged great-aunt.[18] The heteronym presents so believably that he, she, or they are able to break their way into dependably non-fictitious realms: book blurbs, eyewitness accounts, banks, journalism, travel brochures, governmental bodies such as the embassy of a European country. These breaches of literary protocol—norms established to separate the fake from the authentic—are performed in the creation of heteronyms by Fernando Pessoa, Erín Moure, and David Solway in order to encourage readers to ask how much we really know and notice daily about the workings upon us of language and text. What presumptions do we have about the authority inherent in published works, such as books, newspapers, poetry journals, academic articles, and Companions? How much trust do we unconsciously place in a publisher's stated generic divisions between fiction and non-fiction in the literature we read? How do heteronyms change ideas of authorship and author-function, of translator and translated, of a presumed singularity of self and voice?

Heteronyms remind readers not to take the functions, practices, and habits of authoring and reading for granted. For, as Genette urges, one ought not to think of pseudonymity or heteronymity as an exception to signing one's legal name, but as a decided choice. The coinciding of an author's legal

name and the name with which they sign their work ought also to be given a distinct nomenclature, because "to sign a work with one's real name is a choice like any other, and nothing authorizes us to regard this choice as insignificant."[19] Genette suggests the term *omnity* to describe the practice of an author signing their legal name to their books, because "as always, the most ordinary state is the one that, from habit, has never received a name, and the need to give it one responds to the wish to rescue it from this deceptive ordinariness."[20] What heteronyms do, through their disruption to the practice of *omnity*, is disrupt a reader's expectation that when they pick up a book the name on the cover of that book will coincide with the name of the legal person who wrote the words inside. In disrupting the pattern of affixing one's legal name to a work of literature and, in turn, offering alternative possibilities for authorship, heteronyms do not just create new avenues for literary expression; they disrupt the customary. When a reader realizes the customary is just that—a practice or a habit rather than an immovable reality—the uncommon and remarkable possibilities inherent to "common" acts of reading, writing, and translation are revealed. Ideas of how culture is made and who gets to influence current cultures—often also tied to acts of reading, writing, and translation—are also drawn into question.

When an author is a heteronym, the role of authorship becomes part of the work of art and thereby an object to be read. In heteronymic writing, the author—as a classificatory function, a brand, an indication of celebrity, a means of attribution—is a part of the poetics. Authorship itself is shown to be a created and creative entity and thereby open to interpretation by a reader. As when interpreting a poem, a reader's context and lived history will have an effect on her, their, or his interpretation of who an author is and what functions he, they, or she performs. By having a readership, an author is thus shaped and changed in how they are known, recognized, and received. Heteronyms highlight the fact that readers change the lives of authors, just as authors change the lives of readers. Heteronyms complicate authorship and readership such that the authority or meaning of a text can never be understood as a single-handed production. Just as Iris Häussler's *He Named Her Amber*, Brian Jungen's *Sketches Solicited for Wall Drawings*, Jeff Wall's *Fieldwork* and Rebecca Belmore's performances of *Wild* and *Vigil* remind us that any work of art is a collaborative undertaking at play between creation, display, and observation, heteronyms remind us that a book is an event between author, translator, reader, publisher, distributor, and language itself—a book's life is communal.

METAPHORIC POSSIBILITIES: TRANSELATING
THE *AS IF* OF A PORTUGUESE SHEPHERD

Although not particularly well known in North America, Fernando Pessoa "is considered by many critics to be one of the great masters of twentieth century poetry."[21] Just as when, on March 20, 2000, Moure received the sudden and unexpected gift of realizing she could read the Portuguese of Pessoa's poems, "on March 8, 1914, at the age of twenty-six, Pessoa suddenly felt poetically inspired. The title of a poem, 'The Keeper of Sheep,' occurred to him, and sitting down to write it, he poured out thirty poems in a style and of a quality unlike anything he had previously written."[22] Pessoa considered these poems to be written by a voice other than his own, "an apparition of someone in me to whom I at once gave the name Alberto Caeiro."[23] Although Caeiro has never in fact corporally existed, we know as much about his physicality and philosophy as we do of his poetry; for instance, Caeiro "was fair, of medium height, and blue-eyed" and was considered "a bucolic poet of nature perceived directly, a pagan and, more recently, has been seen as objectivist and phenomenalist."[24] Caeiro is a man decidedly different from Pessoa, who was a dark-haired, mustachioed *flâneur* of Lisbon who took afternoon coffee in cafés on busy city streets and was described as an "impeccable aesthete of ironic insensitivity."[25] Pessoa, writer of horoscopes, a Gemini, is nothing like his blonde, blue-eyed, pagan Leo counterpart.

Caeiro's quirky pastoral writings were only the beginning of what would become a prolific outpouring of heteronymic writing. Alberto Caeiro—a romantic counterpoint to the often "self-critical, diffident, and painfully self-aware" tone of Pessoa's own modernist style—is the first of a multitude of heteronymic voices that Pessoa produced.[26] For, as Pessoa himself describes, "once Alberto Caeiro had appeared I soon tried, instinctively and subconsciously, to find disciples for him."[27] Ricardo Reis and Alvaro de Campos came next, apprentices to Caeiro, whom, throughout their poetic practices, Caeiro prodded and shepherded. Many of Pessoa's heteronyms "know each other, influence each other, and criticize each other's works."[28]

Gérard Genette notes that "the pseudonym habit is very much like the drug habit, quickly leading to increased use, abuse, even overdose."[29] He admits, "I don't know whether some Guinness book has registered the world record for pseudonyms, mixing indiscriminately all periods and all categories," but he elects Pessoa as a contender.[30] What Genette does not report upon, however, is whether, when reading heteronymic writing, an author is led to the

increased likelihood of translating and producing heteronyms him-, them-, or herself. For Erín Moure, encountering the relationship between Pessoa and his invented bards—on that providential day in that Providential bookshop, and then through her English translations of Caeiro's *O Guardador de Rebanhos*—was an influence and an inspiration: "Pessoa was having an effect on me that *altered me* as an addressee (a reader) and as an actor-upon-a-text (a translator)."[31]

Moure's *Sheep's Vigil by a Fervent Person* publishes her English poems facing the Portuguese originals of Caeiro's *O Guardador de Rebanhos* in a bilingual edition. Yet the "translations" are deliberately inexact. Pessoa and his heteronymic bard never spent time "walking Vaughan Road" in Toronto,[32] "struggling on the pedals" of a bicycle, "from Trinity-Bellwoods up to Christie Pits, and on to No Frills."[33] Nowhere in the Portuguese original of *O Guardador de Rebanhos* does Caeiro reflect on Toronto's stray cats and hidden creek beds. Rather, Moure's chosen anachronisms and geographical discrepancies point to an unorthodox method of translation, to an accuracy of lyric mood over translational exactitude, to an imagined "as if" that takes Caeiro out of his homeland and into Moure's.

Moure describes the beginnings of *Sheep's Vigil* in the book's introduction: "to amuse and scare myself, I translated a short poem, altering posture and voice, and sometimes (thus) words, but still staying 'true' to the poem."[34] This "staying true to the poem" involved, for Moure, acknowledging her presence as translator, acknowledging her own inescapable authorship of the poems when moving into English from Portuguese: "Fidelity in the sense of reproduction was never my aim. I had the urge to be resolutely true to the gesture and movement of the Pessoan text, to the humour in it, and to Caeiro's philosophy."[35] Whereas most translators endeavour to make themselves invisible in the text—a clear plane of glass through which one language shines to become another—Moure wanted each poem, instead, to be a trans*e*lation, "a translation that lays bare the elation of the project ... it is a way of foregrounding the translator's presence instead of pretending to disappear."[36] As Avasilichioaei notes, "In North America, by and large, a 'good' translation still means smoothness, domestication, and easy readability, as the translator is supposed to disappear so that the author and their original can be more visible."[37] Thus, because of Moure's choice to bring her own geography and history to her translations of Caeiro, she has "been accused with *Sheep's Vigil* of having created a 'false translation.'"[38] A funny complaint, perhaps, given that Caeiro, whom Moure is translating, does not ontologically exist; is, in some

sense, himself "false." But, paradoxically, the biographical falsity of Alberto Caeiro does not diminish the "truth" of his poetry.

Alberto Caeiro's poetry may be "written *dramatically*," Pessoa acknowledges, "but is sincere (in my solemn sense of the word)."[39] For Pessoa sincerity clearly does not mean truth in a factual held-up-in-a-court-of-law sort of sense. For the man who created over seventy fake authors, sincerity manifests in poetry that "must truly depict the experience of one's internal life, the life of the mind and soul" rather than accuracy or empirical exactitude.[40] Pessoa's heteronyms celebrate the fact that if one's internal life at times manifests in a different exterior than one's own skin and in a different tone than one's own habitual voice, one ought not to be concerned with these discrepancies, for "the life of the mind and soul" is fluid in its expression. In this fluidity, Pessoa strived to express the sincere. Sincerity for Pessoa could come just as much from the imagination as it could from factual account, and it is this odd paradox of a sincerity of the "soul" found in Pessoa's heteronymic subterfuge that Moure likewise aims to translate into the English, along with the sounds, rhythms, and meanings of Pessoa's words. Moure translates Pessoa's and Caeiro's "sincerity," found even in authorial trickery, by highlighting her own mind and soul as a translator, the presence rather than the absence of her own authorial voice.

Fidelity to Pessoa's heteronymic project is translated through difference rather than equivalence. Moure's primary translational choices are not based on finding the most exacting equivalents between the source language of Pessoa's Portuguese and her target language of English. Moure's concern with translating Pessoa's heteronymic project is the maintenance of an equivalence of spirit: to translate not just what Aristotle in his *Rhetoric* calls logos (the meaning and structure of a language), but also the ethos of Alberto Caiero's poetry (Moure's own assumptions about the text, rooted in her own place and culture of Toronto), and its pathos (the feelings or moods produced by the text and received by Moure as reader). Sincerity in Moure's translations is thereby, paradoxically, expressed through deliberate translational inexactitude. Moure's translations do not create English derivatives of the Portuguese poems. She claims that "normative fluent translation was not my aim; there are already many excellent normative translations of the work."[41] Moure maintains the originality of Caeiro's poems and Pessoa's heteronymic project by creating her own new English "originals," rather than false English replicas of the Portuguese.

In *The Singularity of Literature*, Derek Attridge argues that a "responsible response to an inventive work of art, science or philosophy," or to "products

of human creativity (and that creativity itself)" is one that brings the work of art "into being anew by allowing it, in a performance of its singularity for me, for my place and time, to refigure the ways in which I, and my culture, think and feel."[42] Moure's translation can be read, under Attridge's definition, as a "responsible response" to Pessoa's work: one that listens to the original from her own subjectivity and temporality, and adds to as much as it takes from the original. Moure's translations listen to the character of Pessoa's original and, rather than solidifying the concrete and stable attributes of the Portuguese text, highlight Pessoa and Caeiro's aptitude for mindful and soulful aliveness, for contingency and change. The imagining that Pessoa conjured in his creation of Caeiro and his brotherhood of heteronyms is captured through Moure's imagining of her own Torontonian Caeiro.

Fernando Pessoa, although never having visited Toronto during his lifetime, now visits in Moure's translations. Pessoa, through Moure's Caiero, stays on Winnett Avenue in the year 2000. He walks along Bay Street and sees it "Paved with gold and God, / and art and hotdog stands and morals."[43] Pessoa's original title is translated and transformed through Moure's own unique perspective and experience in a mixture of Pessoan poetry and Mourean "internal life." *O Guardador de Rebanhos*—in previous translations *The Keeper of Sheep*—becomes, in Moure's words, *Sheep's Vigil*. This titular translation reflects how, for Moure, the act of reading and translating Caeiro's words was more like a vigil than a kind of keeping or keeping-track-of. She did not shepherd Caeiro's poems into being; rather, Caeiro's poems gave Moure a kind of sacred companionship (as all good books do) during her time in Toronto. As the introduction to her work describes, "In just over a week I'd translated some 30 of the 49 poems, in a sort of ecstasy. It was a form of prayer I lit each day, a vigil candle."[44] Fernando Pessoa's legal name is also translated into the title of Moure's book. The full title—*Sheep's Vigil by a Fervent Person*—becomes both title and an indication of Pessoa's authorship. "For in Portuguese, *pessoa* is person," Moure explains, and Fernando becomes Fervent, in honour of the passionate intensity she admires in his work.[45]

In highlighting the alterations that a translator makes to an original text, rather than the semblances, Moure reveals to her audience the phrasal choices, the cadence and clandestine inventions, that are the trusses and beams in any work of writing. She reveals herself as both a reader of Pessoa's poetry and an author in her translations, just as heteronymity foregrounds the performances of readership and authorship over a text. Moure describes translation as "a set of performative gestures implicating the body, performance because the

translator does not enact her body as her own but uses her body to perform 'the author.' Or what we as audience tend unthinkingly to believe is the author."[46] Moure, like Toto in *The Wizard of Oz*, pulls back the curtain to reveal the ordinary man behind the curtain—with his levers and controls—who creates the lights, smoke, and clever voice of the Wizard. Moure notes, "When you read reviews of translated poetry, for example, it is often as if—to be cinematic about it—the nuances of the Joker in the movie *The Dark Knight* were described without mentioning Heath Ledger, or Mankiewicz's *Cleopatra* were discussed with nary a notice of Elizabeth Taylor."[47] Moure's translations reveal their own backstage work, their own acting. She acknowledges the changes that she imposes upon the text and likewise recognizes the changes that Pessoa's and Caeiro's texts have on her.

Richard Kearney, in discussing poetry and the work of the imagination, notes, "Poetry is to be understood here in the extended sense of a play of *poiesis*; a creative letting go of the drive for possession, of the calculus of means and ends.... It is the willingness to imagine oneself in the other person's skin, to see things *as if* one were, momentarily at least, another, to experience how the other half lives."[48] The act of imagination is a necessary condition for empathy. Empathy requires that we project our own circumstances and personalities into the objects of our contemplation. In this way, through an imaginative leap outside of our current or common states of existence, we are able to inhabit a body, a mind, an emotional state, a gender, an occupation, a geographic location, and so on, that we have never—in reality—inhabited. These states are other than us, are different than our own. But, in order that we understand them, they also become likened to what we have perceived previously or what we have a vague sense of knowing. Imagination is not a form of understanding bent toward mastery but toward possibility.

When we imagine and when we empathize we are adrift in metaphorical forms of thinking, in similes. For instance, when we imagine what life might be like as a shepherd, it is "as if" we have guarded sheep. The opening lines to Eirin Moure's *Sheep's Vigil*, Caeiro's Portuguese *Eu nunca guardei rebanhos, / Mas é como se os guardasse*,[49] previously translated by Edwin Honig and Susan Brown as "I never kept sheep, / But it's as if I had done so,"[50] which I would translate (not knowing Portuguese at all) as "but it is *like* I guarded them," is translated by Moure as "What, me, guard sheep? / I made that up; this is poetry."[51]

Literature entices us into becoming mindful of others by requiring that we imaginatively step outside of our conventional lives. The "as if" of imagination expands what is possible. We can become Portuguese though remain

Canadian through our imaginations. We can become male and also remain female when we read, and we can even move back and forth between these binaries and differences altogether. The logic of the imagination is additive: *both/and* rather than *either/or*. By asking us to imagine ourselves "as if" we were an other, literature challenges us to become more than we already actually are.

For Moure, though, even this imaginative work of empathy—the familiarity one has when reading a book that makes it feel "as if" one has had another person's experience—ought not to be fully assimilated. It must be acknowledged that when we act with empathy we are not able to intravenously absorb another's experience into ourselves. The separateness, the leap, that is required in moments of literary empathy, ought, as evidenced in Moure's work, to be acknowledged or maintained. Moure's translations push us to be mindful even in our acts of empathy. If literature, in part, takes us out of what is comfortable, she does not want us to become comfortable in this discomfort, to become complacent in our acts of imagining. Moure reminds us of our hand, our creativity, in trying to understand the world: "I made that up; this is poetry." What Moure does in her translations, and what heteronyms do more generally, is to foreground the work and interplay between the author, character, and reader in producing these moments of "as if" that interrupt established ways of thinking. She highlights the transformative effects of literature's excess on authors and readers, the ways in which texts can bring us more than we can ask for or imagine on our own. Moure claims that when working on *Sheep's Vigil*, "translating was a gesture of excess *person*, of what exceeds the person."[52] This excess *person* next appeared more obviously in *Little Theatres*, Moure's book following *Sheep's Vigil*, with the mysterious appearance of Elisa Sampedrín.

COLLABORATIVE POSSIBILITIES: THE INTERFERING THEATRICS OF A GALICIAN THEATRE DIRECTOR

Since her debut in *Little Theatres*, Elisa Sampedrín's writing has appeared in Erín Moure's *O Cadoiro*, *Expeditions of a Chimæra* (co-authored with Oana Avasilichioaei), *O Resplandor*, and *The Unmemntioable*. Sampedrín has had poetry and translations published in literary journals such as the *Chicago Review*, *West Coast Line*, and *Critical Quarterly*. The contributor pages of these publications reveal her established biography: Sampedrín was raised in Betanzos, Galicia, and trained as a mathematician. Her work in theatre dates from the 1980s and 1990s, and she is known for the creation and

direction of *Teatriños*, a stageless avant-garde theatre company. Since 2000, her work mixes translation, text, and performance in what she calls "textual interference," which she sees as a kind of theatre.[53] Sampedrín has reportedly been interviewed in the Spanish newspaper *Faro de Vigo* in 1981; has been overheard by a stagehand of the Teatro Fausto in Aberdeen, Scotland, in 1984; and was spotted on a Toronto subway train in 1999.[54] In one description of Sampedrín, Moure introduces her style of dress, her possible cultural and religious background, and her troubled reception by a reading public:

> We criticized her for her corduroys, her semitic nose, her ear bangle. We said she was out of touch with the times. We didn't listen to Elisa Sampedrín in 1984; we didn't listen to her in 1991; we forgot about her in 1995, and we spoke against her in 1997. We were in error, really. We might yet profit from listening to her now.[55]

In establishing Sampedrín's existence through geographically specific locations (Spain, Aberdeen, Toronto) at temporally specific moments (1981, 1984, 1991, 1999) through differing media typically considered to be factual (contributor's biographies, news media, reported speech, sight), and in fabricating a previous readerly misconception of Sampedrín's earlier, perhaps controversial, work, Moure is assisting in Sampedrín's interference with, and infiltration into, established non-fictional realities outside the borderlands of her poetry's pages.

This act of interference—for the poetic to deliberately collide with the factual so as to change the course (even momentarily) of what constitutes an established reality—is a chief function of heteronymic writing. The form draws attention to what may well be a hope in all acts of writing: to transform the real life of a reader through the invention and imagination of an author. For instance, in an issue of *West Coast Line*—where supposedly Elisa Sampedrín gave poems to Erín Moure, which Moure then discussed and dissected with Vancouver poet Fred Wah before Wah published Sampedrín's work in the journal—it was noted in her biography in *West Coast Line* that Sampedrín "only interferes in the work of others. She never publishes alone."[56] This collaborative act of Moure and Wah reading, conversing about, and then publishing Sampedrín draws into question the ways in which a poem comes into existence (and is not altogether dissimilar to the collaboration between Häussler and Moos for *He Named Her Amber* at the AGO, which drew into question the collaborations that take place between artworks, artists,

curators, and galleries). Are Moure and Wah, in discussing Sampedrín's work as readers and editors, "interfering" in the poem, or is the poem—and the fictional Sampedrín—interfering in Moure and Wah's practices of reading, editing, and publishing? How could any act of publication take place *alone*? Are not all practices of publication a form of collaboration, an engagement with a public, and a potential interference with a reader's established ways of thinking? The interfering insertion of the *fictional* Sampedrín into the *actual* production of publication draws attention to the inherent ways in which all forms of authorship, readership, and publication are imaginative collaborations. Although concretized as objects of paper and ink or pixel and screen, writing, reading, and publishing begin as imaginings, just like Sampedrín herself. The magic of an imagined thing becoming concrete and of the world, the ways a "regular" life too can be extraordinary and artful at times, is that to which heteronyms keep us attuned.

Elisa Sampedrín's theatre company, *Little Theatres* or *Teatriños*, according to Sampedrín's interviews and descriptions collected in Moure's book of the same name, aims to produce theatrical works that are also not theatrical works but simply reality observed through the framing of a stage; or, at times, theatre that is reality observed without a stage. In this way, even Sampedrín's own philosophical and artistic pursuits in the theatre examine how the lines drawn between what is lived and what is enacted are not as firm as may be supposed:

> In little theatres, everything that happens actually takes place. There's real grass, a real cart making noise, an axle, an arm, fingers. For this reason, the theatre itself is often empty; the action is so quickly over. The only unreal thing is the proscenium, and this the audience thinks will show them what they have come to see.[57]

As is the case with Wittgenstein's observations about the marvellousness of reality observed as a kind of theatre in his letter to Paul Engelmann—mentioned earlier in the discussion of Jeff Wall's staged photographs—there is an "uncanny and wonderful" quality to the kind of theatre that Sampedrín is describing: "Nothing could be more remarkable than seeing someone who thinks himself unobserved engaged in some quite simple everyday activity.... [It would be] more wonderful than anything that a playwright could cause to be acted or spoken on the stage."[58] Sampedrín's observations on theatre suggest that art ought to draw readers closer to reality, not away from it.

Sampedrín's approach to theatre is, she claims, informed by Viktor Shklovsky's observation that art must exist to "make one feel things, to make the stone *stoney*."[59] She writes, "In little theatres, the stone is about as stoney as it can get.... Once the stone is stoney, the play is done. The stone is stoney. Do you get it? Why are you still sitting there?"[60] Ironically, it is through a description of a theatre that does not exist, run by a theatre director who is fabricated by a poet, that the reader comes to contemplate how life, not a fiction or fabricated spectacle, is already significantly beautiful and complex. Audience members may think they need a proscenium arch—or the covers of a book, or the white square walls of a gallery—to experience art, but Sampedrín's *Teatriños* remind us that art also exists in the spaces outside of the theatre: "The play starts now," she insists, "after it's over."[61] The aesthetics behind Sampedrín's innovative theatrical career is an aesthetics of attention. A theatregoer leaves *Teatriños* paying attention to her own life and the connections between the self and the most intricate details of the world: "So even the grass has a voice in little theatres," Sampedrín writes; "While the actor is talking or moving, you can hear it grow. It is not less important in little theatres.... This sound of grass.... When else have there been theatres for the sound of grass?"[62] Indeed, it is not just our observations and attention to other human beings to which Sampedrín wants theatregoers to be alert, but also to the "faces" of more-than-human species of our world as well. Sampedrín extends, in her fictional theatrics, in her aesthetics of attention, a Levinasian ethics.

Foundational to Emmanuel Levinas's concept of "ethics as first philosophy" is the understanding that people cannot help but be responsible to one another in the "face-to-face encounter."[63] Levinas's account of the "face-to-face" encounter serves as the basis for his ethics and for, in his account, all philosophy. The face of the Other calls us into relationality and responsibility with all peoples. Levinas sees the face as a calling to each of us as subjects to "give and serve" the Other; the human face "orders and ordains" us;[64] the Other addresses each of us, calls to each of us, "summons" each of us, and requires our attention.[65] The Other does not even have to utter language for one to feel this "summons" implicit in his or her approach. Yet Sampedrín furthers the intersubjective relationship of Levinasian ethics beyond the human face alone: "In little theatres, there are but faces. Boots are faces, a table is a face, the grass stem has an expression that is facial. When Levinas said 'the face is not of the order of the seen' he was making the right connection, but backward. All of what is seen are faces."[66] Levinas's

first philosophy does not include non-human entities. Sampedrín's version of Levinasian ethics recognizes an ethical call in *all* entities, not just the human: things too require our attention and our reciprocal dialogical care; things too have faces that summon us.

Although Sampedrín is a fictional entity, she is engaging with complex philosophical concepts of ontology and ethics and, indeed, *adding* to Levinasian thought. That Sampedrín cares for non-human entities in her philosophical ponderings is not entirely surprising, for what is she? Is Sampedrín human? Or does she have more in common with the boot or the blade of grass? What of those entities we can't clearly *see*, like Sampedrín herself? Sampedrín's engagement is both an ethics and a question of her own ontology, or, more broadly, the ontology of all fictional, imagined, and unseen creatures that could be said to inhabit this world. Sampedrín's engagement with Levinas extends potentially anthropocentric acts of attention and care to the other-than-human.

Sampedrín, like Caeiro, is a thinking entity. The heteronym is not created simply as a lark but as a vessel, a voice, for authors such as Moure and Pessoa, by which they can explore theoretical terrain that, in their habituated poetic voices, may feel uncharacteristic to themselves and to their omnity, to what they write under their own authorial names. Through Sampedrín and her fictional theatre, Moure is able to focus on the philosophical implications of grass blades and first philosophy, of boots and the summons of the face: a theoretical terrain and a literary form that may not have occurred to Moure thinking in her own habitual languages and in her own point of view. In contemplating ideas of Otherness through a voice outside of Moure's own habituations—through Sampedrín—Levinas's philosophical thinking is embodied, tried out, and lived in Moure's heteronymic form. The uncharacteristic and the surprising, the "interruption" of the Other is present in Moure's acts of thinking through a mind and voice beyond what is, for her, ordinary. The heteronym, in a sense, stands in for the dialogic relationship of the Other. If, as Sampedrín is arguing, the non-human blade of grass has a face that interrupts our habituations—our "sameness" as Levinas calls it—then the heteronym too, as a not-fully-human entity, as an imagined character, has the capacity to call her creator and her readers into an ethics as an Other.

In Levinasian ethics there is the understanding that the physical presence of the Other is needed in order to interrupt our sameness, but the heteronym potentially suggests that we also have the capacity—through the poetic imagination, through the fictional imagining of a character—to surprise ourselves out of the ordinary, out of our sameness. Levinas is skeptical of writing as a

means of this kind of ethical interruption because writing is not a face-to-face encounter; there is no direct Other that we are presented with, in the flesh, when we read written language. Spoken words, on the other hand, according to Levinas, have a stronger capacity for ethical exchange. As Gerald Bruns notes,

> for Levinas, of course, the priority of sound over semantics is meant to indicate the event of sociality: sound means the *presence* of others making themselves felt in advance of what is said. Sound is not the medium of propositional language but of other people. More than this, however, the sound of words is an ethical event.[67]

Yet, Bruns also notes that Levinas's ethics may include the concept of an alterity with our own selves, which, at times, and possibly through the creation of art, does have the capacity to interrupt us in ethically meaningful ways: "*even when I myself speak*—even in self-expression—I am no longer an 'I', am no longer self-identical, but am now beside myself: 'To speak is to interrupt my existence as a subject, a master.'"[68] Thus, when Sampedrín "speaks," or thinks, or theorizes, as a heteronym she interrupts Moure as a solitary subject, as a master of a text.

Erín Moure notes of Alberto Caeiro that he is a poet who gives us "his philosophy" but that Caeiro does this philosophizing while also "having fun, dissimulating, and goading his fellow poets."[69] Sampedrín too gives us her philosophies but also has fun, dissimulates, and goads Moure. For instance, the first encounter one likely has with Sampedrín when one picks up a copy of *Little Theatres* is not her poetry in the peritext of the book but an epitextual blurb on the book's back cover. Sampedrín's blurb for potential readers of Moure's book, however, would be considered by most publishing houses to be utterly substandard promotional material. Sampedrín writes, "Moure: where have I heard that name before? I thought she'd left. What on earth is she up to now?"[70] Sampedrín's awkward observations could hardly be considered a recommendation for a reader to purchase or read Moure's work. The blurb suggests obscurity, a forgotten poet. Any indication of fame or notoriety that epitextual book blurbs tend to advertise is absent from Sampedrín's lackadaisical, even insulting, suggestion of Moure's waning literary prominence. Sampedrín acts as a foil to Moure. If the poet begins to believe that she is the centre of attention, the sole agent of creative power in the production of a book, the heteronym is there to remind her that she may be less important than she thinks: a book is a collaborative event between author, reader, publisher, and

language itself. The author is not a solitary subject, is not the master of her text, is not even its sole creator: she is a participant in a book's creation, she is one voice in a conversation.

As a poet, theatre director, and book blurb writer, Elisa Sampedrín draws attention to the collaborative aspects of authorship through her acts of interruption, but it is through her work as translator—particularly in *Expeditions of a Chimæra*—that Sampedrín's chaotic force dizzies readers, and her author, into seeing the strangeness and complication of translating one language into another, and in writing in our own languages at all. *Expeditions of a Chimæra*, co-authored by Oana Avasilichioaei and Erín Moure, "with interferences by Elisa Sampedrín,"[71] begins by explaining Sampedrín's hand in a series of translations that encompass the first section of the book: "It appears that in the 1990s Elisa Samepdrín spent time in Romania, where she fell in with the poems of Nichita Stănescu and attempted, with no knowledge of Romanian, to translate them into English, which she was also unfamiliar with."[72] *Expeditions of a Chimæra* never reveals Sampedrín's heteronymic status, nor is the fictive status of another newly created heteronym, Otilia Acacia, revealed. (It appears that Genette was right when he described heteronymity as a habit "very much like the drug habit, quickly leading to increased use, abuse, even overdose,"[73] for Erín Moure's encounter with Fernando Pessoa's heteronym Alberto Caeiro led to the creation of her own heteronym, Elisa Sampedrín, who, in turn, inspired Oana Avasilichioaei to create the heteronym Otilia Acacia, whose first appearance is in *Expeditions of a Chimæra*). One clue to Acacia's heteronymic status, however, is the fact that she, as Sampedrín did for *Little Theatres*, blurbs the book: "*Expeditions of a Chimæra* is simply a joyful romp in poetry, and a thoroughly disreputable book."[74] *Expeditions of a Chimæra* then becomes a tangle of different voices, authors, and translators, some of whom corporally exist, others who are imagined, all interfering with language itself through unconventional acts of translation.

Because there are so many authors and heteronyms meddling with the translations on each given page of *Expeditions*, the authors have placed footnotes beneath the translated poetry to help "explain" the wormholes riddled throughout the text. The explanations, however, do not make the process of translation or authorship clearer; rather they read as though one is slipping further away from any kind of commonplace understanding of what translation, or, indeed, writing, entails at all. Note 1, for the poem "Prajina/Cotetul, *restored to Romanian by O.A., from the English of E.S.*" states:

Because Elisa Sampedrín erroneously translated, in the previous piece, a poem by Nichita Stănescu that had not been written in the first place, Oana Avasilichioaei, Stănescu's Canadian translator, was obliged to translate backward, and create the original Stănescu poem we have here.[75]

Note 2, for the poem "Coatful, *tr. E.S. from the Romanian of O.A.*" states:

The problem with Avasilichioaei's translation backward in time into the original Romanian of Sampedrín's translation entitled "The Roost" is that it renders Sampedrín's purported translation *accurate*. And we all know that Sampedrín does not know Romanian.[76]

Note 3, for the poem "Prank/1:45, *by E.M.*" states:

Maintaining her insistence that Sampedrín's translations are impossible, and are in fact not hers, Moure claims this to be the original poem, and refutes any resemblance to Stănescu's work, though allows for the possibility of coincidence between her original poem and Avasilichioaei's translation of the translation of Stănescu's poem.[77]

Note 4, for the poem "Jocul/1:45, *tr. O.A. from the English of E.M.*" states:

Avasilichioaei distrusts the notion that an original ever existed or could exist, but admits, when pressed, that a translation is an original, and that she has access to the only true translation of Moure's poem, which she attempts here to restore into the language of Stănescu. At least we now have this original, and are relieved.[78]

The result is a layered and circling logic that defies linear thinking and any notion of an authentic "original" that can be captured through translation. It is precisely what cannot be captured through translation that becomes the focal point of the book, alongside the anomalies and contradictions of relationships between authors, heteronymic or otherwise. As Moure—riffing on Roman Jakobson—writes:

The communicative function of language is not the only function, and it's probably not the most powerful or important. The poetic function—the function that ties rhythm, the body, our mothers, the unconscious (which

does not fear contradiction)—bears us hard up against the boundaries of the communicative function, allows us to push it further, to break past it.... As physics shows us, evolution and change occur as a result of disruptions, anomalies, and contradictions, not as a result of a continual line of order.[79]

Moure is identifying, in this passage, and in the convolutions of translation found in *Expeditions of a Chimæra*, how, in Jakobson's categories, the Poetic Function of language can complicate our more commonplace functions of communication—such as the Referential or the Conative—because the function of the Poetic is to interrogate what language is and to test the limits of the capacities of language's varying forms.

While the Referential is descriptive of our world (e.g., *The cherry trees all along Bute Street are in bloom*) and the Conative calls one to do something particular in the world (e.g., *Anna, please pour me and Pooh Bear more tea*), the Poetic asks *how* we describe what is outside of us, and in what ways the forms of language can influence, complicate, and mediate our human experiences. The Poetic may even go so far as to ask whether language is even *capable* of communication. Can language express the contradictions and convolutions of our hearts, our unconsciousnesses, our bodies? Can language disorder as much as order us? The Poetic asks whether we can translate backward, and whether we can translate a poem that has not even been written in the first place. The Poetic draws attention to language's workings on us, just as a heteronym draws attention to authorship's workings on us, and just as the circular linguistic mazes of Moure, Sampedrín, Avasilichioaei, Acacia, and Stănescu draw attention to the forms and functions of language (as much as the deformities and malfunctions) that we might encounter when entering into acts of translation.

Sampedrín acts as a force of interference and disruption, but her meddling in translation—as with her meddling in poetry and theatre—is not without cause. As a heteronym, Sampedrín pushes Moure and the reader to look at language outside of habitual patterns, and to question the authority entrusted to language and to the figure of the author. Translation—particularly the translations that Sampedrín performs between two languages in which she is not fluent—has the ability to "disturb English in beautiful ways, and disturb the authenticity process."[80] This disturbance of the "authenticity process" is also exemplified in the collaborative nature of *Expeditions of a Chimæra* and in the collaborative work of heteronyms more broadly.

Collaboration is inherently disruptive of authoritative or singular authorship. Collaboration is as contingent on listening as it is on writing or

production due to the fact that the already relational properties of language are inevitably amplified through collaboration: "Language exists because of the necessity of dialogue between two beings. Language is only because it moves from me to you to her to me, etc."[81] Moure and Avasilichioaei describe how, in order for the dialogic action of collaboration to work, one must become equally absorbed by listening as one is by writing, telling, or speaking. The pair also describes how one might initially think of listening as an inactive position; yet, in collaboration "listening becomes acute. One must listen with the whole body, not just the ears. Listening is an active act—involves response, for you have to show you are listening—and an agreement to constantly risk the unknown, to feel destabilized and out of this instability be willing to create new connections."[82] In the case of *Expeditions of a Chimæra*, Moure is in collaboration with Avasilichioaei; thereby they must listen to each other and risk being destabilized by each other to create the translations and poems in the book. But Moure and Avasilichioaei are also in collaboration with Stănescu, whom they are translating, and in collaboration with Sampedrín and Acacia, their heteronyms. They are in collaboration with multiple languages, many of which each author and heteronym do not fully grasp; languages, which, it could be argued, are never fully graspable. Language escapes us, makes us, changes us. As Anne Carson writes, with a nod to Gertrude Stein, in her introduction to *Autobiography of Red*, "Words bounce ... words will do what they want to do and what they have to do."[83] It is precisely this unruliness that Sampedrín and her cohorts in the creation of *Expeditions of a Chimæra* celebrate. The vulnerability and lack of control inherent to authorship is also what heteronyms exemplify.

The idea of an author listening to a character or a character destabilizing an author into taking new creative risks at first sounds preposterous. How could a non-living entity, which an author is creating in her head, become a collaborator, an outside force of influence and instability? Is the author not in control? Yet both Fernando Pessoa and Iris Häussler describe the personas of Alberto Caeiro and Mary Amber O'Shea as forces that are not within their strict command as authors and artists. In fact, both Pessoa and Häussler speak of how character creation—when understood as collaboration rather than a form of artistic control—can be freeing: "They [my heteronyms] explode within my mind in a manner of seduction," Pessoa describes;[84] "it is like taking off a corset," says Häussler.[85] To be interrupted and changed by what (or whom) we write has the potential to be far more exhilarating than understanding authorship as a means of mastery.

As the relationship between Moure and Sampedrín indicates, the potentiality for collaboration over corroboration exists in heteronymic authorship. Yet heteronyms, like hoaxes, are performed with varying intentions, functions, and outcomes. While the heteronyms of Erín Moure and Fernando Pessoa "know each other, influence each other, and criticize each other's works,"[86] their Greek heteronymic counterpart, Andreas Karavis, tends more often to conspire with his creator, David Solway, in order to strengthen and buoy Solway's existent concerns about the state of Canadian literature and his own poetic position in the country's literary landscape.

CRITICAL POSSIBILITIES: A GREEK FISHERMAN SUFFERING FROM THE "MALADY OF ATWOODISM"

In October 1999, *Books in Canada* ran a lavish spread on a newly discovered contemporary Greek poet, Andreas Karavis. Montreal poet David Solway had encountered Karavis's poetry while travelling throughout Greece and began work on the English translations of Karavis's two published books in 1993: *White Poems* (*Aspra Poiimata*, self-published by Karavis in 1965) and *The Dream Masters* (*Oneirou Kyriarchi*, published by Ikaria Press, Athens, in 1989). Solway writes in *Books in Canada* of his first encounters with Karavis's poetry: "When I first came upon *White Poems* in the dhimarcheion of Amorgos, I knew with growing conviction as I read from poem to poem, as if I were travelling from island to island, that I was listening to one of the most interesting and original voices in modern Greek poetry."[87] Solway published his English translations of Karavis's poems in North American journals such as the *Antigonish Review* and the *Atlantic*. In *Books in Canada*, Solway writes of the poet's "astonishing popularity with Greek readers, both among the literati and the common people" and the article touts Karavis as "Greece's modern Homer."[88]

In 2000, Solway's English translations of Karavis were published in monograph to celebrated reception. Yiorgos Chouliaris, press attaché to the Greek embassy, hosted the launch of *Saracen Island: The Poems of Andreas Karavis* at Molivos, a Greek taverna-style restaurant in downtown Montreal.[89] "The embassy," Solway noted, "wanted to highlight the two-way relationship between the Canadian imagination and the Greek imagination."[90] Ben Downing reported for the *Guardian* that the notoriously private bard appeared to have briefly attended the reception: "a man claiming to be Karavis, and who certainly looked and sounded the part—he muttered in Greek and wore

a fisherman's cap—had dropped by briefly."[91] To all present, it was clear that an important new voice in contemporary poetry had been discovered. In the year following *Saracen Island*'s release, interest in Karavis mounted, instigating the publication of an academic monograph dedicated to the poet. *An Andreas Karavis Companion*, compiled by Solway, includes rare interviews, academic papers, and biographical details about the poet's life. Yet, despite the appearance of the poet at the party, despite the embassy's affiliation with the book launch and the legitimizing academic apparatus of a published companion, *Globe and Mail* reporter Matthew Hays eventually revealed that "Karavis is actually a literary hoax—Solway's invented alter ego."[92] Andreas Karavis is the heteronym of David Solway. The man posing as Karavis at the party? Solway's family dentist, Mel Heft.[93]

Unlike Erín Moure—who refrains from commenting on Elisa Sampedrín's purpose as a heteronym or even publicly acknowledging her authorship of Elisa, which assists Sampedrín's individuality and autonomy as a poet—David Solway has published numerous essays on Andreas Karavis's raison d'être. Solway's commentaries offer three distinct rationales for writing and publishing heteronymically: to refresh and enliven Solway's writing practice; to gain notoriety that Solway feels his poetry deserves but that has yet to have been achieved with a broad Canadian readership; and, paradoxically, to critique the notoriety that reading publics give to other fellow Canadian poets, whom Solway deems "dull," "bland," "torpid," "drab," "slack," and suffering the "malady of Atwoodism."[94] All three of Solway's incentives for publishing heteronymically reveal the complications of what Donald Foster, a scholar of authorial attribution and anonymity, describes as "the changing nature of a writer's proprietary interest in his or her personal name, and of the uses to which that name may be put by others."[95] In fabricating an author and then commenting publicly on the outcome of Karavis's appearance, Solway draws attention to resultant choices of authorial attribution, and the accompanying, if erratic, bestowal of fame.

In his essay "In the Name of the Author," Foster suggests that as copyright developed in Britain a market began to develop for texts officially attributed to particular authors' names. The public's associations with an author's name began to determine the commodified worth of an author's work: "Professional authorship emerged in Britain as a road to celebrity status."[96] Poets and essayists began to perceive "the degree to which authorial control of the attribution function may shape not only the meaning of the text but the trajectory of a professional career,"[97] and clever authors began to

choose anonymity, pseudonymity, and omnity for individual works as best served their livelihoods and reputations. What Solway does in revealing and acknowledging his choices of omnity and heteronymity throughout his literary career is to instigate a public conversation about the experience of professional authorship along with its limits, frustrations, and, as he sees it, the development of a "spiritual lethargy" in the writings and readings of Canada's best-known authors.[98] Solway perceives his creation of Karavis to be an antidote to "all that is depressing and parochial and unadventurous in Canadian life and letters."[99]

Solway has described Karavis as a "mentor" who took over his life with "rhetorical exuberance."[100] This mentorship and exuberance was primarily instigated through a new poetic voice—the voice of Karavis—that jolted Solway out of his own habitual poetic style that he had become mired in while writing over the past decade: "I knew that, as happens at least once in the career of every poet, I had arrived at that curious writing juncture which may be described as both impasse and crossroads."[101] Solway connects this impasse to a repetition of tone and style that he began to notice in his published work as a poet: "My previous book, *Chess Pieces*, following on *Bedrock* and *Modern Marriage*, represented the end of what I call the "psychic decade," a period of eight to twelve years in which poets tend to consolidate their verbal deportment and to begin impersonating themselves."[102] Karavis came into being, Solway describes, "in order to change my poetic style and voice," after Solway had come to the conclusion that "the elaborate poetics and tendency to the cerebral that had marked my work for many years had to be replaced by a new language that engaged the world more directly."[103] One can see that a change in poetic style and a move to language that engages the world more directly does indeed surface with Solway's shift from omnity to heteronymity when comparing two poems published in the *Atlantic* by David Solway just four months apart—"The Dream," attributed to Solway, and "Credo" ultimately attributed to his heteronym and included in *Saracen Island: The Poems of Andreas Karavis*.

In "The Dream," published in December 1997 under Solway's own name, the poem is so unearthly and "cerebral," as Solway describes his work, as to be about a dream dreamt inside a dream, nearly, perhaps, dreamt inside another. The first-person narrator in "The Dream" repeats a refrain upon waking—"I dreamed that you had ceased to love me"—three times within the fifteen lines of the poem, creating a repetition that becomes incantatory, nearly soporific. There are only a few concrete nouns scattered throughout

the poem: beds, a lover's heart and eyes, and an oast (a kiln used for drying hops). Yet even these concrete objects lack a heft or vibrancy in how they are employed: the beds are imagined, the heart is stopped, the eyes only glanced at, and the oast becomes a symbol of confusion and destruction, the opposite of a future made plain. The poem's logic is rooted in the painful paradox of willed action verses the uncontrollable, unwillable, sensations of dreams. Despite the speaker repeatedly "willing" him-, them-, or herself "awake," upon waking, they find themselves possibly, nightmarishly, still inhabiting a dream, unable to identify felt emotions, not knowing if "it / was terror or relief I felt."[104] The dreams' meanings, like the speaker's felt emotions, are unstable. The poem resides in the interior life of the speaker, not particularly engaging in the daily or concrete.

In contrast, "Credo," published in the *Atlantic* in March 1998 and ultimately attributed to Andreas Karavis in Solway's *Saracen Island*, departs markedly from the heightened phantasm and ephemeral diction of "The Dream." Unlike in "The Dream," concrete nouns abound in nearly every line. "Credo" is a poem in attendance to the landscape. The poem personifies the physical world, giving objects and animals vocational tasks: the sun is personified as "a blacksmith" leaving "its hammer print / on the cliffside," stars flash "like knitting needles," the smell of "quince and oleander" is described as "sabbath incense," a pregnant cat "wobbles by / like a fishing boat." The painful unattainable loop of self-inscribed longing in "The Dream" has been transformed into a vibrant contemplation of the elemental in Karavis's "Credo," reminiscent of Pablo Neruda's odes wherein the spiritual is revealed in the concrete: a simple grain of salt as a "translucent cathedral,"[105] or a rider whirring a bicycle back to life with his pedalling as an image of resurrection.[106] Karavis's "rhetorical exuberance" is clearly discernible in the shift of tone and technique apparent in the two poems, published only four months apart. Yet Solway claims that "there was no doubt in my mind that had I published these [the Karavisian-style] poems in a book issued under my own name, the most I could have expected would have been a brief *réclame* followed by oblivion."[107]

The choice to publish works outside the scope of *omnity* (whether anonymously, pseudonymously, or heteronymously), although varied and dependent on individual circumstance, has often been used as a means of avoiding public scrutiny or notoriety: "Memorial poems were typically issued without attribution as a matter of decorum because the object of elegy was to glorify the deceased, not the poet. Writers of satires and epigrams often remained

anonymous if only to escape resentment or epigrammatic paybacks."[108] For Solway, to write heteronymically and, after receiving positive reception for the Karavisian poetry, to acknowledge his hand in the creation of both the work and the "poet" is, on the contrary, a means of gaining notoriety.

Solway writes of the delight he took when he "was informed by a reasonably well-known Canadian poet/editor at a party one evening that in her estimation Karavis was indeed Nobelizable," and when another poet, "who must have stumbled across an obscure translation somewhere, confided that Karavis had exerted a significant influence on his development."[109] Solway's "proprietary interest" in Karavis's name increases concomitantly with the bardic fisherman's rising popularity with Canadian readers. Upon his attribution and association with Karavis, Solway's notoriety extends to his non-Karavisian works: "After years of systematic neglect I recently discovered, while browsing the Vancouver Public Library's web page for new acquisitions, that I was now 'the noted poet.' Quite a metamorphosis."[110] These examples demonstrate how Solway manages the attribution function of Andreas Karavis to the advantage of his professional career. Had the public not liked Karavis's poetry, Solway could have responded that the whole project had been a joke and pointed out that the critics ought not to take themselves so seriously. However, in light of the poems being well received, Solway is able to revel in his hand in the trick, eagerly accepting praise, for instance, from "another Canadian writer, who had never commented one way or another on my work before" who "sent congratulations for my bringing so visionary and 'big-voiced' a poet into a diminished poetic landscape."[111]

In his essays and commentaries on his heteronymic project, Solway openly admits to desiring public recognition. He likens his position as poet, before the creation of Karavis, to "certain artists, deprived of audience and venues" who "wear out the years, however safely, in exile."[112] Solway accepts rather than shies away from the publicized claim that Karavis is Greece's Modern Homer by acknowledging his personal stake in that "variant of every poet's epic dream: to find some day, as one comes to anchor in a strange yet familiar and desired latitude, the blind dog of recognition stirring on the hearth."[113] Solway acknowledges, "I needed Karavis in order to materialize on the plane of literary existence in this country since the passion for linguistic variety and architectonic discipline when manifested in one's own work is the kiss of death here."[114] Solway also describes Karavis's work "as a sort of *moly*, a drug intended to combat the arid, sanctimonious, overly earnest and Presbyterian atmosphere in which much of our own literature malingers."[115] According to

Solway's descriptions of Karavis, the heteronym operates as a contradiction: Karavis is instigated to insult Canadian readers whose approval Solway also admittedly seeks.

One of the most exciting aspects of heteronymic writing is the ability of the heteronym to surprise and to surpass previously held expectations of the capabilities and capacities of an author's established poetic voice. The heteronym appears and, as Solway himself notes, there is a "tenor of play, of different possible outcomes, of seductive risk rather than suffering endurance, of defiant otherness rather than complacent identity, of all that is possible and plural and exalted rather than what is single-pleated and given and common-place."[116] Frequently, when Solway writes poems as Karavis—as evidenced with "Credo"—this plurality and possibility is foregrounded in the poems' playful experiments and rich differences from Solway's own established poetic voice. However, as soon as Solway steps in to define and defend Karavis's existence in his numerous essays on the purpose and point of his heteronym's creation—whether published in newspaper articles and journals or at work in many of the reported interviews and conversations in *An Andreas Karavis Companion*—the risk and play of the project quickly become diminished and demarcated by Solway's own concerns, jealousies, and obsessions.

One target of Solway's criticism is Margaret Atwood, or at least what he perceives she stands for in terms of the state of Canadian literature. Solway writes, "Karavis is meant to counteract the malady of Atwoodism that we suffer from in this country, the coast-to-coast slackness and blandness that devitalizes so many of our writers."[117] He compares Canadian writers to those from Greece: "Total strangers to attic salt, we tend to look askance on anything that resembles creative friskiness or the innovation of stylistic heterocosms since these distract us from the drab and subfusc literary mise en scène we have comfortably settled into,[118] likening Canadian aesthetics to what is boring and comfortable and "attic" aesthetics to what is creative, innovative, and "frisky." Solway describes Atwood's literary productions as "predictable, unvarying, wooden, truncated, connotatively flaccid, oddly *nasal* in their timbre, and devoid of real signifying power because relying for their effect on a near-perfect correlation with the cultural temper of an audience desperate for corroboration."[119] Yet, aside from producing a base and gener-alized reading of decades of an author's work without reference to a single line or image to support his "critical" conclusions, Solway forgets that when the "cultural temper of an audience" turns toward his own work he is not dismayed. Atwood's pre-eminence in Canadian literature, which Solway rails

against numerous times in his essays about Karavis, is linked to the authorial notoriety that Solway seeks. The commodification and branding of authorship that has come with Atwood's Canadian and international success may well be at the heart of Solway's heteronymic attack, but Solway also clearly takes pleasure in being recognized as a "noted poet" by the same readership who borrow, buy, read, and consume literature, including—presumably—work by Atwood. He does not consider that the praise might indicate that his work too has become "predictable, unvarying," and "wooden." Instead, Solway is glad for the corroboration between Karavis's work and the tastes and tempers of readers.

In pitting Karavis's work against Atwood's, there is an implication that Solway believes Canadian readers are drawn to Karavis for different reasons than they are drawn to Atwood. Solway's belief that Karavis can surprise readers and give readers a jolt of vitality is linked—in problematically stereotypical ways—to an idea of the vitality of an exotic other. Solway's claims about Karavis's popularity in Canadian literature rely on the exoticization of Southern Europeans as "hot-blooded" and "passionate," as opposed to cold Northerners as "frigid" and "unfeeling." Throughout Solway's descriptions of Atwood's poetry as compared to Karavis's poetry is the implicit juxtapositioning of the cerebral, careful, Canadian poet against the earthy, bodily, passionate, and more risk-taking Greek poet found in Karavis.

Solway's choice to single out Atwood in his derisive attacks on Canadian literature is, no doubt, deliberate. As Lorraine York writes in *Margaret Atwood and the Labour of Literary Celebrity*, Atwood "possesses a considerable amount of cultural capital," she is "a star," and she is considered by many readers to be "a literary hero."[120] Atwood, it could be argued, is the leading figure of literary fame in Canada, and therefore, given Solway's admitted lack of fame, his perceived antagonist. Along with public recognition, Atwood also stands for traits in Canadian culture that Solway finds artistically impeding, just as, for Solway, Karavis stands for liberating traits found in Greek culture: passion, masculinity, virility, risk. However, given the vehemence and focus of Solway's attacks on Atwood, and given that one of the "Greek" traits Solway finds most remarkable in his interactions with Karavis is a celebration of traditional gender divisions between men and women and an upholding of strident patriarchal culture, one cannot help but wonder whether Solway's critiques are actually directed not at a poetic style but at a gendered person. It appears that Solway has, in part, invented Karavis—based on problematic racial stereotyping—in order to denigrate Margaret Atwood, who for

decades has been an icon of feminism, and to mourn a dissolving patriarchy for which Solway feels nostalgic.

The venom that Solway has toward Atwood's cerebral style and feminist agenda also feels rather ironic in a current cultural climate where a variety of contemporary feminist writers have recently criticized Atwood's public voice as a liberal feminist thinker. When Atwood signed the online UBC Accountable open letter condemning the University of British Columbia for firing the novelist Steven Galloway for what an internal investigation called "serious allegations" about his conduct as the Chair of UBC's Creative Writing Department, her status as an icon for Canadian feminist writing and thinking significantly wavered. In the era of #MeToo, Atwood's name on the letter affronted feminists and emerging writers who saw her offering her support to an established male author who held a position of significant institutional power, rather than supporting the complainants. Contemporary feminists have criticized Atwood for not recognizing systemic power structures (wealth, class, race, fame, non-inclusive gender binaries, institutional hierarchy, etc.) that affect one's experience as a woman. Nor has Atwood recognized her own position of privilege within Canadian literature, and the effect her fame and notoriety have on the lives of emerging writers under duress as they strive toward success in their chosen field of creative writing. When defending her signature affixed to the UBC Accountable letter, her comments do not engage in intersectional feminist thinking as she makes presumptive public statements on other women's lives and experiences.[121] Many contemporary feminist thinkers regard Atwood's signing of the UBC Accountable letter as an act that protects hierarchies of gender, privilege, and institutional power rather than rebelling against the damage these hierarchies cause, in direct contrast to the message of her earlier feminist works such as *The Handmaid's Tale*.[122] These days, Atwood and Solway may have more in common than Solway's initial anti-Atwood tirades might indicate. Regardless, Solway's directed animosity toward Atwood and fellow feminist thinkers becomes funnelled through Karavis's voice in ways that I do not consider, as Solway does, to be a "benign" use of a heteronym.[123]

Susanna Egan, in *Burdens of Proof: Faith, Doubt, and Identity in Autobiography*, writes of David Solway's heteronymic project, "I want to acknowledge the Karavis situation as sheer fun. It highlights the trickster element inherent in so much fraudulent activity, about which I have from time to time been adopting a more reproving tone."[124] Solway too describes Karavis as "fun, a property that doesn't exactly abound in our literature" and

as "essentially benign."[125] But there are distinctly patriarchal and culturally stereotypical resonances in Solway's literary criticism surrounding Karavis's biography that make the "Karavis situation" not simply "sheer fun," as Egan and Solway suggest. What becomes particularly concerning is when Andreas Karavis ceases to be a refreshing jolt to the expected *omnity* of Canadian literature, or an inspired shift to Solway's own poetic techniques, and instead becomes a mouthpiece for what appears to be Solway's own patriarchal bias against women writers and his own racial assumptions about Greek culture. Solway's bias is then mirrored and fortified in his stereotypical presentation of Karavis as "suitably manly and Greek,"[126] a poet who is "traditional" in his opinion that "men and women are profoundly determined by their fixed, biological make-up,"[127] and who, during a visit by Solway to Greece, is dismissive of the work of feminist theorists—such as Judith Butler, Donna Haraway, Julia Kristeva, Hélène Cixous, and Luce Irigaray—all of whom Solway lumps together in a single afternoon's discussion with Karavis at the beach. Karavis, Solway reports, responds to contemporary feminism with dismay, calling feminist and queer theorists "old cows," a "coven of sour Podarges, dripping venom rather than honey," and "parasites and trouble-makers."[128] Upon hearing about concerns feminist thinkers raise with regard to sexuality and gender, Karavis speculates that "we really are at the end of days."[129] One could read these responses, as Egan does, as an "elaborate mimicry of scholarship" that "calls conventional scholarship into question—and to account,"[130] yet the scholarship of Butler, Haraway, Kristeva, Cixous, and Irigaray could hardly be considered "conventional." If Solway had wanted to mock conventional scholarship, feminist and queer theory would not be the most obvious target. In fact, Solway's mockery of feminist and queer theories through the mouthpiece of Karavis points to a respect, or at least a nostalgia, for more traditional, "conventional" modes of thinking about both gender and scholarship. The misogyny of Karavis's claims are so closely linked to Solway's own complaints about Atwood, and female writers more broadly, that it is impossible to interpret Karavis's poems as parodying, rather than reinstating, patriarchal opinions.

Diana Fitzgerald Bryden notes in her review of Andreas Karavis's *Saracen Island* in the *National Post*, "There are some hilarious moments of machismo: Whitewashed walls are 'mixed from the seminal lime' and, in Karavis's idealized past, 'young girls, intact for marriage, / blessed their men in every dialect.'"[131] Fitzgerald Bryden asks, "Is this as funny if Karavis is himself and not Solway?"—suggesting that the instances of parody in Karavis's poetry are

built on North American stereotypes of an aging Mediterranean patriarchal culture—"Is this what Solway expects us to expect from a typical Greek poet? Or is this what he would expect?"[132] When Karavis discusses "young girls / intact for marriage" does the sentiment become quaint and forgivable because it is presented as foreign and antiquated? How would the lines change if written under Solway's own name, or if the poem was set in Canada? Where does the persona of the heteronym end and where do the opinions of the author begin? Is employing Karavis as a heteronym simply a mask that makes Solway's sexist opinions somehow more permissible because they come from an octogenarian Aegean? A heteronymic project that draws attention to inaccurate assumptions that readers may have about culture and gender in order to critique, rather than re-inscribe, stereotypes is an exciting use of the literary form. However, I fear that Solway has not envisioned Karavis's machismo to be the object of critique, but rather as a fictional escape from the "the ideological storms now agitating the literary and academic climate in the West ... with that cluster of disciplines grouped under the rubric of Gender or Cultural Studies" that so anger and frustrate Solway himself.[133]

For instance, the patriarchal resonances in the dismissal of Atwood's poetry tend to be written in Solway's voice, not in Karavis's. It is Solway who describes Atwood's literary style as "flaccid,"[134] while he notes that Karavis's is "hard."[135] It is Solway who describes Atwood as a "dowager"[136] and Karavis as a "renegade."[137] However, there are also moments when the cultural, gendered, and stylistic concerns of Solway bleed troublingly into the voice of Karavis. Although it is Solway who states, "Thus I slowly came to regard Andreas Karavis, from a Canadian perspective, as an antidote to the spiritual lethargy of many of our best known writers, in particular Margaret Atwood,"[138] the quotation continues—through the use of a conditional construction followed by Karavis's reported speech—with Solway employing Karavis's language to corroborate his already-held opinions of Atwood's work: "the goddess of dullness (whom Karavis would have called *akoskiniti*, which is to say 'unsifted')."[139] In this subtle grammatical shift, Karavis, as heteronym, is employed to confirm Solway's opinions, adding his voice, and his language, to Solway's critical chorus. Thus, in orchestrating a heteronym that is compliant, Karavis's ability to shake Solway from his regular poetics and political outlooks is nullified. Derek Attridge observes that there are "parallels between responding to the other in the process of creation and responding to the other in the form of a person; in both, respect for the singularity of the other involves a willingness to have the grounds of

one's thinking recast and renewed."[140] When Solway's opinions bleed into the voice of Karavis, the heteronym's singularity is lost. The grounds of Solway's thinking are not recast but reiterated. The otherness of Karavis begins to become Solway's deferential same.

David Solway's choice to inscribe Andreas Karavis with his own biases is not, simply put, as *imaginary* as letting Karavis define his own fate through poetic and philosophical divergence and variation. Solway's self-identity, in many ways, remains more important to him—particularly in connection to his desire for literary fame—than does keeping Karavis strange, divergent, and not entirely knowable. Kearney describes the work of imagination as a refusal "to sacrifice the strange on the altar of self-identity."[141] Elisa Sampedrín and Alberto Caeiro stretch the identities of their authors by instigating an encounter with alterity. The function of Sampedrín and Caeiro is, in part, to surprise both their authors and their readers with difference. Ultimately the heteronyms of Erín Moure and Fernando Pessoa enliven the scope of their authors' habituated thoughts and poetic forms. The heteronym reminds authors that they are not solely in charge of a text's creation and interpretation, and this lack of authority can be understood, when embraced, as a liberation. As Derek Attridge notes of ethical relationality,

> To act morally toward other persons entails, it hardly needs saying, as full an attempt at understanding them and their situation as one is capable of; yet both the primary claim of another person upon one and the final measure of one's behaviour lies in the response to, and affirmation of, the otherness which resists that understanding.[142]

Attridge's claim extends to reading and to writing. A heteronym, like Moure's description of translation, "involves permeability, not equivalence. It involves the formation and reformation of identities" and is "always already unstable. And thus fruitful. And political, because even to make these claims ... solicits a discomfort, a backlash."[143] Art, it can be argued, works best when it counters the assurance of the ego, when it shakes us from comfort. Andreas Karavis has this potential. But, because Solway, godlike, creates Karavis in his own image, Karavis's possibility, plurality, and defiant difference become less potent, less, as Karavis might say, virile.

In one of his essays in the series "How Poems Work" published in the *Globe and Mail*, Carmine Starnino—whom Solway describes as "my accomplice"[144] in the creation of Karavis—dedicates an essay to Karavis's poetry,

writing, "The real question (one rarely discussed in the uproar over the pseud-onymous source of all this material) is whether Solway's mischief offers the satisfaction of real poetry."[145] Despite Karavis gaining more notoriety and media popularity than Solway, what of the quality of Karavis's poetry? How is the "seductive risk" of Karavis's poetry acknowledged on Canadian soil? Does Karavis's poetry break the cycle of torpor that Solway sees in the country's, and in Atwood's, literature? An answer to Starnino's question can arguably be found in Fitzgerald Bryden's measured review of Karavis: "Karavis has written some beautiful, some witty, and some mediocre poems."[146] At first Starnino's question appears to be a most valid one: is the poetry of Solway, writing as Karavis, meritorious *as poetry* without the context of Karavis's heteronymic status? However—just as it is not the technique and skill that Mary O'Shea executes in crafting her waxen globes that is primary to Iris Häussler's *He Named Her Amber*—a heteronym is not just the poetry that they have written on the page. Starnino's New Critical approach to Karavis's work is not an apt procedure for reading his heteronymic texts because the context of production and reception is part of the heteronym's creation and literary function. To read only Karavis's poetry is to travel with one's nose in the guidebook, ignoring the bustling metropolis or the complex ecosystem that one is visiting. The author's creation of a heteronymic persona, the discovery of that persona by an audience, and the ways that an author is also transformed through the voice and poetry of the heteronym are an equally important part of the trip.

TRANSLATIONAL POSSIBILITIES: (DIS)COMFORTS OF THE MOTHER TONGUE

Moure and Solway are writers who have created fake authors and fake trans-lated texts in order to reveal the habits and procedures, the comforts and dis-comforts, established in Canada with regard to authorship, literature, and, in particular, translation. In *Sheep's Vigil by a Fervent Person*, Moure's translations of Caeiro bring this heteronym's work not just into a new language, but also into a new era and a new city. Sampedrín translates the poetry of Stănescu from the Romanian without knowing how to read Romanian. Solway trans-lates the work of Karavis from Greek, yet *Saracen Island* does not have any of Karavis's original Greek poems printed next to Solway's translations for the quite obvious reason that there are no originals. The unconventionality of Moure's, Sampedrín's, Solway's, and Karavis's multilingual translations and the discomfort their heteronyms create through mistranslating, untranslating,

pretending to translate, not really translating at all, and translating reinvigorates critical conversations about how language in Canada is inseparable from Canadian culture. Through acts of "identity correction" these heteronyms remind readers of the work that needs to be done to unstifle ourselves creatively and decolonize ourselves politically so that we can collectively produce art and literature that maps onto the diversity of cultures present on this land.

Solway's concerns with unexamined comfort primarily focus on the "monotony" and "tameness-and-sameness" he sees in Canadian literature and its readers, arguing that "readers of Atwood ... undergo no spiritual change or evolution whatsoever."[147] His criticism centres on the *reception* of poetry in Canada: the effects that reviews, news media, and international acclaim have on an audience's relationship to a text, author, and translator. Solway claims, "what is designated as 'Canadian style,' certainly in our poetry, is almost entirely reproductive and literal—which would account for its devastating monotony."[148] The limitation of thinking of Canada as "linguistically dual" could also be said to account for its "reproductive" quality, particularly with translation, as translations circulate primarily back and forth between Canada's two official languages.

Moure, on the other hand, approaches unquestioning cultural tempers by looking at the ingrained relationships readers develop—often unknowingly—with languages themselves that they encounter, read, and speak on a daily basis. She claims "the translator calls into question our purest, most originary beliefs (which we could call non-beliefs, for we don't even know we have them) about our own language and expression in that language, and about ourselves as citizen members of a state."[149] Her focus is on the *production* of translation in Canada, and how cultural production is inevitably enmeshed with national policies on language use and dissemination. Moure's foregrounding of collaboration and contingency in her poetic projects emphasizes that "writing is always and forever a social practice," that "words bear ideologies," and that discourse, then, "has to be questioned, turned over, or it shores up what is, for me, an oppression and silencing of others."[150]

Moure and Solway's heteronyms ask readers to wonder why more imaginative and inclusive Canadian authorial and translational cultural practices do not yet exist. It is through an ethics of imagination and through disruption to procedural norms that these heteronyms do important work in reimagining what Canadian culture and literature has the potential to include and to be. The term "identity correction" is used by a group of American artists and political activists called the Yes Men, who, through fake news reports,

websites, and public appearances, highlight unjust political and corporate policies. While in disguise, the Yes Men make fictional statements that are, in context, often seemingly outrageous, but which usually embody the values and practices they hope their "target" corporations and leaders would choose to follow in reality.[151] For instance, they described George W. Bush as "the self-proclaimed 'ecology governor'" as he "presided over Texas as it became the most polluting state in the Union";[152] and "on the twentieth anniversary of the Union Carbide chemical spill at Bhopal, India, which devastated the region in 1984, killing at least twenty thousand people and sickening untold thousands more," the Yes Men falsely claimed—while impersonating a Dow Chemical executive during an interview on BBC World television—that the company "had decided to make reparations to the victims and to remediate the toxic site, at a cost of 12 billion dollars," in what the fake corporate officer, Jude Finisterra, deemed "'the first time in history that a publicly owned company of anything near the size of Dow has performed an action which is significantly against its bottom line simply because it is the right thing to do.'"[153] While Moure's and Solway's heteronyms have not—yet!—espoused corporate transformation on the BBC World News, the creation of fake translators and fake translated texts by Solway and Moure illuminates a lack of translational possibilities in Canada. By filling this void of translations in Canada that are other than French and English with pretend authors, pretend translators, and pretend translated texts—in languages such as Greek, Portuguese, Galician, and Romanian—the silencing of other languages and cultures in Canada is made imaginatively visible.

The ways that translations primarily come to exist in Canada are through the financial support of translation and publishing grants run by the federal government through agencies such as the Canada Council and subventions administered through the Social Sciences and Humanities Research Council. The problem with the grants, however, is that in order for a work to be eligible, translations are limited to French, English, and, much more recently, "an Aboriginal (First Nations, Inuit or Métis) language."[154] This means that any source text outside of these languages cannot receive public funding to be translated in Canada. To be clear, a book written in Spanish, Arabic, or Norwegian will not receiving funding even if its target language of translation is a "Canadian" language of English, French, Halkomelem, or Nisga'a. Beyond Canada's border, in order to *internationally* promote the work of Canadian authors, there are grants available for the first translation of literary works by Canadian authors for publication abroad into languages

other than French and English—but the source texts for these grants are also limited to English, French, and "an Aboriginal (First Nations, Inuit or Métis) language,"[155] so that a Canadian writer who has written a work in Finnish, Korean, or Pashto will not be eligible for funding to translate their book for publication, whether abroad or in Canada. "Why is the influx of multiple languages important to Canadian culture?" is a valid question that I believe Moure and Solway's heteronyms work to answer. The disruption and "identity correction" that Moure and Solway are performing with their heteronyms primarily targets the problem of translations not occurring in Canada from and into any "non-official" languages. It is this "identity correction" that I will mostly be discussing here, but I do want to address Indigenous language revitalization and translation as well before returning to the question of other "international" languages entering translational practices, publishing, and culture in Canada.

One reason that funding multiple language translations in Canada may seem superfluous at this time is a desire for the reclamation and revitalization of Indigenous languages nearly eradicated by the country's colonialism. Our colonial history upholds the idea that Canadian culture is, and ought to be, bilingual. A valid question regarding current translational practices is "Why should we focus on source texts from other parts of the world and in other languages when the work of revitalizing Indigenous languages that are verging on extinction is needed for their preservation?" I too believe that the work of Indigenous language revitalization is vital at this time in Canadian history. But I also think it's important to recognize that the work of language revitalization is different than the work of translation. Translation and language revitalization are two very different cultural projects. The two cultural projects are not, however, mutually exclusive: cultural support from federal sources could certainly be allocated to both a diversity in translations and a commitment to Indigenous language revitalization in Canada. As a federally funded practice, Indigenous *translation* programs need to proceed with cautious consideration and willing Indigenous counsel, as the mandates for funding these translations carry serious cultural concerns, which only Indigenous people, rather than settler administrators, ought to determine for themselves.

For instance, as a settler in Canada, it would feel a privilege for me to be able to access Indigenous stories and cultures through a printed translation of one of the Indigenous languages in my country of origin; however, I am also aware that the act of translating Cree or Inuktitut or Ojibwa into my mother tongue of English can also be understood as yet another re-inscription

of colonization that has resulted in cultural genocide. First, to translate an Indigenous or Métis language into English or French—or even, depending on tribal histories and relations, to translate one Indigenous language into another historically dominant Indigenous language—enacts colonial and tribal histories that have led to the scarcity and extinction of Indigenous languages throughout Canadian history, rather than to their flourishing and celebration.

Further, to convert many of the works that originate in an Indigenous or Métis language into printed text has the capacity to devalue certain sacred, cultural, and even legal purposes of oral Indigenous and Métis traditions. Many stories found in these languages were never created with the intention of being confined to print. Further, the permissions of who is allowed to produce and circulate printed translations from Indigenous and Métis languages under the federal granting agencies mandates are not clearly stated or established, which could result (and has already historically resulted) in the circulation of translations from Indigenous languages into English and French whose permissions were never given to the translator from living members of the Indigenous community, again re-inscribing colonial practices and disrespectfully disregarding Indigenous, Inuit, and Métis protocols. So, recognizing that Indigenous language revitalization and translation are, I believe, somewhat outside the scope of Moure's and Solway's heteronymic projects, I want to return to the problems in current Canadian translation practices that these authors *do* point out and are working to correct.

Having the Canadian government's financial support for publishing translation may seem at first like a multicultural enterprise, yet the primarily bilingual mandates of the grants are culturally limiting and structurally colonial in terms of what is considered Canadian content worthy of receiving assistance for production in Canada and for international dissemination. These limitations are linked to the fact that the National Translation Program for Book Publishing falls under the Government of Canada's official language strategy, the *Roadmap for Canada's Official Languages 2013–2018*, legislation that followed the *Roadmap for Canada's Linguistic Duality 2008–2013*, which ended on March 31, 2013.[156] In his opening message, then Prime Minister of Canada, the Right Honourable Stephen Harper (or, at least, one of his staff writers, in another kind of authorship beyond omnity) writes:

> As Prime Minister, I am proud to present the *Roadmap for Canada's Official Languages 2013–2018* to Canadians. By building on the successes of the last five years, this Roadmap shows the way forward to an even stronger and

more united Canada—a Canada where English and French, the languages of our national identity, are a greater source of pride for all Canadians than ever before.[157]

This statement, and the mandates of this document itself which then extend to the mandates of the translation grants administered by the federal government, identifies English and French as "the languages of our national identity," and identifies Canada as a country of "linguistic duality," which, albeit a part of the founding colonial myths of Canada as a nation, certainly does not speak in any concrete way to the lived experiences of the Indigenous, globalized, and multicultural citizenship that also makes up the country. (What the Right Honourable Prime Minister Justin Trudeau's government will do with the *Roadmap for Canada's Official Languages* upon its renewal in 2019 could significantly change the country's current language policy and governance.) It is in the dearth of globalized languages found in translation in Canada where the "identity correction" of Sampedrín and Karavis can assist in creating both aesthetic and political change in Canada's linguistic and literary cultural climate.

Through Sampedrín and Karavis's mistranslating, untranslating, pretending to translate, not really translating at all, and transelating, the heteronyms pester the status quo insistently enough that languages other than those "official" to Canada actually do begin to get public cultural exposure and receive print publication in Canada. Both Solway's criticism of contemporary Canadian poetry as being reproductive and monotonous and Moure's criticism that language use must be questioned and turned over so that the oppression and silencing of other voices does not occur are dynamically enacted through the existence and "corrective" work of their heteronyms. The Greek, Portuguese, Galician, and Romanian present in the poetry of Karavis and Sampedrín begin to populate publications in Canada with languages other than those related to the country's French and English colonial past, and begin to represent the "one-fifth of Canada's population, or nearly 6,630,000 people" who speak a language other than English or French at home."[158] The heteronyms existing, speaking, and writing in Greek, Portuguese, Galician, and Romanian are a glimmering, if small, representation of the "more than 200 mother tongues" from "23 major language families" actively spoken in Canada on a regular basis.[159]

Just as Jude Finisterra, the Yes Men's fake Dow Chemical corporate officer, gets viewers of the BBC News asking why one of the world's wealthiest

companies is *not* making reparations to the victims of the Union Carbide chemical spill in Bhopal, India, as this *is* the right thing to do, Karavis and Sampedrín take on a much smaller "identity correction" regarding language and culture in Canada. The existence of these fake poets identifies two cultural losses that occur when Canadians as a nation are not exposed to translated texts from languages other than French and English. First, Canadian readers, writers, translators, and publishers—unless they decide to purchase or publish work from abroad, often at personal expense—are forced to stagnate intellectually and artistically in our colonial history, despite Canada supposedly being a "post-colonial" nation, and despite the country's rich multiculturalism and multilingualism. The rhythms of other languages do not inflect our own, nor do experiences or mindsets of authors writing from different geographical locales affect our understanding of humanity. Our sense of the world becomes smaller.

Moure's translation of Caeiro's *O Guardador de Rebanhos* was a rare literary event in Canada: the publication of a Portuguese book translated into English by a Canadian poet. "It so rarely happens that languages other than French and English are present in public life in Canada," Moure notes, that "one of the pleasures in publishing *Sheep's Vigil by a Fervent Person* was seeing a Canadian book include Portuguese."[160] Yet, even in the unusual circumstance of a Portuguese book being published in Canada, "Pessoa's name was originally left off the cover and title page by the Canadian publisher.... The physical book at first elided that it was a translation."[161] To elide acknowledgement of translation, and to hinder translational possibilities in Canada through exclusive and colonial-minded policy-making, is to ignore the transculturalism of present-day Canada. Moure argues that current policies suggest a national, or at least a governmental, belief that "to accept translation from languages other than French and English would put our founding myths at risk of foundering in some way."[162] She believes that "in our arts councils, funding limitations for translation don't exist for the sake of the promotion of Canadian literature, but to maintain a certain figuration of the state, of Canadian nationhood or, in Quebec, of Quebec nationhood ... and thus other languages need to be shut out as less, as non-Canadian."[163] Which leads to the second "identity correction" needed in Canada, which these heteronyms address: a re-examination of the mistaken yet commonly held belief that Canada is a cultural mosaic.

In 1938, John Murray Gibbon's book *Canadian Mosaic* was published. The book's metaphorical premise has emerged as a national ideology for Canada's

cultural and immigration policies, an ideology that is still commonly held in the country today. It is believed that the nation of Canada, like a mosaic, enables citizens to maintain our unique and separate cultural entities while forming a colourful national whole. American cultural immigration policies, on the other hand, are thought to resemble a melting pot, "where people of diverse origins have allegedly fused to make a new people."[164] However, as Howard Palmer argues in "Mosaic versus Melting Pot? Immigration and Ethnicity in Canada and the United States,"

> There is, of course, some truth to this distinction, but it oversimplifies both the American and the Canadian experiences. It ignores the fact that the mosaic approach has not always been the prevailing attitude toward immigrant adjustment in Canada, it obscures the fact that Canada and the United States have shared very similar immigration policies (particularly on the question of which ethnic, national, and racial groups were the most desirable), and it neglects the fact that, at least with regard to immigrant groups, the history of racism, nativism, and discrimination has been very similar in the two countries.[165]

Canada's current translational policies fortify our country's history of discrimination and colonialism, eliding differences rather than embracing a transcultural attitude toward diversity. Sontag acknowledges that because translation is an activity "practised in every nation but subject to national traditions, there are greater pressures in some countries than in others to efface as much as possible the evidence of foreignness."[166] "To efface as much as possible the evidence of foreignness" is not a practice conducive to Canada's mosaic image; yet, the translational limitations that Solway and Moure creatively confront clearly do impede difference and protect an imperial model of assimilation. "Were the state to support translation from other languages," Moure suggests, "we Canadians might end up confronted with some hard questions about who we are."[167]

At a time in Canada's history when—during an address to the countries gathered for the 2009 G20 summit in Pittsburgh—then Prime Minister Stephen Harper made the statement that Canada "has no history of colonialism,"[168] it appears that an effacement and elision of our colonial past is part of Canada's contemporary political identity. Government-funded literary translations maintain a bias toward the country's two official languages, both of which are the languages remnant of our colonial history with France and

England. Moure's translations from Pessoa's Portuguese, Sampedrín's trans-
lations from Romanian, Solway's translations from Greek into English: all
of these heteronymic projects defy current Canadian translational policies
by bringing diverse cultures and languages into published Canadian works.
These other cultures and languages then become—even if fictionally—a part
of Canada's cultural landscape. The fictionality at play in Solway's, Moure's,
and Sampedrín's translations can thus be read as forms of "identity correction"
similar to those performed by the Yes Men.

As Carrie Lambert-Beatty notes of the Yes Men's performances, "The
efficacy of positive identity correction—and the poetry—turns on this power
to shift something into the range of the plausible."[169] The power of "faking"
a reality that one wants to be achievable is twofold: "The art of the plausible
discloses consensus about the way things are; but it also can make a new
reality sensible: accessible both to feeling and reason."[170] Solway and Moure
question current translational practices by highlighting what is *not* being done
by federal granting agencies. They are "correcting" the policies on translation
by translating what doesn't exist, in languages that are not funded.

Derek Attridge notes that "the formally innovative work, the one that
most estranges itself from the reader, makes the most sharply challenging eth-
ical demand."[171] Susan Sontag writes, "Translation is the circulatory system
of the world's literatures. Literary translation ... is pre-eminently an ethical
task ... [that] duplicates the role of literature itself, which is to extend our
sympathies ... to secure and deepen the awareness (with all its consequences)
that other people, people different from us, really do exist."[172] What Solway,
Karavis, Moure, and Sampedrín's heteronymic and translational devious-
ness tells us is that those "other people, people different from us"—even if
fictive, imaginative, or heteronymic—are best at "sharply challenging" the
ethics of the remnant colonial translational practices and public policies still
present in Canadian literary culture. The heteronym's interruption of current
translational practices advocates for the imagination and innovation that
Canada's translational policies need in order to change access to translations
in a new direction that reflects the multilingual, and multicultural "mosaic"
nation that Canada claims to be. Wouldn't it be startling and elating to hear,
celebrated in Canadian culture, the cadences and intellectual differences of
multiple mother tongues?

The Art of Stumbling

IN JEFF WALL'S *The Stumbling Block* A MOUSTACHED MAN WEARING A custom-built protective uniform lies prone in the middle of a busy downtown sidewalk. He is padded in sporting gear—as a quarterback, backcatcher, or hockey goalie might be—with shoulder pads, knee pads, shin pads, and a helmet. The man has a water bottle in front of him at the ready, suggesting that the work he is doing is physically taxing. His tubular protective gear is dirty from use, and appears all in one piece, so that the man is partly reminiscent of well-protected riot police and partly reminiscent of the Caterpillar from *Alice's Adventures in Wonderland*. Lewis Carroll's Caterpillar asks Alice upon their meeting, "Who are *you*?" to which she struggles to reply, "I—I hardly know, Sir, just at present—at least I know who I *was* when I got up this morning, but I think I must have been changed several times since then."[1] Alice's encounter with the Caterpillar, through his riddling questions about her identity, is a philosophically jarring one for the protagonist and possibly for the reader. With Wall's character of the Stumbling Block, one is meant to physically trip in one's encounter with the strange fellow. This act of stumbling is similar to what is provoked by the Caterpillar's philosophical interrogations, although the Stumbling Block also offers a kinaesthetic

Figure 26. Jeff Wall, *The Stumbling Block*. 1991. Transparency in lightbox, 229 × 337.5 cm. Courtesy of Jeff Wall.

moment of puzzlement along with a conversational one. Wall's character appears to impart moments of halting and ponderous reflection to the people with whom he comes in contact, just as the Caterpillar does for Alice. It is notions of identity (who we are and how we become)—and the fact that our selves often escape easy explanations and taxonomies—that Wall's imagined Stumbling Block, like the Caterpillar, makes us encounter.

Wall describes how, when he started to work with computers in his art practice, his process of digitally tinkering with his photographic images led him to "the idea that I could use the otherworldly 'special effects' to develop a kind of philosophical comedy . . . a field of reflection in which humanity appears as infinitely imperfectable."[2] Wall relates his image of humanity as "infinitely imperfectable" to learning: "I guess the key metaphor is 'learning.' We learn; we never complete the process of learning, and so learning is a kind of image of incompletion and limitation but a hopeful image as well. I've tried to express this feeling, and this love of learning in pictures."[3] Wall describes how he then took this feeling and love of learning and created the character of Stumbling Block, an imagined bureaucratic employee whose role is to interrupt the habitual for the sake of personal transformation and insight:

In *The Stumbling Block*, I thought I could imagine a further extrapolation of society in which therapy had evolved to a new, maybe higher stage than it has up to now. In my fantasy, the Stumbling Block helps people change. He is there so that ambivalent people can express their ambivalence by interrupting themselves in their habitual activities. He is an employee of the city, as you can tell from the badges on his uniform. Maybe there are many Stumbling Blocks deployed on the streets of the city, wherever surveys have shown the need for one. He is passive, gentle and indifferent: that was my image of the perfect "bureaucrat of therapy." He does not give lessons or make demands; he is simply available for anyone who somehow feels the need to demonstrate— either to themselves or to the public at large—the fact that they are not sure they want to go where they seem to be headed. The interruption is a curative, maybe cathartic gesture, the beginning, the inauguration of change, healing, improvement, resolution, wholeness, or wellness.[4]

On the left side of the photo a young man with his skateboard has just "stumbled" and is deep in revelation. On the right is a middle-aged businessman with a briefcase who has likewise just "stumbled." And of course, in the middle of the image, we have a young woman in mid-stumble herself, declaring an uncertainty about her direction and her need for "curative interruption," as Wall calls this fall.

I see *The Stumbling Block*, as I see the works of Häussler, Jungen, Wall, Belmore, Moure, Pessoa, Sampedrín, Solway, and Karavis, as enacting a kind of Socratic questioning in the streets of a modern-day Athens: a disruption of our pretences of knowing, of solid fact, of assumption. *The Stumbling Block* depicts a moment of disruption to habit and routine. The urban street scene is set during a busy workday. Most of the figures are dressed in business attire. A bike courier in the background appears to be on a delivery. The man in a uniform and a blue vest holds a device, perhaps as part of his trade or for communication. The kid on a skateboard also appears to have been in the middle of moving between one destination in his day and another. Judging by the busy traffic on the street and by the daylight reflected in the mirrored windows of the office tower in the background, this photograph was most likely taken just before or after a workday or during a lunch break. The people appear to be on familiar routes running errands during a typical day. Yet, in the midst of routine lies the Stumbling Block, who is set in place to disrupt regularity. This disruption is integral to the various forms of hoaxes examined

in this book, and to the epistemological revisions each work has the capacity to instill in viewers and readers.

The works I have been discussing in the preceding sections of this book all have the capacity to disturb and disorient the habits of viewers, readers, and institutions—whether a gallery patron's interactions with artworks, a museum-goer's relationship to ethnography and history, or a reader's understanding of authorship. All of these artists and writers not only complicate our ideas of truth but make us uncomfortable in our (un)knowing. They make us question our certitude. They make us, for a moment, trip on tiny aberrations in our habitual modes of daily aesthetic and ethical engagements so that we might reimagine the boundaries of what is possible. What Wall's *The Stumbling Block* depicts, though, is not an act of disorientation that takes place in a gallery, museum, or book (although viewing Wall's photograph would likely occur in such a location). Rather, it is a small act of disruption to society, a "stumble" taken by an individual on their daily walk to or from work or on a lunch break, that causes that person to take notice of their life in a new light through a momentary break from habit and inattention.

I want to end my discussion of hoaxes with this image because I believe the disruptive work of hoaxes ought not to end in a gallery, museum, or within the pages of a book (especially not this book). I would want for hoaxes and their study to affect a viewer or reader's lived existence beyond these institutions. I would hope that a hoax does not end with a viewer or reader's frustration or delight at the object of disruption, but that the disruption instilled by the fakery of a hoax begins to change a person's "real" life.

Hoaxes—such as those examined in this book—disrupt the narratives of histories and identities seen in galleries, museums, and literature, but they do so, I believe, in a way that reminds us of our relationship to, and part in, the creation of these institutions. Hoaxes, in troubling an unquestioned trust in our experiences of galleries, museums, and books, have the potential to inspire curiosity and contemplation toward other aspects of life that, unexamined, can be taken for granted: vocations, affections, systems of belief, ideas of one's country, history, ideas of abled-ness, injustices that occur in the acquisition and distribution of wealth, or the hierarchal taxonomies we place on gender and race, for instance. The narratives of histories and identities seen in galleries, museums, and literature are not—hoaxes remind us—separate from lived lives. The story of a maid and her orbs of wax; the headdresses and dream catchers scratched into a gallery wall; the stances of bodies captured in a photograph; a woman wailing out names on Cordova

Street; translations of poetry, whether factual or fictive—all are small chances for viewers to attend to their own identities and to ask questions about who they are and how they have been shaped into the persons standing before these works of art and these characters in literature. Hoaxes also ask how the cultural institutions created by society, which so often house these objects and ideas, also affect our collective and individual identities.

The disruption hoaxes perform to the various parties and pacts that negotiate the making of meaning in society disorients viewers and readers by insisting that these institutions, and the individuals who take part in these institutions, not be deadened by habit. Hoaxes are mimetic of the pitfalls, traps, lies, misunderstandings, betrayals, and surprises that life will inevitably bestow upon each of us. Hoaxes remind viewers and readers that our lives and our stories are relational and that, although we may not have agency over who or what disrupts our lives, we do have agency over how we react to this relationality and how we proceed when we are disrupted. Wall's *The Stumbling Block*, and the artist's discussion of the photo, speaks to these disruptions of dailiness that I see exemplified in hoaxes. The photograph also suggests possible benefits that these disruptions and acts of "stumbling" might have upon one's daily life.

The hoaxes examined in this book are not simply jokes, or malicious acts, or lies, or glib comments on Canadian society made to undercut the seriousness of art, of ethnography, or of literature. These hoaxes are little disrupters, deliberately employed Stumbling Blocks, positioned throughout our most hallowed institutions so that galleries, museums, works of literature, and the departments of universities that study cultures and their creations continue to be places of learning and self-examination. Hoaxes are sites wherein our pretenses are felled and both individuals and institutions are given the chance for a more honest self-awareness of daily practices and habits. Hoaxes are, through their deceptions and interruptions, ironically, loyal to reality and all of its complications.

Acknowledgements

I HAVE HAD THE DEEP PRIVILEGE OF WRITING THIS BOOK AT MANY different kitchen tables, coffee shops, and library carrels across Canada. The places where I work are on treaty lands and unceded territories, and I want to give my acknowledgement and gratitude to the First Peoples on whose land I have had the chance to live, work, write, teach, learn, and ride my bike. I am grateful for my time present in Halifax, on Mi'kma'ki, the ancestral and unceded territory of the Mi'kmaq People. This territory is covered by the "Treaties of Peace and Friendship" which Mi'kmaq Wəlastəkwiyik (Maliseet), and Passamaquoddy Peoples first signed with the British Crown in 1726. The treaties did not deal with surrender of lands and resources but in fact recognized Mi'kmaq and Wəlastəkwiyik (Maliseet) title and established the rules for what was to be an ongoing relationship between nations. I am grateful for my time in Toronto, the traditional territory of the Wendat, the Anishnaabeg, Haudenosaunee, Métis, and the Mississaugas of the New Credit First Nation. For thousands of years the land on which I lived and studied while at the University of Toronto and Massey College has been the traditional land of the Huron-Wendat, the Seneca, and the Mississaugas of the Credit River. I am grateful for my time at the Banff Centre for Arts and Creativity, located on the lands of Treaty 7 territory, the traditional lands of the Stoney Nakoda, Blackfoot, and Tsuut'ina Nations. I am grateful for my time in Vancouver, living and teaching on the unceded territories of the Coast Salish Peoples, specifically the xʷməθkwəy̓əm (Musqueam), Skwxwú7mesh (Squamish), and Səl̓ílwətaʔ (Tsleil-Waututh) Nations, and I am grateful for the First Peoples, Inuit, and Métis artists, writers, and colleagues from across Turtle Island, often living in places that are not their traditional territories due to circumstance, whose conversations have kept me company and begun in me the long process of decolonization and reconciliation during the writing of this book. Thank you.

This book is written with gratitude to the Social Sciences and Humanities Research Council of Canada, the Department of English at the University of Toronto, the School of Graduate Studies at the University of Toronto, Massey College, the Harvard English Institute, the Association for Canadian College and University Teachers of English (ACCUTE), the Banff Centre for Arts and Creativity, and the *Awards to Scholarly Publications Program of the Federation for the Humanities and Social Sciences* for their kind financial support.

Thank you to the organizers, fellow panellists, and participants at the following conferences where I presented work toward this book while the ideas were still in development: *ACCUTE*, Congress 2017, Ryerson University, Toronto; *ACCUTE*, Congress 2016, University of Calgary; *Dalhousie English Speaker's Series*, Dalhousie University, Halifax, 2012; *ACCUTE*, Congress 2012, University of Waterloo and Wilfrid Laurier University; the 2012 Annual Conference of the *Canadian Museums' Association*, Gatineau, Quebec; *ACCUTE*, Congress 2011, University of New Brunswick, Fredericton; *Fakery: An American Territory?* Université Rennes 2 Haute Bretagne, Rennes, France 2010; *ACCUTE*, Congress 2010, Concordia University, Montreal.

Thank you to the editors of the *Dalhousie Review* who published an excerpt from this manuscript in their Spring 2013 issue: *Make Believe: Truth, Fiction, and Friction.* Thank you to the editors of *Poetry Is Dead Magazine* who published my essay "The Art of Stumbling" in their Fall 2016 *Intersections* issue, which helped me to reimagine some of the introductory and concluding thoughts to this manuscript.

Thank you to the Elizabeth Bishop House Artists' Residence in Great Village, Nova Scotia, and Rivendell Retreat Centre on Bowen Island, British Columbia, for offering me quiet places to work on either side of the country.

With thanks to the libraries, librarians, and interlibrary loan departments of the Killam Memorial Library at Dalhousie University, King's College Library, John P. Robarts Research Library, Thomas Fisher Rare Book Library, Trinity College Library, E. J. Pratt Library, Robertson Davies Library, UBC Libraries, Langara College Library with special thanks to Ophelia Ma and Alison Sullivan, the Vancouver Public Library, the Archives and Library of the National Gallery of Canada, Basil Girgrah, Tyana Grundig at the Canadian Broadcasting Corporation, and the CBC Reference Library, archivist Cheryl Siegel and Danielle Currie and the Library and Archives of the Vancouver Art Gallery, Eva Athanasiu and Sean Weaver and the Art Gallery of Ontario, Dan Pon at Grunt Gallery, Teresa Sudeyko and the Morris and

Helen Belkin Art Gallery, Dan Starling at Jeff Wall Studio, Daniel Faria Gallery, and Catriona Jeffries Gallery.

Thank you to my creative writing students at Dalhousie University and my colleagues in the English Department. Thank you to the English Department at Saint Mary's University. Thank you to the Art History and Critical Studies Department at the University of Nova Scotia College of Art and Design, and especially to my students in the summer of 2013. Thank you to the Department of English at the University of Toronto, especially to my fellow graduate students. Thank you to Langara College snəw̓eyaɬ leləm̓, especially my students and colleagues in the English Department, for their collegial support and for making Langara one of the best places at which I have had the privilege to teach.

For the company, conversations, food, wine, and love, thank you: Stephanie Adams, Lindsay Anderson, Phanuel Antwi, Tony Antoniadas, Matt Balcarras, Bonnie Bartlett, Heather Bartlett, Rosie Battershill, Steph Boulton, Annie Bray, Sarah DeJong Carson, Jesse Dekoster-Gaete, Mike Cheatley, Bob and Marlene Cheatley, Christ Church Cathedral Vancouver, Rafał Czechor, Michael Doan, Rebecca Dolgoy, Lindsey Eckert, Zoe Fitch, Scott Fotheringham, Ruth Fotheringham, Marc-André Fortin, Liliana Gaete, Ben Gallagher, Katie Gorrie, Clare Goulet, Sue Goyette, Kate Hall, Ami Harbin, Warren Heiti and his family, Ryan Henderson, Letitia Henville, Judith Herz, Clyde Hunt, Autumn Johnson, Eric Johnson, Anna Lee, Evan Lee, my fellow fellows at Massey College, Carmen Mathes, Marks and Margaret McAvity, Colleen Mooney, Mark Munn, Daniel Newman, Cillian O'Hogan, Finn O'Hogan, Jasmine Oore, Megan Otton, Jillian Povarchook, Jeffrey Preiss, the entire Prud'homme Library Project team, Karen Schaffer, Anne Simpson, Sue Sinclair, Vanessa Sorenson, Sorrento Centre, Nick Thran, Laura Tompkins, Dana VanVeller, Dave Warne, Shannon Webb-Campbell, Caren Weisbart, Hana Wild, Erin Wunker, Guylaine Williams, and Neve Young.

For your wisdom, generosity, scholarship, and time, thank you: William Barker, Rebecca Belmore, Mark Cheetham, Melba Cuddy-Kean, Carrie Dawson, Melanie Delva, Andrew DuBois, Marlene Goldman, Anthony Graesch, Iris Häussler, Daniel Heath Justice, Mark Kingwell, Carry Lambert-Beatty, Chantal Lee, Bob McGill, David Moos, Erín Moure, Carol Percy, David Schaepe, Ella Soper, Justin Wilson, and Lorraine York.

Thank you to Siobhan McMenemy, Robert Kohlmeier, Clare Hitchens, and everyone at Wilfrid Laurier University Press. Thank you, Margaret

Crammond. Thank you, Michel Vrana, for the gorgeous cover and interior designs. Thank you to Kai Liu for photographic assistance. Thank you to Duncan Parizeau for all of your work on the notes, bibliography, and index. Thank you to my anonymous readers whose suggestions and encouragements significantly helped edit and shape this manuscript. Any errors or omissions are mine.

Thank you to Sarah Selecky for telling me that I needed to go see the strange archaeological dig at the Grange and for all of the conversations we have ever had before and since. Thank you Claire Battershill and Sheryda Warrener for your love and intelligence in all things, but most especially for our chats about writing, teaching, and parenting. Jocelyn Parr, for our friendship—for all that it holds dear and for all that it lets go. Jacquie and Bart Jessup, thank you for your unconditional love, and for hours of stroller walks with Francis so I could get this book done. I am a writer because of you. James Cheatley, for your generosity of spirit, your loving and supportive company, for teaching me to taste the metaphors and geographies in a glass of wine, and for being a wonderful dad to Francis. I love you and I couldn't have done this without you. Francis Michael Peace Cheatley Jessup, for your bright and curious joy. Mari Ruti, this book is for you. Your friendship, mentorship, care, humour, intelligence, keen eye, and company have sustained me over many years. I cannot tell you how grateful I am for all you have taught me about being a writer and about being human.

Notes

INTRODUCTION

1. See Lewis Hyde, *Trickster Makes This World: Mischief, Myth, and Art* (New York: North Point Press, 1999).
2. "Account of Literary Forgeries," from Robertson on the Parian Chronicle, *Classical Journal* 16 (1817): 123–44, Google Books, accessed November 27, 2018, https://tinyurl.com/ybf7c9lg.
3. Alan D. Sokal, "A Physicist Experiments with Cultural Studies," *Lingua Franca* 6, no. 4 (1996): 62.
4. See Lawrence Weschler, *Mr. Wilson's Cabinet of Wonder: Pronged Ants, Horned Humans, Mice on Toast, and Other Marvels of Jurassic Technology* (New York: Vintage, 1996).
5. Linda Hutcheon, *The Canadian Postmodern: A Study of Contemporary English-Canadian Fiction* (Don Mills, ON: Oxford University Press, 1988), viii.
6. Friedrich Wilhelm Nietzsche, *Beyond Good and Evil: Prelude to a Philosophy of the Future*, trans. R. J. Hollingdale (Harmondsworth, UK: Penguin Books, 1973), 19.
7. *Oxford English Dictionary*, 2nd online ed., s.v. "hoax," 2018.
8. Hunter Steele, "Fakes and Forgeries," *British Journal of Aesthetics* 17, no. 3 (1977): 258.
9. Julia Abramson, *Learning from Lying: Paradoxes of the Literary Mystification* (Newark: University of Delaware Press, 2005), 12.
10. K. K. Ruthven, *Faking Literature* (Cambridge: Cambridge University Press, 2001), 36.
11. Brian McHale, "'A Poet May Not Exist': Mock-Hoaxes and the Construction of National Identity," in *The Faces of Anonymity: Anonymous and Pseudonymous Publication from the Sixteenth to the Twentieth Century*, ed. Robert J. Griffin (New York: Palgrave Macmillan, 2003), 236.
12. McHale, "Mock-Hoaxes," 236
13. McHale, "Mock-Hoaxes," 237.

14. Ludwig Wittgenstein, *Philosophical Investigations*, trans. G. E. M. Anscombe (Oxford: Blackwell, 1972), 42§130.

15. Wittgenstein, *Philosophical Investigations*, 28§66.

16. Wittgenstein, *Philosophical Investigations*, 28§66.

17. Wittgenstein, *Philosophical Investigations*, 28§66.

18. Wittgenstein, *Philosophical Investigations*, 28§66.

19. Wittgenstein, *Philosophical Investigations*, 28§66.

20. Wittgenstein, *Philosophical Investigations*, 28§66.

21. Wittgenstein, *Philosophical Investigations*, 28§66.

22. Wittgenstein, *Philosophical Investigations*, 28§67.

23. Mark Kingwell, "Imagining the Artist: Going to Eleven and the Legacies of Joseph Wagenbach," in *Opening Gambits: Essays on Art and Philosophy* (Toronto: Key Porter, 2008), 119–32.

24. Jorge Luis Borges, *Selected Non-Fictions*, ed. Eliot Weinberger, trans. Ester Allen, Suzanne Jill Levine, and Eliot Weinberger (New York: Viking, 1999), 231.

25. Jonathan Lear, *A Case for Irony* (Cambridge, MA: Harvard University Press, 2011), ix.

26. Ami Harbin, *Disorientation and Moral Life* (New York: Oxford University Press, 2016), xii.

27. I feel I should also mention that this book does not address issues pertaining to fake news or recent online cultural debates regarding mainstream and alternative media. For a book that thoughtfully addresses current issues pertaining to online culture, albeit focused on the United States, I recommend Angela Nagle's *Kill All Normies: Online Culture Wars from 4chan and Tumblr to Trump and the Alt-Right* (London: Zero Books, 2017).

PART ONE

1. Jennifer Rieger, "Collection X: The Grange," Art Gallery of Ontario online, last modified April 15, 2013, http://www.ago.net/collection-x-the-grange.

2. Matthew Teitelbaum, Epilogue to *He Named Her Amber*, by Iris Häussler (Toronto: Art Gallery of Ontario, 2011), 172.

3. Jennifer Rieger, "Collection X."

4. Sara McDowell, *The Indigenous History of Tkaronto*, University of Toronto Libraries Research Guides, last updated December 17, 2018, https://guides .library.utoronto.ca/Toronto.

5. Barb Nahwegahbow, "Wampum Holds Power of Earliest Agreements," Aboriginal Multi-Media Society website, published 2014, https://tinyurl .com/ycznfutc.

6. Iris Häussler, *He Named Her Amber* (Toronto: Art Gallery of Ontario, 2011), 7.

7. Häussler, *He Named Her Amber*, 6–10.

8. Häussler, *He Named Her Amber*, 146–51.

9. Häussler, *He Named Her Amber*, 41.

10. Chantal C. Lee, "*He Named Her Amber*: The Archaeologist's View," Iris Häussler (website), published 2010, http://haeussler.ca/amber/archeologist.html.

11. Iris Häussler, interview by the author, November 19, 2009, at the Grange, Art Gallery of Ontario, Toronto.

12. Wittgenstein, *Philosophical Investigations*, 28§66.

13. Kingwell, "Imagining the Artist," 122–24.

14. Iris Häussler, *The Legacy of Joseph Wagenbach*, 2006, sculpture and performance, 105 Robinson Street, Toronto, Ontario.

15. Kingwell, "Imagining the Artist," 131.

16. David Moos, "Rehearsal," *He Named Her Amber* (Toronto: Art Gallery of Ontario, 2011), 108–11.

17. Moos, "Rehearsal," 108.

18. Kingwell, "Imagining the Artist," 124.

19. Häussler, *He Named Her Amber*, 100.

20. Judith Beattie and Helen M. Buss, eds., *Undelivered Letters to Hudson's Bay Company Men on the Northwest Coast of America, 1830–57* (Vancouver: University of British Columbia Press, 2003), 254–55.

21. Häussler, *He Named Her Amber*, 100.

22. Häussler, *He Named Her Amber*, 99–100.

23. *Oxford English Dictionary*, 2nd online ed., s.v. "viscera," 1989.

24. Häussler, *He Named Her Amber*, 100.

25. Häussler, *He Named Her Amber*, 100.

26. Häussler, *He Named Her Amber*, 100.

27. Abramson, *Learning from Lying*, 18.

28. Philippe Lejeune, "On Autobiography," trans. Katherine Leary, ed. Paul John Eakin (Minneapolis: University of Minnesota Press, 1989), 64.

29. Carrie Lambert-Beatty, *Make-Believe: Parafiction and Contemporary Art* (Chicago: University of Chicago Press, forthcoming), 66.

30. Gérard Genette, *Paratexts: Thresholds of Interpretation*, trans. Jane Lewin. Literature, Culture, Theory 20 (Cambridge: Cambridge University Press, 1997), back cover.

31. Lejeune, "On Autobiography," 110.

32. See P. B. Coremans, *van Meegeren's Faked Vermeers and De Hooghs: A Scientific Examination* (London: Cassell, 1949).

33. See Lejeune, "On Autobiography."

34. Kingwell, "Imagining the Artist," 124.

35. Eric Hebborn, *The Art Forger's Handbook* (London: Cassell, 1997), xv.

36. Moos, "Rehearsal," 113.

37. Abramson, *Learning from Lying*, 16.

38. Abramson, *Learning from Lying*, 14.

39. Moos, "Rehearsal," 110.

40. Abramson, *Learning from Lying*, 16.

41. Abramson, *Learning from Lying*, 16.

42. Abramson, *Learning from Lying*, 16.

43. Linda Hutcheon, *Irony's Edge: The Theory and Politics of Irony* (London: Routledge, 1994), 91.

44. Hutcheon, *Irony's Edge*, 91.

45. Wayne Booth, *A Rhetoric of Irony* (Chicago: University of Chicago Press, 1974), 28.

46. Booth, *Rhetoric of Irony*, 13.

47. Hutcheon, *Irony's Edge*, 93.

48. Booth, *Rhetoric of Irony*, 85–86.

49. Booth, *Rhetoric of Irony*, 35–37.

50. Hutcheon, *Irony's Edge*, 94.

51. Abramson, *Learning from Lying*, 16.

52. Abramson, *Learning from Lying*, 13.

53. Moos, "Rehearsal," 107.

54. Geordie Haley, quoted in Adria Young, "*Threnodies*: Uniting Music and Dance to Give Shape to a Musical Mood, *Threnodies* Follows the Rich Tradition of Improvisational Jazz," *The Coast: Halifax's Weekly Newspaper*, July 5, 2012, https://tinyurl.com/ydatrgee.

55. Susanne Chui, quoted in Young, "*Threnodies*."

56. David Moos, "*He Named Her Amber*: Curator's Statement," January 2009, http://haeussler.ca/amber/curator.html.

57. Moos, "Rehearsal," 107.

58. Moos, "Rehearsal," 107.

59. Moos, "Curator's Statement."

60. Häussler, interview.

61. Robert Enright, "The Consolation of Plausibility: An Interview with Jeff Wall," *Border Crossings* 19, no. 1 (February 2000): 50.

62. Now archived at http://archive.haeussler.ca/anthserv/index.html.

63. Chantal Lee, *Anthropological Services Ontario*, extension of Iris Häussler's *He Named Her Amber*, accessed November 1, 2018, http://archive.haeussler.ca/anthserv/ASO_logo.html.

64. Lee, *Anthropological Services Ontario*, http://archive.haeussler.ca/anthserv/ASO_logo.html.

65. Hyde, *Trickster*, 8.

66. Iris Häussler, personal email to author, January 30, 2018.

67. Häussler, personal email.

68. Mark Kingwell, "The Legacy of Joseph Wagenbach," statement for panel discussion, Goethe-Institut Toronto, September 20, 2006, http://haeussler .ca/legacy/MarkKingwell.html.

69. Häussler, *He Named Her Amber*, 26.

70. Häussler, *He Named Her Amber*, 26.

71. Häussler, *He Named Her Amber*, 26.

72. Häussler, interview.

73. Robert Taft, introduction to *The Human Figure in Motion*, by Eadweard Muybridge (New York: Dover, 1955), vii–viii.

74. Gillian MacKay, "Brilliant Disguise: Iris Häussler's Fact-Meets-Fiction Odysseys," *Canadian Art* (Winter 2009): 84.

75. Häussler, interview.

76. Dalia Judovitz, *Drawing on Art: Duchamp and Company* (Minneapolis: University of Minnesota Press, 2010), 145.

77. Judovitz, *Drawing on Art*, 145.

78. Kingwell, "Imagining the Artist," 124.

79. Judovitz, *Drawing on Art*, 145.

80. MacKay, "Brilliant Disguise," 86.

81. Häussler, *He Named Her Amber*, 162.

82. Häussler quoted in MacKay, "Brilliant Disguise," 86.

83. Genette, *Paratexts*, 39.

84. Genette, *Paratexts*, 46.

85. Genette, *Paratexts*, 53–54.

86. Kingwell, "Imagining the Artist," 128–30.

87. Kingwell, "Imagining the Artist," 127.

88. Kathryn Blaze Carlson, "Art or Artifice? Toronto Artist's 'Historical' Exhibition Offends Some Artistic Sensibilities," *National Post*, November 27, 2009, A8.

89. Häussler, *He Named Her Amber*, 56.

90. Abramson, *Learning from Lying*, 50.

91. Harbin, "Bodily Disorientation," 265.

92. Häussler, *He Named Her Amber*, 80.

93. Häussler, *He Named Her Amber*, 64.

94. Iris Häussler, private correspondence, a selection of letters to Chantal Lee, starting November 17, 2008, and a selection of letters to Iris Häussler, starting January 2009, shared by Iris Häussler with the author, November 19, 2009, email attachment.

95. Häussler, *He Named Her Amber*, 80.

96. Häussler, *He Named Her Amber*, 64–66.

97. Carrie Lambert-Beatty, "Make-Believe: Parafiction and Plausibility," *October* 129 (Summer 2009): 82.

98. Häussler, *He Named Her Amber*, 72.

99. Häussler, *He Named Her Amber*, 82.

100. Lynne Kenneith Brogden quoted in MacKay, "Brilliant Disguise," 83.

101. Anne Carson, "Essay on What I Think about Most," in *Men in the Off Hours* (Toronto: Vintage Books, 2001), 30.

102. Carson, "Essay," 30.

103. Carson, "Essay," 30.

104. Carson, "Essay," 30.

105. Carson, "Essay," 30–31.

106. Harbin, "Bodily Disorientation," 265.

107. Edward Casey quoted in Harbin, "Bodily Disorientation," 264.

108. Edward Casey quoted in Harbin, "Bodily Disorientation," 264.

109. Harbin, "Bodily Disorientation," 264.

110. Viktor Shklovsky, "Art as Technique," trans. Lee T. Lemon and Marion Reis, in *The Critical Tradition*, ed. David H. Richter (New York: Saint Martin's Press, 1989), 741.

111. Shklovsky, "Art as Technique," 741.

112. Shklovsky, "Art as Technique," 741.

113. Shklovsky, "Art as Technique," 741.

114. Kingwell, "Imagining the Artist," 127.

115. Lear, *A Case for Irony*, 21.

116. Lear, *A Case for Irony*, 21.

117. Lear, *A Case for Irony*, 31.

118. Moos, "Rehearsal," 110.

119. Moos, "Rehearsal," 110.

120. Shklovsky, "Art as Technique," 741.

121. Iris Häussler quoted in Carlson, "Art or Artifice?," A8.

122. Shklovsky, "Art as Technique," 741.

123. Lambert-Beatty, "Make-Believe," 68.

124. Hyde, *Trickster*, 91.

125. Lambert-Beatty, "Make-Believe," 58.

126. Lambert-Beatty, "Make-Believe," 78.

127. Emmanuel Levinas, "Idéologie et Idéalisme," in *De Dieu qui vient à l'idée* (Paris: Vrin, 1982), 31.

128. Lambert-Beatty, "Make-Believe," 70.

129. Jessica Bradley quoted in MacKay, "Brilliant Disguise," 86.

130. Ruthven, *Faking Literature*, 2.

131. Häussler, "Personal Interview."

132. *The Blind Man*, no. 2, International Dada Archive (Iowa City: University of Iowa Libraries), https://tinyurl.com/mksdll9.

133. Nick Paton Walsh, "It's a New Cultural Revolution," *Guardian* (London), June 11, 2000, https://tinyurl.com/yaqrfkpw.

134. Yuan Cai and Jian Jun Xi, *Two Artists Piss on Duchamp's Urinal*, Tate Modern, London, 2000.

135. Paul Ingram, "Pissing in Duchamp's Fountain," *3:AM Magazine*, June 23, 2014, https://tinyurl.com/ybcp7ozq.

136. Mark Blacklock "Art Attacks," *Telegraph* (London), June 26, 2003, https://tinyurl.com/ydajcjt5.

137. Blacklock, "Art Attacks."

138. Blacklock, "Art Attacks."

139. Blacklock, "Art Attacks."

140. Häussler, *He Named Her Amber*, 70.

141. Häussler, *He Named Her Amber*, 70.

142. Häussler, *He Named Her Amber*, 70.

143. Häussler, *He Named Her Amber*, 70–71.

144. Häussler, *He Named Her Amber*, 71.

145. Martha Baillie, "An Encounter with Joseph Wagenbach," *Brick* (Summer 2007): 79.

146. Martha Baillie, "Memoir of a Tour Guide," in *He Named Her Amber*, by Iris Häussler (Toronto: Art Gallery of Ontario, 2011), 94.

147. Baillie, "Memoir," 96.

148. Baillie, "Memoir," 97.

PART TWO

1. "A History of Residential Schools in Canada," CBC.ca, last updated March 21, 2016, https://tinyurl.com/y7r64zqj/.

2. Melanie Delva, "Truth and Reconciliation," public lecture, Christ Church Cathedral, Vancouver, BC, February 22, 2016.

3. "Aboriginal Nutritional Experiments Had Ottawa's Approval," CBC.ca, last updated July 30, 2013, https://tinyurl.com/ydcjd5dx.

4. *The Survivors Speak: A Report of the Truth and Reconciliation Commission of Canada*, Truth and Reconciliation Commission of Canada online, last updated May 5, 2017, http://publications.gc.ca/pub?id=9.800109&sl=0.

5. *The Survivors Speak.*

6. Taiaiake Alfred, foreword to *Unsettling the Settler Within: Indian Residential Schools, Truth Telling, and Reconciliation in Canada* (Vancouver: University of British Columbia Press, 2011), ix–x.

7. Paul Kane, "Wanderings of an Artist," in *Paul Kane's Frontier*, ed. J. Russell Harper (Toronto: University of Toronto Press, 1971), 51.

8. Kane, "Wanderings."

9. I. S. MacLaren, "'I Came to Rite Thare Portraits': Paul Kane's Journal of His Western Travels, 1846–1848," *American Art Journal* 21, no. 2 (1989): 7.

10. MacLaren, "'I Came to Rite,'" 7.

11. Russell Harper, *Paul Kane's Frontier* (Toronto: University of Toronto Press, 1971), 28.

12. John Brewer, *Ethnography* (Philadelphia: Open University Press, 2000), 10.

13. "Paul Kane," National Gallery of Canada online, copyright 2018, https://tinyurl.com/y75h4bpm.

14. "Paul Kane," National Gallery of Canada.

15. Arlene Gehmacher, "Paul Kane: Life and Work," Art Canada Institute website, accessed November 28, 2018, https://tinyurl.com/y8j5avku.

16. Gehmacher, "Paul Kane: Life and Work."

17. Gehmacher, "Paul Kane: Life and Work."

18. Diane Eaton and Sheila Urbanek, *Paul Kane's Great Nor-West* (Vancouver: UBC Press, 1997), ix–x.

19. Eaton and Urbanek, *Paul Kane's Great Nor-West*, x.

20. Brewer, *Ethnography*, 10.

21. *Reducing the Number of Indigenous Children in Care*, Indigenous Services Canada, last modified March 5, 2019, https://bit.ly/2zJZA9z.

22. Daniel Francis, *The Imaginary Indian: The Image of the Indian in Canadian Culture* (Vancouver: Arsenal Pulp, 1999), 22.

23. Sonny Assu, "Personal Totems," in *Troubling Tricksters: Revisioning Critical Conversations*, ed. Deanna Reder and Linda M. Morra (Waterloo, ON: Wilfrid Laurier University Press, 2010), 148.

24. Office of the High Commissioner for Human Rights, "Convention on the Prevention and Punishment of the Crime of Genocide," United Nations, https://tinyurl.com/yckyhytb.

25. Quoted in Marc-André Fortin, "Rebranding Canadian Identity at the Canadian Museum of History: Keeping the Aboriginal Subject as an Artifact of Absence," joint panel with the Association of Canadian College and University Teachers of English (ACCUTE) and the British Society for Literature and Science (BSLS) at the Congress of the Canadian Federation of Humanities and Social Sciences, Calgary, AB, May 30, 2016.

26. Fortin, "Rebranding Canadian Identity."

27. Mark Rifkin, *Beyond Settler Time: Temporal Sovereignty and Indigenous Self-Determination* (Durham, NC: Duke University Press, 2017), 2.

28. Paulette Regan, *Unsettling the Settler Within* (Vancouver: University of British Columbia Press, 2011), 68.

29. Regan, *Unsettling the Settler Within*, 68.

30. Regan, *Unsettling the Settler Within*, 68.

31. Thomas King, *The Inconvenient Indian: A Curious Account of Native People in North America* (Toronto: Anchor Canada, 2013), 1–2.

32. Coco Fusco, "The Other History of Intercultural Performance," *Drama Review* 38, no. 1 (1994): 145, https://tinyurl.com/ybkoohya.

33. Lambert-Beatty, *Make-Believe*.

34. Fusco, "The Other History," 146.

35. Lambert-Beatty, *Make-Believe*.

36. Hal Foster, "The Artist as Ethnographer?," in *The Traffic in Culture: Refiguring Art and Anthropology*, ed. G. Marcus and F. Myers (Berkeley: University of California Press, 1995), 305.

37. Foster, "Artist as Ethnographer?," 305.

38. Foster, "Artist as Ethnographer?," 304.

39. Jeff Derksen, "Big Failures," in *Resonant Dialogues: 25 Years of the Second Story Art Society in Calgary* (Calgary: Truck Gallery, 2009), 55.

40. Derksen, "Big Failures," 53.

41. James Clifford, *The Predicament of Culture* (Cambridge, MA: Harvard University Press, 1998), 7.

42. Arthur MacGregor, "Collectors and Collections of Rarities in the Sixteenth and Seventeenth Centuries," in *Tradescant's Rarities: Essays on the Foundations of the Ashmolean Museum, 1683, with a Catalogue of the Surviving Early Collections* (Oxford: Clarendon, 1983), 70.

43. Jacob Gruber, "Ethnographic Salvage and the Shaping of Anthropology," *American Anthropologist*, n.s., 72, no. 6 (1970): 1290.

44. "Report of the Parliamentary Select Committee on Aboriginal Tribes (British Settlements)," reprinted with comments by the Aborigines Protection Society, published for the Society by William Bell, Aldine Chambers, London, Paternoster Row, and Hatchard and Son, Piccadilly, 1837, Google Books, accessed November 28, 2018, https://tinyurl.com/ycq3teat.

45. "Report of the Parliamentary Select Committee," https://tinyurl.com/ycq3teat.

46. "Report of the Parliamentary Select Committee," https://tinyurl.com/ycq3teat.

47. "Report of the Parliamentary Select Committee," https://tinyurl.com/ycq3teat.

48. "North American Ethnographic Collection," American Museum of Natural History website, copyright 2018, http://research.amnh.org/anthropology/database/nae_sub.

49. "Hall of Northwest Coast Indians," *American Museum of Natural History*, accessed November 27, 2018, https://tinyurl.com/ydy4fagw.

50. Brian Jungen quoted in Matthew Higgs, "Brian Jungen in Conversation with Matthew Higgs," in *Brian Jungen* (Vienna: Secession, 2003), 23.

51. Jeff Derksen, "Fun Critique in Ethnographic Fields," *Fuse* 21, no. 3 (1998): 47.

52. Derksen, "Fun Critique," 48.

53. Jungen quoted in Higgs, 23.

54. Derksen, "Big Failures," 53.

55. Cuauhtémoc Medina, "High Curios" in *Brian Jungen* (Vancouver: Vancouver Art Gallery Press, 2010), 32–33.

56. Museum of Modern Art, "Glossary of Art Terms," *MoMALearning*, accessed December 4, 2018, https://tinyurl.com/y72akqm4.

57. Kyo Maclear, "Pup Tent," *Canadian Art* 17, no. 4 (Winter 2000): 74.

58. Maclear, "Pup Tent," 74.

59. Derksen, "Big Failures," 53.

60. Leigh Kamping-Carder, "Lost and Found: Reversing Minimalism and Ethnography in Brian Jungen's *Field Work*," *Seven Oaks Magazine*, April 12, 2006, 20.

61. Kamping-Carder, "Lost and Found," 20.

62. Homi K. Bhabha, interview by Solange de Boer and Zoë Gray, in *Brian Jungen: Source Book* (Rotterdam: Witte de With Center for Contemporary Art, 2006), 23.

63. Bhabha interview, 23.

64. Derksen, "Big Failures," 48–56.

65. Jungen quoted in Higgs, 23–24.

66. Derksen, "Big Failures," 56.

67. Medina, "High Curios," 31.

68. Regan, *Unsettling the Settler Within*, 67.

69. Celia Haig-Brown and David Nock, *With Good Intentions: Euro-Canadian and Aboriginal Relations in Colonial Canada* (Vancouver: University of British Columbia Press, 2006), 4.

70. Robert Enright, "The Consolation of Plausibility: An Interview with Jeff Wall," *Border Crossings* 19, no. 1 (February 2000): 50.

71. Ludwig Wittgenstein, *Culture and Value*, trans. Peter Winch (Chicago: University of Chicago Press, 1984), 6e–7e.

72. Wittgenstein, *Culture and Value*, 6e–7e.

73. Wittgenstein, *Culture and Value*, 7e.

74. Michael Fried, "Being There: Michael Fried on Two Pictures by Jeff Wall," *Artforum* 43, no. 1 (2004), https://tinyurl.com/y9ck5jsu.

75. Michael Fried, *Why Photography Matters as Art as Never Before* (New Haven, CT: Yale University Press, 2008), 82.

76. Fried, *Why Photography Matters*, 82.

77. Fried, *Why Photography Matters*, 82.

78. Dana Lepofsky et al., "Exploring Stó:lō-Coast Salish Interaction and Identity in Ancient Houses and Settlements in the Fraser Valley, British Columbia," *American Antiquity* 74, no. 4 (October 2009): 596.

79. Fried, "Why Photography Matters," 82.

80. Fried, "Why Photography Matters," 82.

81. Fried, "Why Photography Matters," 82.

82. Brewer, *Ehtnography*, 10.

83. Kathleen DeWalt and Billie DeWalt, *Participant Observation: A Guide for Fieldworkers* (New York: Rowman Altamira, 2011), 1–15.

84. DeWalt and DeWalt, *Participant Observation*, 1.

85. Fried, "Why Photography Matters," 82.

86. David Schaepe, telephone interview with the author, December 10, 2018.

87. Schaepe, telephone interview.

88. Schaepe, telephone interview.

89. Anthony Graesch, telephone interview with the author, April 19, 2014.

90. Graesch, telephone interview.

91. Anthony Graesch, "Archaeological and Ethnoarchaeological Investigations of Households and Perspectives on a Coast Salish Historic Village in British Columbia" (PhD diss., University of California, Los Angeles, 2006).

92. Lepofsky et al., "Exploring," 595.

93. Graesch, "Investigations of Households."

94. Graesch, "Investigations of Households."

95. Graesch, telephone interview.

96. Graesch, telephone interview.

97. Graesch, telephone interview.

98. Graesch, telephone interview.

99. Jeff Wall quoted in Arthur Lubow, "The Luminist," *New York Times Magazine*, February 25, 2007, 7, https://tinyurl.com/y9pfrx3s/.

100. Lubow, "The Luminist," 7.

101. Wittgenstein, *Culture and Values*, 6e–7e.

102. Graesch, telephone interview.

103. Graesch, telephone interview.

104. Graesch, telephone interview.

105. Graesch, telephone interview.

106. Schaepe, telephone interview.

107. Graesch, telephone interview.

108. Graesch, telephone interview.

109. Jay Ruby, "Visual Anthropology," in *Encyclopedia of Cultural Anthropology*, ed. David Levinson and Melvin Ember (New York: Henry Holt and Company, 1996), 1345.

110. Graesch, telephone interview.

111. Fried, "Why Photography Matters," 84.

112. Graesch, telephone interview.

113. Graesch, telephone interview.

114. Wittgenstein, *Culture and Value*, 7e.

115. Paul Chatt Smith, *Everything You Know about Indians Is Wrong* (Minneapolis: University of Minnesota Press, 2009), 53.

116. Avery Gordon, *Ghostly Matters: Haunting the Sociological Imagination* (Minneapolis: University of Minnesota Press, 1997), 195.

117. Rebecca Belmore, "Wild," in *Rebecca Belmore: Rising to the Occasion*, ed. Daina Augaitis and Kathleen Ritter (Vancouver: Vancouver Art Gallery, 2008), 49.

118. King, *Inconvenient Indian*, 2–3.

119. Belmore quoted in Kathleen Ritter, "The Reclining Figure and Other Provocations," in *Rebecca Belmore: Rising to the Occasion*, ed. Daina Augaitis and Kathleen Ritter (Vancouver: Vancouver Art Gallery, 2008), 57.

120. Helene Vosters, "Beyond Memorialization: Activating Empathy for the 'Lost Subjects of History' through Embodied Memorial Performance," *Canadian Theatre Review* 157 (2014): 34.

121. Sherene Razack quoted in Maggie Tate, "Re-presenting Invisibility: Ghostly Aesthetics in Rebecca Belmore's *Vigil* and *The Named and the Unnamed*," *Visual Studies* 30, no. 1 (2015).

122. Razack quoted in Tate, "Re-presenting Invisibility."

123. Sherene Razack, "Gendered Racial Violence and Spacialized Justice: The Murder of Pamela George," *Canadian Journal of Law and Society* 15, no. 2 (2000).

124. Ta-Nehisi Coates, *Between the World and Me* (New York: Spiegel and Grau, 2015), 11.

125. Coates, 11.

126. Belmore, "Wild," 83.

127. Kevin Griffin, "Bodies Become Terrible Beauties: Rebecca Belmore's Images Explore First Nations Themes in Provocative Manner," *Vancouver Sun*, June 14, 2008, D13.

128. Jackie Hansen, "Missing and Murdered Indigenous Women and Girls: Understanding the Numbers," Amnesty International website, accessed December 11, 2018, https://tinyurl.com/y9oqdz4t.

129. Marina Abramović, *The Artist Is Present*, May 2010, live performance, assorted materials, Museum of Modern Art, New York, https://www .moma.org/calendar/exhibitions/964.

130. Vosters, "Beyond Memorialization," 37.

131. Coates, 10.

PART THREE

1. Eirin Moure, *Sheep's Vigil by a Fervent Person: A Transelation of Alberto Caeiro/Fernando Pessoa's* O Guardador de Rebanhos (Toronto: Anansi, 2001), vii–viii.

2. Moure, *Sheep's Vigil*, viii.

3. Erín Moure, *My Beloved Wager: Essays from a Writing Practice* (Edmonton: NeWest Press, 2009), 188.

4. Erín Moure and Erin Balsar. "Erín Moure discusses Sheep's Vigil by a Fervent Person," *CBC Canada Reads Poetry*, web interview, April 19, 2011, CBC Reference Library, email message to author, November 21, 2018.

5. Genette, *Paratexts*, 47.

6. Natalee Caple, "Passing between Two Toledos or Desperately Seeking Sampedrín: Some Thoughts on Elisa Sampedrín," *Open Letter* 14, no. 2 (2010): 111.

7. *Oxford English Dictionary*, 2nd online ed., s.v. "heteronym," 2018.

8. Susan Sontag, "The World as India: The St. Jerome Lecture on Literary Translation," Susan Sontag Foundation website, April 2, 2012, https:// tinyurl.com/7cvxm4u.

9. Oana Avasilichioaei and Erín Moure, "Translation, Collaboration, and Reading the Multiple," *Canadian Literature* 210–211 (2011): 207–18, https:// canlit.ca/full-issue/?issue=210-211.

10. Michel Foucault, "What Is an Author?," in *Modern Criticism and Theory*, 2nd edition, ed. David Lodge and Nigel Wood (Harlow, UK: Pearson, 2000), 178.

11. Mark Rose, *Authors and Owners: The Invention of Copyright* (Cambridge, MA: Harvard University Press, 1993), 1–2.

12. Robert Griffin, *The Faces of Anonymity: Anonymous and Pseudonymous Publication from the Sixteenth to the Twentieth Century* (New York: Palgrave, 2003), 10.

13. Genette, *Paratexts*, 47.

14. Richard Zenith, Introduction to *The Book of Disquiet*, by Fernando Pessoa, ed. and trans. Richard Zenith (New York: Penguin, 2002), viii.

15. Genette, *Paratexts*, 48.

16. Genette, *Paratexts*, 4–5.

17. Moure, *Sheep's Vigil*, 131.

18. Moure, *Sheep's Vigil*, 131; Peter Rickard, "The Genesis of the Heteronyms," in *Fernando Pessoa: Selected Poems*, ed. and trans. Peter Rickard (Austin: University of Texas Press, 1976), 25.

19. Genette, *Paratexts*, 39–40.

20. Genette, *Paratexts*, 39.

21. Greg Mahr, "Pessoa, Life Narrative, and the Dissociative Process," *Biography* 21, no. 1 (Winter 1998): 26.

22. Mahr, "Pessoa," 26.

23. Rickard, "Genesis," 25.

24. Moure, *Sheep's Vigil*, 131; Rickard, "Genesis," 25.

25. José Blanco, introduction to *A Galaxy of Poets: 1888–1935*, by Fernando Pessoa, trans. and ed. José Blanco (Camden, UK: Libraries and Arts Department, 1985), 39.

26. Mahr, "Pessoa," 29.

27. Rickard, "Genesis," 25.

28. Moure, *My Beloved Wager*, 320.

29. Genette, *Paratexts*, 52.

30. Genette, *Paratexts*, 52–53.

31. Moure, *My Beloved Wager*, 189.

32. Moure, *Sheep's Vigil*, 5.

33. Moure, *Sheep's Vigil*, 49.

34. Moure, *Sheep's Vigil*, viii.

35. Moure, *My Beloved Wager*, 192.

36. Erín Moure and Erin Balsar. "Erín Moure Discusses."

37. Avasilichioaei and Moure, "Translation," 210.

38. Moure, *My Beloved Wager*, 175.

39. Fernando Pessoa, quoted in Edwin Honig and Susan M. Brown, introduction to *O Guardador de Rebanhos,* by Alberto Caeiro, trans. E. Honig and S. Brown (Rhinebeck, NY: Sheep Meadow Press, 1997), xii.

40. Alberto Caeiro, *O Guardador de Rebanhos,* trans. E. Honig and S. Brown (Rhinebeck, NY: Sheep Meadow Press, 1997), 28.

41. Moure, *My Beloved Wager*, 182.

42. Derek Attridge, *The Singularity of Literature* (New York: Routledge, 2004), 125.

43. Moure, *Sheep's Vigil*, 97.

44. Moure, *Sheep's Vigil*, viii.

45. Moure, *Sheep's Vigil*, viii.

46. Moure, *My Beloved Wager*, 175.

47. Moure, *My Beloved Wager*, 175.

48. Richard Kearney, *The Wake of Imagination* (Minneapolis: University of Minnesota Press, 1988), 368–69.

49. Moure, *Sheep's Vigil*, 2.

50. Caeiro, *O Guardador*, 3.

51. Moure, *Sheep's Vigil*, 3.

52. Moure, *My Beloved Wager*, 191.

53. Elisa Sampedrín [Erín Moure], "Contributors," *Chicago Review* 53, no. 2–3 (2007): 254.

54. Erín Moure, *Little Theatres: Teatriños* (Toronto: House of Anansi, 2005), 37–42.

55. Moure, *Little Theatres*, 43.

56. Elisa Sampedrín [Erín Moure], "Poems," *West Coast Line* 42, no. 1 (2008): 98–99.

57. Sampredrín, *Little Theatres*, 38.

58. Wittgenstein, *Culture and Values*, 6e–7e.

59. Shklovsky, "Art as Technique," 741.

60. Sampredrín, *Little Theatres*, 40.

61. Sampredrín, *Little Theatres*, 25.

62. Sampredrín, *Little Theatres*, 40.

63. Emmanuel Levinas, *Entre Nous: Thinking of the Other*, trans. Michael Smith and Barbara Harshav (New York: Columbia University Press, 1998), 35, 55, 107.

64. Emmanuel Levinas, *Ethics and Infinity: Conversations with Philippe Nemo*, trans. Richard A. Cohen (Pittsburgh: Duquesne University Press, 1985), 95–98, 119.

65. Emmanuel Levinas, *Otherwise Than Being: or, Beyond Essence*, trans. Alphonso Lingis (The Hague: Martinus Nijhoff, 1981), 139.

66. Sampredrín, *Little Theatres*, 9.

67. Gerald L. Bruns, "The Concepts of Art and Poetry in Emmanuel Levinas's Writings," in *A Cambridge Companion to Emmanuel Levinas*, ed. Simon Critchley and Robert Bernasconi (Cambridge: Cambridge University Press, 2002), 229.

68. Bruns, "Concepts," 229.

69. Moure, *My Beloved Wager*, 188.

70. Sampredrín, *Little Theatres*, back cover.

71. Oana Avasilichioaei and Erín Moure, *Expeditions of a Chimæra* (Toronto: BookThug, 2009), 3.

72. Avasilichioaei and Moure, *Expeditions*, 12.

73. Genette, *Paratexts*, 52.

74. Avasilichioaei and Moure, *Expeditions*, back cover.

75. Avasilichioaei and Moure, *Expeditions*, 13.

76. Avasilichioaei and Moure, *Expeditions*, 14.

77. Avasilichioaei and Moure, *Expeditions*, 15.

78. Avasilichioaei and Moure, *Expeditions*, 16.

79. Moure, *My Beloved Wager*, 53.

80. Avasilichioaei and Moure, "Translation," 211.

81. Avasilichioaei and Moure, "Translation," 212.

82. Avasilichioaei and Moure, "Translation," 212.

83. Anne Carson, *Autobiography of Red* (Toronto: Vintage, 1999), 3.

84. Fernando Pessoa, *A Galaxy of Poets: 1888–1935*, trans. and ed. José Blanco (Camden, UK: Libraries and Arts Department, 1985), 1–18.

85. MacKay, "Brilliant Disguise," 86.

86. Moure, *My Beloved Wager*, 320.

87. David Solway, "The Pelagic Bard of Kalypso's Isle," *Books in Canada* 28, no. 7 (1999): 20.

88. Solway, "The Pelagic Bard," 20.

89. David Solway, "Found in Translation," *Canadian Notes and Queries* 76 (2009): 10.

90. Matthew Hays, "Karavis: Greek God of Poetry or Literary Hoax?" *Globe and Mail*, October 10, 2000, R1.

91. Ben Downing, "Modern Homer Unmasked as a Mythical Figure," *Guardian* (London), March 24, 2001, https://tinyurl.com/ybqhtfjm/.

92. Hays, "Karavis," R1.

93. Solway, "Found in Translation," 10.

94. Solway, "Found in Translation," 8.

95. Donald W. Foster, "In the Name of the Author," *New Literary History* 33, no. 2 (2002): 377.

96. Foster, "In the Name of the Author," 379.

97. Foster, "In the Name of the Author," 382.

98. Solway, "Found in Translation," 8.

99. Solway, "Found in Translation," 7.

100. David Solway, "Medicine for the CanLit Soul: The Poet Andreas Karavis Was Dreamed Up as a Hoax. That Didn't Stop the World from Treating Him as Real," *National Post*, January 6, 2001, B10.

101. Solway, "Found in Translation," 7.

102. Solway, "Found in Translation," 7.

103. Solway, "Medicine," B10.

104. David Solway, "The Dream," *Atlantic*, December 1, 1997, https://tinyurl.com/y9bpwd09.

105. Pablo Neruda, "Ode to Salt," in *Selected Odes of Pablo Neruda*, trans. Margaret Sayers Peden (Berkeley: University of California Press, 1990), 367.

106. Neruda, "Ode to Bicycles," in *Selected Odes of Pablo Neruda,* trans. Margaret Sayers Peden (Berkeley: University of California Press, 1990), 285–87.

107. Solway, "Found in Translation," 11.

108. Foster, "In the Name of the Author," 378.

109. Solway, "Found in Translation," 11.

110. Solway, "Found in Translation," 13.

111. Solway, "Found in Translation," 11.

112. Solway, "Found in Translation," 11.

113. Solway, "The Pelagic Bard," 11.

114. Solway, "Found in Translation," 11.

115. Solway, "Found in Translation," 7.

116. Solway, "Found in Translation," 8.

117. Solway, "Found in Translation," 8.

118. Solway, "Found in Translation," 8.

119. Solway, "Found in Translation," 7.

120. Lorraine York, *Margaret Atwood and the Labour of Literary Celebrity* (Toronto: University of Toronto Press, 2013), 4.

121. Constance Grady, "Why *Handmaid's Tale* Author Margaret Atwood Is Facing #MeToo Backlash," Vox.com, January 17, 2018, https://tinyurl.com/y8v9ockj.

122. For further critical engagement on the impact of the UBC Accountable letter on Canadian literature, see Hannah McGregor, Julie Rak, and Erin Wunker, eds., *Refuse: CanLit in Ruins* (Toronto: Book*hug Press, 2018).

123. Solway, "Medicine," B10.

124. Susanna Egan, *Burdens of Proof: Faith, Doubt, and Identity in Autobiography* (Waterloo, ON: Wilfrid Laurier University Press, 2011), 110.

125. Solway, "Medicine," B10.

126. Solway, "Medicine," B10.

127. David Solway, *An Andreas Karavis Companion* (Montreal: Véhicule Press, 2000), 98.

128. Solway, *Karavis Companion,* 105–6.

129. Solway, *Karavis Companion,* 98.

130. Egan, *Burdens of Proof,* 110.

131. Diana Fitzgerald Bryden, "Literary Mystery Seeded with Clues," *National Post,* January 6, 2006, B11.

132. Fitzgerald Bryden, "Literary Mystery," B11.

133. Solway, *Karavis Companion,* 98.

134. Solway, "Found in Translation," 7.

135. Solway, "The Pelagic Bard."

136. Solway, "Found in Translation," 8.

137. Solway, "Medicine," B10.

138. Solway, "Found in Translation," 7.

139. Solway, "Found in Translation," 7.

140. Attridge, *Singularity*, 128.

141. Kearney, *The Wake of Imagination*, 368.

142. Attridge, *Singularity*, 129.

143. Avasilichioaei and Moure, "Translation," 208.

144. Solway, "Medicine," B10.

145. Carmine Starnino, "How Poems Work," *Globe and Mail*, September 21, 2002, D18.

146. Fitzgerald Bryden, "Literary Mystery," B11.

147. Solway, "Found in Translation," 8.

148. Solway, "Found in Translation," 8.

149. Moure, *My Beloved Wager*, 196.

150. Moure, *My Beloved Wager*, 49.

151. Lambert-Beatty, "Make-Believe," 62.

152. Lambert-Beatty, "Make-Believe," 62.

153. Lambert-Beatty, "Make-Believe," 66.

154. "Translation: Arts across Canada," Canada Council for the Arts website, accessed November 26, 2018, https://tinyurl.com/y8mkuyph.

155. "Translation: Arts Abroad," Canada Council for the Arts website, accessed November 26, 2018, https://tinyurl.com/y9yo3wvn.

156. *Roadmap for Canada's Official Languages 2013–2018: Education, Immigration, Communities*, Government of Canada, last modified March 28, 2018, https://tinyurl.com/ycbx5bwk.

157. *Roadmap*, https://tinyurl.com/ycbx5bwk.

158. Statistics Canada, "Linguistic Characteristics of Canadians," Government of Canada, last updated July 23, 2018, https://tinyurl.com/yav3qqed.

159. Statistics Canada, "Immigrant Languages in Canada," Government of Canada, last updated July 23, 2018, https://tinyurl.com/ya84vf5z.

160. Moure, *My Beloved Wager*, 195.

161. Moure, *My Beloved Wager*, 195–98.

162. Moure, *My Beloved Wager*, 196.

163. Moure, *My Beloved Wager*, 196.

164. Howard Palmer, "Mosaic versus Melting Pot? Immigration and Ethnicity in Canada and the United States," *International Journal* 31, no. 3 (1976): 488.

165. Palmer, "Mosaic," 488.

166. Sontag, "The World as India."

167. Moure, *My Beloved Wager*, 196.

168. Stephen Harper quoted in Aaron Wherry, "What He Was Talking about When He Talked about Colonialism," *Maclean's*, October 1, 2009, https://tinyurl.com/ycw4j2uo.

169. Lambert-Beatty, "Make-Believe," 66.
170. Lambert-Beatty, "Make-Believe," 66.
171. Attridge, *Singularity*, 130–31.
172. Sontag, "The World as India."

CONCLUSION

1. Lewis Carroll, *Alice's Adventures in Wonderland* and *Through the Looking-Glass* (1865/1871; repr., London: Penguin, 1998), 41.
2. Jeff Wall quoted in Thierry Pelenec, *Jeff Wall: The Complete Edition* (New York and London: Phaidon, 2009), 21.
3. Wall quoted in Pelenec, *Jeff Wall*, 21.
4. Wall quoted in Pelenec, *Jeff Wall*, 21.

Bibliography

"Aboriginal Nutritional Experiments Had Ottawa's Approval." CBC.ca. Last
updated July 30, 2013. https://tinyurl.com/ydcjd5dx.

Abramson, Julia. *Learning from Lying: Paradoxes of the Literary Mystification.*
Newark: University of Delaware Press, 2005.

"Account of Literary Forgeries." From Robertson on the Parian Chronicle.
Classical Journal 16 (1817): 123–44. Google Books. Accessed November 27, 2018.
https://tinyurl.com/ybf7c9lg.

Adler, Dan. "On Iris Häussler" *Artforum* 47, no. 8 (April 2009): 197.

Agrell, Siri. "Does the Artist's Story Affect the Art? I Was Sucked In by Iris
Häussler, but My Reaction Was Authentic." *National Post*, September 12, 2006.

Ahmed, Sara. *Queer Phenomenology: Orientations, Objects, Others.* Durham, NC:
Duke University Press, 2006.

Aldarondo, Cecilia. "Hidden in Plain Sight: Iris Häussler's *He Named Her Amber*."
Art Papers (July/August 2009): 32–39.

———. "Yes, There Is a Joseph Wagenbach: History and the Performativity of
What Might Be True." *Performance Research* 16, no. 2 (2011): 154–62.

Alfred, Taiaiake. Foreword to *Unsettling the Settler Within: Indian Residential
Schools, Truth Telling, and Reconciliation in Canada.* Vancouver: University of
British Columbia Press, 2011.

American Museum of Natural History. Northwest Coast Hall. Accessed
November 27, 2018. https://tinyurl.com/ydy4fagw.

Ames, Michael. *Cannibal Tours and Glass Boxes: The Anthropology of Museums.*
Vancouver: University of British Columbia Press, 1992.

Aristotle. *Poetics.* Translated by Gerald F. Else. Ann Arbor: University of Michigan
Press, 1967.

———. *Rhetoric.* Translated by Hugh Lawon-Tancred. London: Penguin Classics,
1992.

Arnold, Jeanne, Anthony Graesch, Elinor Ochs, and Enzo Ragazzini. *Life at Home in the Twenty-First Century: 32 Families Open Their Doors*. Los Angeles: Cotsen Institute of Archaeology Press, 2012.

Assu, Sonny. "Personal Totems." In *Troubling Tricksters: Revisioning Critical Conversations*, edited by Deanna Reder and Linda M. Morra, 135–54. Waterloo, ON: Wilfrid Laurier University Press, 2010.

Attridge, Derek. *The Singularity of Literature*. New York: Routledge, 2004.

Augaitis, Daina. *Brian Jungen*. Vancouver: Art Gallery of Vancouver and Douglas and McIntyre, 2005.

Augaitis, Daina, and Kathleen Ritter, eds. *Rebecca Belmore: Rising to the Occasion*. Vancouver: Vancouver Art Gallery, 2008.

Avasilichioaei, Oana, and Erín Moure. *Expeditions of a Chimæra*. Toronto: BookThug, 2009.

———. "Translation, Collaboration, and Reading the Multiple." *Canadian Literature* 210–211 (2011): 207–18. https://canlit.ca/full-issue/?issue=210-211.

Bailey, Liz. "Why Have Some Artists Turned to Anthropology in Their Practice and How Has This Turn Been Interpreted and Critiqued?" Liz Bailey (website). https://tinyurl.com/y8a8b2em.

Baillie, Martha. "An Encounter with Joseph Wagenbach." *Brick* (Summer 2007).

———. "Memoir of a Tour Guide." In *He Named Her Amber*, by Iris Häussler. Toronto: Art Gallery of Ontario, 2011.

———. "Two Works by Iris Häussler: *He Named Her Amber* and *Honest Threads*." As part of the *Truth or Dare* panel arranged by the Koffler Gallery, Toronto, March 5, 2009.

Baird, Daniel. "Trauma Mama: Angry, Eloquent, Fragile, Native Artist Rebecca Belmore Takes Her New Work to the Venice Biennale." *Walrus*. Updated August 23, 2017. https://thewalrus.ca/trauma-mama/.

Barents, Els. "Typology, Luminescence, Freedom: Selections from a Conversation with Barkan, Elazar." In *The Guilt of Nations: Restitution and Negotiating Historical Injustice*. Baltimore: Johns Hopkins University Press, 2000.

Beattie, Judith Hudson, and Helen M. Buss, eds. *Undelivered Letters to Hudson's Bay Company Men on the Northwest Coast of America, 1830–57*. Vancouver: University of British Columbia Press, 2003.

Beckett, Alice. *Fakes: Forgery and the Art World*. London: Richard Cohen Books, 1995.

Belmore, Rebecca. *The Named and the Unnamed*. 2002. Video projection, light bulbs, dimensions variable. Morris and Helen Belkin Art Gallery, Vancouver.

———. "Wild." In *Rebecca Belmore: Rising to the Occasion*, edited by Daina Augaitis and Kathleen Ritter. Vancouver, Vancouver Art Gallery, 2008.

Bergo, Bettina. "Emmanuel Levinas." *Stanford Encyclopedia of Philosophy*. Last modified August 3, 2011. https://plato.stanford.edu/entries/levinas/.

Bhabha, Homi K. Interview by Solange de Boer and Zoë Gray. In *Brian Jungen: Source Book*. Rotterdam: Witte de With Center for Contemporary Art, 2006.

Blanco, José. Introduction to *A Galaxy of Poets: 1888–1935*, by Fernando Pessoa. Translated and edited by José Blanco. Camden, UK: Libraries and Arts Department, 1985.

The Blind Man. No. 2. International Dada Archive. Iowa City: University of Iowa Libraries. https://tinyurl.com/mksdll9.

Boas, Franz. "The Indian Tribes of the Lower Fraser River." In *Report of the Sixty-fourth Meeting of the British Association for the Advancement of Science Held at Oxford in August 1894*. Early Canadiana Online. https://tinyurl.com/y7xr8ve4.

Booth, Wayne. *A Rhetoric of Irony*. Chicago: University of Chicago Press, 1974.

Borges, Jorge Luis. *Selected Non-Fictions*. Edited by Eliot Weinberger. Translated by Ester Allen, Suzanne Jill Levine, and Eliot Weinberger. New York: Viking, 1999.

Bradley, Jessica. "Rebecca Belmore: Art and the Object of Performance." In *Rebecca Belmore: "Fountain."* Kamloops and Vancouver: Kamloops Art Gallery and Morris and Helen Belkin Art Gallery, 2005. Exhibition catalogue.

Brewer, John. *Ethnography*. Philadelphia: Open University Press, 2000.

Bruns, Gerald L. "The Concepts of Art and Poetry in Emmanuel Levinas's Writings." In *A Cambridge Companion to Emmanuel Levinas*, edited by Simon Critchley and Robert Bernasconi, 206–33. Cambridge: Cambridge University Press, 2002.

Bryce, Benjamin. "The Mosaic vs. the Melting Pot? A Roundtable and Podcast." ActiveHistory.ca. November 23, 2012. https://tinyurl.com/nup8nur.

Buium, Greg. "Body Language." CBC.ca. Last updated July 8, 2008. https://tinyurl.com/y9nzq84j.

Caeiro, Alberto. *See* Pessoa, Fernando.

Caple, Natalee. "Passing Between Two Toledos or Desperately Seeking Sampedrín: Some Thoughts on Elisa Sampedrín." *Open Letter* 14, no. 2 (2010).

Carroll, Lewis. *Alice's Adventures in Wonderland* and *Through the Looking-Glass*. 1865/1871. Reprint, London: Penguin, 1998.

Carson, Andrea. "Inside the Outsider's Mind: Iris Häussler's *The Legacy of Joseph Wagenbach*." *Border Crossings* 26, no. 2 (2007): 64–70.

Carson, Anne. *Autobiography of Red*. Toronto: Vintage, 1999.

———. "Essay on What I Think about Most." In *Men in the Off Hours*. Toronto: Vintage, 2001.

Cheetham, Mark, and Linda Hutcheon. *Remembering Postmodernism: Trends in Canadian Art, 1970–1990*. Toronto: Oxford University Press, 2012.

Clapperton, Jonathan Alex. "Contested Spaces, Shared Places: The Museum of Anthropology at UBC, Aboriginal Peoples, and Postcolonial Criticism." *BC Studies* 165 (2010): 7–30.

Clark, Jay T. J., Claude Gintz, Serge Guilbaut, and Anne Wagner. "Representation, Suspicions, and Critical Transparency." In *Jeff Wall: Selected Essays and Interviews*. New York: Museum of Modern Art, 2007.

Clifford, James. *The Predicament of Culture*. Cambridge, MA: Harvard University Press, 1988.

Coates, Ta-Nehisi. *Between the World and Me*. New York: Spiegel and Grau, 2015.

Cohen, Ted. "Metaphor and the Cultivation of Intimacy." *Critical Inquiry* 5, no. 1 (Autumn 1978): 3–12.

Coles, Alex, ed. *Site-Specificity: The Ethnographic Turn*. London: Black Dog, 2001.

Coremans, P. B. *Van Meegeren's Faked Vermeers and De Hooghs: A Scientific Examination*. London: Cassell, 1949.

Critchley, Simon. *The Ethics of Deconstruction*. London: Blackwell, 1992.

Dawkings, Heather. "Paul Kane and the Eye of Power: Racism in Canadian Art History." *Vanguard* 15, no. 4 (1986): 14–17.

Delva, Melanie. "Truth and Reconciliation." Public lecture at Christ Church Cathedral, Vancouver, February 22, 2016. https://thecathedral.ca/sermons/melanie-delva/.

Derksen, Jeff. "Big Failures." In *Resonant Dialogues: 25 Years of the Second Story Art Society in Calgary*. Calgary: Truck Gallery, 2009.

———. "Fun Critique in Ethnographic Fields." *Fuse* 21, no. 3 (1998): 47–48.

DeWalt, Kathleen, and Billie DeWalt. *Participant Observation: A Guide for Fieldworkers*. New York: Rowman Altamira, 2011.

Dick, Terrance. "Portrait of the Artist as a Young Fake." *Globe and Mail*, September 16, 2006.

Dictionary of the Social Sciences. s.v. "salvage anthropology." Oxford: Oxford University Press, 2002.

Duchamp, Marcel. *Fountain*. 1917. Porcelain replica by Arturo Schwarz, based on photograph by Alfred Steiglitz, 360 × 480 × 610 mm. Tate Modern, London.

———. *With My Tongue in My Cheek*. 1959. Plaster and pencil on paper mounted on wood, 25.0 × 15.0 × 5.1 cm. Musée National d'Art Moderne, Centre Georges Pompidou, Paris.

Duchamp, Marcel, and Alfred Wolkenberg. *Marcel Duchamp Cast Alive*. 1967. Bronze with chessboard of onyx and black Belgian marble, 54.61 × 42.55 × 23.5 cm. Nelson-Atkins Museum of Art, Kansas City, MO.

Dyer, Geoff. *The Ongoing Moment*. New York: Pantheon, 2005.

Eaglestone, Robert. *Ethical Criticism: Reading after Levinas*. Edinburgh: Edinburgh University Press, 1997.

Eaton, Diane, and Sheila Urbanek. *Paul Kane's Great Nor-West*. Vancouver: UBC Press, 1997.

Egan, Susanna. *Burdens of Proof: Faith, Doubt, and Identity in Autobiography*. Waterloo, ON: Wilfrid Laurier University Press, 2011.

Emin, Tracey. *My Bed*. 1998. Mattress, linens, pillows, objects, 79 × 211 × 234 cm. Tate Britain, London.

Enright, Robert. "The Consolation of Plausibility: An Interview with Jeff Wall." *Border Crossings* 19, no. 1 (February 2000): 50.

Fenton, James. "No Strings Attached." *Guardian* (London), March 8, 2003. https://tinyurl.com/yaj3yz4k.

Fortin, Marc-André. "Rebranding Canadian Identity at the Canadian Museum of History: Keeping the Aboriginal Subject as an Artifact of Absence." Joint panel with the Association of Canadian College and University Teachers of English and the British Society for Literature and Science at the Congress of the Canadian Federation of Humanities and Social Sciences, Calgary, AB, May 30, 2016.

Foster, Donald W. "In the Name of the Author." *New Literary History* 33, no. 2 (2002): 375–96.

Foster, Hal. "The Artist as Ethnographer?" In *The Traffic in Culture: Refiguring Art and Anthropology*, edited by G. Marcus and F. Myers. Berkeley: University of California Press, 1995.

Foucault, Michel. "What Is an Author?" In *Modern Criticism and Theory*. 2nd ed. Edited by David Lodge and Nigel Wood. Harlow, UK: Pearson, 2000.

Francis, Daniel. *The Imaginary Indian: The Image of the Indian in Canadian Culture*. Vancouver: Arsenal Pulp, 1999.

Fried, Michael. "Being There: Michael Fried on Two Pictures by Jeff Wall." *Artforum* 43, no. 1 (September 2004). https://tinyurl.com/y9ck5jsu.

———. *Why Photography Matters as Art as Never Before.* New Haven, CT: Yale University Press, 2008.

Fusco, Coco. "The Other History of Intercultural Performance." *Drama Review* 38, no. 1 (1994): 143–67. https://tinyurl.com/ybkoohya.

Gehmacher, Arlene. "Paul Kane: Life and Work." Art Canada Institute website. Accessed November 28, 2018. https://tinyurl.com/y8j5avku.

Genette, Gérard. *Paratexts: Thresholds of Interpretation.* Translated by Jane Lewin. Literature, Culture, Theory 20. Cambridge: Cambridge University Press, 1997.

George-Cosh, David. "Hoax or Art? Man's Life Fabricated as Part of an Elaborate Project." *National Post*, September 12, 2006.

———. "Reclusive Downtown Artist a Hoax: Hundreds Toured Queen West Home." *National Post*, September 12, 2006.

Goddard, Peter. "The Man Who Wasn't There; Phantom Sculptor's 'Abandoned' Art Really Wasn't What It Seemed." *Toronto Star*, March 17, 2007.

Gordon, Avery F. *Ghostly Matters: Haunting the Sociological Imagination.* Minneapolis: University of Minnesota Press, 1997.

Grady, Constance. "Why *Handmaid's Tale* Author Margaret Atwood Is Facing #MeToo Backlash." Vox.com. January 17, 2018. https://tinyurl.com/y8v9ockj.

Graesch, Anthony. "Archaeological and Ethnoarchaeological Investigations of Households and Perspectives on a Coast Salish Historic Village in British Columbia." PhD diss., University of California, Los Angeles, 2006.

———. "Material Indicators of Family Busyness." *Social Indicators Research* 93, no. 1 (2009): 85–94.

———. "Modeling Ground Slate Knife Production and Implications for the Study of Household Labor Contributions to Salmon Fishing on the Pacific Northwest Coast." *Journal of Anthropological Archaeology* 26, no. 4 (2007): 576–606.

Grafton, Anthony. *Forgers and Critics: Creativity and Duplicity in Western Scholarship.* Princeton, NJ: Princeton University Press, 1990.

Grande, Sandy. *Red Pedagogy: Native American Social and Political Thought.* Lanham, MD: Rowman and Littlefield, 2004.

Gray, Charlotte. "At Home in the Grange." In *House Guests: The Grange 1817 to Today.* Toronto: Art Gallery of Ontario, 2001.

Griffin, Kevin. "Artist Slips under Sheets at All-Night Art Party." West Coast Life. *Vancouver Sun*, June 26–July 2, 2008.

Griffin, Robert J. *The Faces of Anonymity: Anonymous and Pseudonymous Publication from the Sixteenth to the Twentieth Century.* New York: Palgrave Macmillan, 2003.

Gruber, Jacob. "Ethnographic Salvage and the Shaping of Anthropology." *American Anthropologist*, n.s., 72, no. 6 (1970): 1289–99.

Guardian (London). "Vandal Takes Scissors to Artist's Adaptation of Rodin Sculpture." April 7, 2003. https://tinyurl.com/y89ahhq4.

Haig-Brown, Celia, and David A. Nock. *With Good Intentions: Euro-Canadian and Aboriginal Relations in Colonial Canada.* Vancouver: University of British Columbia Press, 2006.

Hansen, Jackie. "Missing and Murdered Indigenous Women and Girls: Understanding the Numbers." Amnesty International website. Accessed December 11, 2018. https://tinyurl.com/y9oqdz4t.

Harbin, Ami. "Bodily Disorientation and Moral Change." *Hypatia* 27, no. 2 (2012): 261–80.

———. *Disorientation and Moral Life.* New York: Oxford University Press, 2016.

Harper, Russell. *Paul Kane's Frontier.* Toronto: University of Toronto Press, 1971.

Häussler, Iris. *He Named Her Amber.* Toronto: Art Gallery of Ontario, 2011. Exhibition catalogue.

Hebborn, Eric. *The Art Forger's Handbook.* London: Cassell, 1997.

Higgs, Matthew. "Brian Jungen in Conversation with Matthew Higgs." In *Brian Jungen.* Vienna: Secession, 2003.

"A History of Residential Schools in Canada." CBC.ca. Last updated March 21, 2016. https://tinyurl.com/y7r64zqj.

Honig, Edwin, and Susan M. Brown. Introduction to *The Keeper of Sheep: "O Guardador de Rebanhos."* Translated by Edwin Honig and Susan M. Brown. Rhinebeck, NY: Sheep Meadow Press, 1997.

Hutcheon, Linda. *The Canadian Postmodern: A Study of Contemporary English-Canadian Fiction.* Don Mills, ON: Oxford University Press, 1988.

———. *Irony's Edge: The Theory and Politics of Irony.* London: Routledge, 1994.

———. *Splitting Images: Contemporary Canadian Ironies.* Toronto: Oxford University Press, 1991.

———. *A Theory of Parody: Teachings of Twentieth-Century Art Forms.* New York: Methuen, 1985.

Hyde, Lewis. *Trickster Makes This World: Mischief, Myth, and Art.* New York: North Point Press, 1999.

Ingram, Paul. "Pissing in Duchamp's Fountain." *3:AM Magazine,* June 23, 2014. https://tinyurl.com/ybcp7ozq.

Jakobson, Roman. "Closing Statement: Linguistics and Poetics." In *Style in Language,* edited by Thomas Sebeok. Cambridge, MA: MIT Press, 1960.

Judovitz, Dalia. *Drawing on Art: Duchamp and Company*. Minneapolis: University of Minnesota Press, 2010.

Jungen, Brian. *Brian Jungen*. Vancouver: Contemporary Art Gallery, 2001. Exhibition catalogue.

———. *Brian Jungen: Source Book*. Rotterdam: Witte de With Center for Contemporary Art, 2006.

———. *Field Work, 1997–1998 (remade 2006)*. 2006. Carved into gallery walls, dimensions variable. Vancouver Art Gallery, Vancouver.

———. *Prototypes for a New Understanding*. 1998–2005. Nike Air Jordans, human hair, dimensions variable.

———. *Sketches Solicited for Wall Drawings*. Paint, vinyl decals, solicited drawings, dimensions variable. Truck Gallery, Calgary, and Charles H. Scott Gallery, Vancouver. 1997–1999.

———. *Toronto Field Work 2000*. 2000. Latex paint on wall. Dimensions unknown. YYZ Artists' Outlet, Toronto Pearson International Airport, Toronto.

Kamping-Carder, Leigh. "Lost and Found: Reversing Minimalism and Ethnography in Brian Jungen's *Field Work*." *Seven Oaks Magazine*, April 12, 2006.

Kane, Paul. *Assiniboine Hunting Buffalo*. ca. 1851–56. Oil on canvas, 46 × 73.7 cm. National Gallery of Canada, Ottawa.

———. *Flathead Woman and Child, Caw-wacham*. ca. 1848–53. Oil on canvas, 75.7 × 63.2 cm. Montreal Museum of Fine Art, Montreal.

———. *Kee-a-kee-ka-sa-coo-way, The Man Who Gives the War Whoop*. ca. 1848. Oil on canvas, 0.61 m × 15.24 cm. Royal Ontario Museum, Toronto.

———. "Wanderings of an Artist." In *Paul Kane's Frontier*, edited by J. Russell Harper. Toronto: University of Toronto Press, 1971.

Karavis, Andreas. *See* Solway, David.

Kearney, Richard. *The Wake of Imagination*. Minneapolis: University of Minnesota Press, 1988.

Kennedy, Maev. "Rodin's Lovers Bound with a Mile of String." *Guardian* (London), February 26, 2003. https://tinyurl.com/y76490wp.

King, Thomas. *The Inconvenient Indian: A Curious Account of Native People in North America*. Toronto: Anchor Canada, 2013.

Kingwell, Mark. "Imagining the Artist: Going to Eleven and the Legacies of Joseph Wagenbach." In *Opening Gambits: Essays on Art and Philosophy*. Toronto: Key Porter, 2008.

———. "The Legacy of Joseph Wagenbach." Statement for panel discussion, Goethe-Institut Toronto, September 20, 2006. http://haeussler.ca/legacy/MarkKingwell.html.

Lambert-Beatty, Carrie. *Make-Believe: Parafiction and Contemporary Art*. Chicago: University of Chicago Press, forthcoming.

———. "Make-Believe: Parafiction and Plausibility." *October* 129 (Summer 2009): 51–84.

Lear, Jonathan. *A Case for Irony*. Cambridge, MA: Harvard University Press, 2011.

Lederman, Marsha. "Rebecca Belmore: Rising to the Occasion—Once Again." *Globe and Mail*, June 28, 2008.

Lejeune, Philippe. "On Autobiography." In *Theory and History of Literature 52*. Translated by Katherine Leary. Edited by Paul John Eakin. Minneapolis: University of Minnesota Press, 1989.

Lepofsky, Dana, David M. Schaepe, Anthony P. Graesch, Michael Lenert, Patricia Ormerod, Keith Thor Carlson, Jeanne E. Arnold, Michael Blake, Patrick Moore, and John J. Clague. "Exploring Stó:lō-Coast Salish Interaction and Identity in Ancient Houses and Settlements in the Fraser Valley, British Columbia." *American Antiquity* 74, no. 4 (October 2009): 595–626.

Levinas, Emmanuel. "Enigma and Phenomenon." In *Basic Philosophical Writings*, edited by Adriann T. Peperzak, Simon Critchley, and Robert Bernasconi, 63–77. Bloomington: Indiana University Press, 1996.

———. *Entre Nous: Thinking of the Other*. Translated by Michael Smith and Barbara Harshav. New York: Columbia University Press, 1998.

———. *Ethics and Infinity: Conversations with Philippe Nemo*. Translated by Richard A. Cohen. Pittsburgh: Duquesne University Press, 1985.

———. "Idéologie et Idéalisme." In *De Dieu qui vient à l'idée*. Paris: Vrin, 1982.

———. *Otherwise Than Being: or, Beyond Essence*. Translated by Alphonso Lingis. The Hague: Martinus Nijhoff, 1981.

———. "Reality and Its Shadow." In *The Levinas Reader*, translated by Alphonso Lingis, edited by Seán Hand, 129–43. Oxford: Blackwell, 1989.

———. *Totality and Infinity*. Translated by Alphonso Lingis. Pittsburgh: Duquesne University Press, 1969.

Lubow, Arthur. "The Luminist." *New York Times Magazine*, February 25, 2007. https://tinyurl.com/y9pfrx3s/.

MacGregor, Arthur. "Collectors and Collections of Rarities in the Sixteenth and Seventeenth Centuries." In *Tradescant's Rarities: Essays on the Foundations of the Ashmolean Museum, 1683, with a Catalogue of the Surviving Early Collections*. Oxford: Clarendon, 1983.

MacKay, Gillian. "Brilliant Disguise: Iris Häussler's Fact-Meets-Fiction Odysseys." *Canadian Art* (Winter 2009): 82–87.

MacLaren, I. S. "'I Came to Rite Thare Portraits': Paul Kane's Journal of His Western Travels, 1846–1848." *American Art Journal* 21, no. 2 (1989): 6–88.

Maclear, Kyo. "Pup Tent." *Canadian Art* 17, no. 4 (Winter 2000): 74–75.

Mahr, Greg. "Pessoa, Life Narrative, and the Dissociative Process." *Biography* 21, no. 1 (Winter 1998): 24–35.

McDowell, Sara. *The Indigenous History of Tkaronto*. University of Toronto Libraries Research Guides. Last updated December 17, 2018. https://guides .library.utoronto.ca/Toronto.

McGregor, Hannah, Julie Rak, and Erin Wunker, eds. *Refuse: CanLit in Ruins*. Toronto: Book*hug Press, 2018.

McHale, Brian. "'A Poet May Not Exist': Mock-Hoaxes and the Construction of National Identity." In *The Faces of Anonymity: Anonymous and Pseudonymous Publication from the Sixteenth to the Twentieth Century*, edited by Robert J. Griffin, 233–52. New York: Palgrave Macmillan, 2003.

Medina, Cuauhtémoc. "High Curios." In *Brian Jungen*. Vancouver: Vancouver Art Gallery Press, 2010.

Menzel, Peter. *Material World: A Global Family Portrait*. San Francisco: Sierra Club, 1994.

Milroy, Sarah. "At Home on the Grange." *Globe and Mail*, September 15, 2001. https://tinyurl.com/y7kjfyqj.

———. "Rebecca Belmore: Al Dente." *Globe and Mail: Report on Business*, Visual Arts Supplement, May 2005.

———. "Strangeness at the Grange." *Globe and Mail*, November 29, 2008.

———. "Trauma and Triumph." *Globe and Mail*, October 8, 2002.

Moos, David. "*He Named Her Amber*: Curator's Statement." January 2009. Accessed November 12, 2010. http://haeussler.ca/amber/curator.html.

———. "Rehearsal." In *He Named Her Amber*, 105–13. Toronto: Art Gallery of Ontario, 2011.

Moure, Eirin. *Sheep's Vigil by a Fervent Person: A Transelation of Alberto Caeiro/ Fernando Pessoa's "O Guardador de Rebanhos."* Toronto: House of Anansi, 2001.

Moure, Erín. *Little Theatres: Teatriños*. Toronto: House of Anansi, 2005.

———. *My Beloved Wager: Essays from a Writing Practice*. Edmonton: NeWest Press, 2009.

———. *O Cadoiro*. Toronto: House of Anansi, 2007.

———. *O Resplandor*. Toronto: House of Anansi, 2010.

Moure, Erín, and Erin Balsar. "Erín Moure Discusses *Sheep's Vigil by a Fervent Person*." *CBC Canada Reads Poetry*. Web interview April 19, 2011.

Museum of Modern Art. "Glossary of Art Terms." *MoMALearning*. Accessed December 4, 2018. https://tinyurl.com/y72akqm4.

Muybridge, Eadweard. *The Human Figure in Motion*. Dover: New York, 1955.

Nahwegahbow, Barb. "Wampum Holds Power of Earliest Agreements." Aboriginal Multi-Media Society website. Published 2014. https://tinyurl.com/ycznfutc.

Neruda, Pablo. "Ode to Bicycles." In *Selected Odes of Pablo Neruda*, translated by Margaret Sayers Peden, 282–87. Berkeley: University of California Press, 1990.

———. "Ode to Salt." In *Selected Odes of Pablo Neruda*, translated by Margaret Sayers Peden, 366–69. Berkeley: University of California Press, 1990.

Nietzsche, Friedrich. *Beyond Good and Evil*. Translated by R. J. Hollingdale. Harmondsworth, UK: Penguin, 1973.

———. "On Truth and Lie in an Extra-Moral Sense." https://tinyurl.com/27hzkn.

"North American Ethnographic Collection." Anthropology Division. American Museum of Natural History website. Accessed November 28, 2018. http://research.amnh.org/anthropology/database/nae_sub.

Office of the High Commissioner for Human Rights. "Convention on the Prevention and Punishment of the Crime of Genocide." United Nations website. https://tinyurl.com/yckyhytb.

Palmer, Howard. "Mosaic versus Melting Pot? Immigration and Ethnicity in Canada and the United States." *International Journal* 31, no. 3 (1976): 488–528.

Parker, Cornelia. *The Distance: A Kiss with Added String*. 2003. Original Rodin sculpture and mile of string. Tate Britain Museum, London.

"Paul Kane." National Gallery of Canada online. Copyright 2018. https://tinyurl.com/y75h4bpm.

Paull, H. M. *Literary Ethics: A Study in the Growth of the Literary Conscience*. London: Thornton Butterworth, 1928.

Pelenec, Thierry. *Jeff Wall: The Complete Edition*. New York: Phaidon, 2009.

Pessoa, Fernando. *A Galaxy of Poets: 1888–1935*. Translated and edited by José Blanco. Camden, UK: Libraries and Arts Department, 1985.

———. *A Little Larger Than the Entire Universe: Selected Poems*. Edited and translated by Richard Zenith. New York: Penguin, 2006.

———. *Always Astonished: Selected Poems of Fernando Pessoa*. Translated by Edwin Honig. San Francisco: City Lights, 2001.

———. *The Book of Disquiet*. Edited and translated by Richard Zenith. New York: Penguin, 2002.

———. *The Collected Poems of Alberto Caeiro*. Translated by Chris Daniels. Exeter, UK: Shearsman, 2007.

———. *The Keeper of Sheep: "O Guardador de Rebanhos."* Translated by Edwin Honig and Susan M. Brown. Rhinebeck, NY: Sheep Meadow Press, 1997.

———. *Poems of Fernando Pessoa.* Translated by Edwin Honig. San Francisco: City Lights, 2001.

———. *Selected Poems.* Edited and translated by Peter Rickard. Austin: University of Texas Press, 1976.

Razack, Sherene H. "Gendered Racial Violence and Spacialized Justice: The Murder of Pamela George." *Canadian Journal of Law and Society* 15, no. 2 (2000): 91–130.

Reder, Deanna, and Linda M. Morra, eds. *Troubling Tricksters: Revisioning Critical Conversations.* Waterloo, ON: Wilfrid Laurier University Press, 2010.

Reducing the Number of Indigenous Children in Care. Indigenous Services Canada. https://bit.ly/2zJZA9z.

Regan, Paulette. *Unsettling the Settler Within: Indian Residential Schools, Truth Telling, and Reconciliation in Canada.* Vancouver: University of British Columbia Press, 2011.

Reid, Shier. "Cheap." In *Brian Jungen.* Vancouver: Charles H. Scott Gallery, 2000.

"Report of the Parliamentary Select Committee on Aboriginal Tribes (British Settlements)." Reprinted with Comments by the Aborigines Protection Society. Published for the Society by William Bell, Aldine Chambers, London: Paternoster Row, and Hatchard and Son, Piccadilly, 1837. Google Books. Accessed November 28, 2018. https://tinyurl.com/ycq3teat.

Rickard, Peter. "The Genesis of the Heteronyms." In *Fernando Pessoa: Selected Poems,* edited and translated by Peter Rickard. Austin: University of Texas Press, 1976.

Rieger, Jennifer. "Collection X: The Grange." Art Gallery of Ontario online. Last modified April 15, 2013. http://www.ago.net/collection-x-the-grange.

———. "History of the Grange." Art Gallery of Ontario online. Copyright 2018. http://www.ago.net/history-of-the-grange.

———. *House Guests: The Grange 1817 to Today.* Toronto: Art Gallery of Ontario, 2001.

Rifkin, Mark. *Beyond Settler Time: Temporal Sovereignty and Indigenous Self-Determination.* Durham, NC: Duke University Press, 2017.

Ritter, Kathleen. "The Reclining Figure and Other Provocations." In *Rebecca Belmore: Rising to the Occasion,* edited by Daina Augaitis and Kathleen Ritter. Vancouver: Vancouver Art Gallery, 2008.

Roadmap for Canada's Official Languages 2013–2018: Education, Immigration, Communities. Government of Canada. Last modified March 28, 2018. https://tinyurl.com/ycbx5bwk.

Rodin, Auguste. *The Kiss*. 1882. Marble, 181.5 × 112.5 × 117 cm. Musée Rodin, Paris.

"Rodin String Art Repaired." BBC News online. Last updated April 8, 2003. http://news.bbc.co.uk/2/hi/entertainment/2927487.stm.

Rose, Mark. *Authors and Owners: The Invention of Copyright*. Cambridge, MA: Harvard University Press, 1993.

Ruby, Jay. "Visual Anthropology." In *Encyclopedia of Cultural Anthropology*, edited by David Levinson and Melvin Ember. New York: Henry Holt and Company, 1996.

Ruthven, K. K. *Faking Literature*. Cambridge: Cambridge University Press, 2001.

Sampedrín, Elisa. *See* Moure, Erín.

Schaepe, David, Keith Thor Carlson, John Sutton Lutz, Naxaxalhts'i (Albert "Sonny" McHalsie), eds. *Towards a New Ethnohistory: Community-Engaged Scholarship among the People of the River*. Winnipeg: University of Manitoba Press, 2018.

Shklovsky, Viktor. "Art as Technique." Translated by Lee T. Lemon and Marion Reis. In *The Critical Tradition*, edited by David H. Richter. New York: Saint Martin's Press, 1989.

Smith, Paul Chatt. *Everything You Know about Indians Is Wrong*. Minneapolis: University of Minnesota Press, 2009.

Sokal, Alan D. "A Physicist Experiments with Cultural Studies." *Lingua Franca* 6, no. 4 (1996): 62–64.

———. "Transgressing the Boundaries: Toward a Transformative Hermeneutics of Quantum Gravity." *Social Text* 46–47 (1996): 217–52.

Solway, David. *An Andreas Karavis Companion*. Montreal: Véhicule Press, 2000.

———. "Credo." *Atlantic*, March 1998. https://tinyurl.com/ycjkbefw.

———. "The Dream." *Atlantic*, December 1, 1997. https://tinyurl.com/y9bpwdo9.

———. "Found in Translation." *Canadian Notes and Queries* 76 (2009): 7–13.

———. "The Pelagic Bard of Kalypso's Isle." *Books in Canada* 28, no. 7 (1999). https://tinyurl.com/ycumvk8x.

———. *Saracen Island: The Poems of Andreas Karavis*. Montreal: Véhicule Press, 1998.

Sontag, Susan. "The World as India: The St. Jerome Lecture on Literary Translation." Susan Sontag Foundation website. April 2, 2012. https://tinyurl.com/7cvxm4u.

Statistics Canada. "Immigrant Languages in Canada." Government of Canada. Last updated July 23, 2018. https://tinyurl.com/ya84vf5z.

———. "Linguistic Characteristics of Canadians." Government of Canada. Last updated July 23, 2018. https://tinyurl.com/yav3qqed.

Steele, Hunter. "Fakes and Forgeries." *British Journal of Aesthetics* 17 (1977): 254–58.

Steiner, George. "A Man of Many Parts." *Observer* (London), June 3, 2001. https://tinyurl.com/y87m43md.

Steinmann, Kate. "Iris Häussler: *He Named Her Amber*." *Contemporary Art* 104 (2009): 42. https://cmagazine.com/issues/104/pdf.

The Survivors Speak: A Report of the Truth and Reconciliation Commission of Canada. Ottawa: Truth and Reconciliation Commission of Canada, 2015. http://publications.gc.ca/pub?id=9.800109&sl=0.

Taft, Robert. Introduction to *The Human Figure in Motion*, by Eadweard Muybridge. New York: Dover, 1955.

Tate, Maggie. "Re-presenting Invisibility: Ghostly Aesthetics in Rebecca Belmore's *Vigil* and *The Named and the Unnamed*." *Visual Studies* 30, no. 1 (2015): 20–31.

Teitelbaum, Matthew. Epilogue to *He Named Her Amber*, by Iris Häussler (exhibition catalogue). Toronto: Art Gallery of Ontario, 2011.

Townsend-Gault, Charlotte, and James Luna. *Rebecca Belmore: The Named and the Unnamed.* Vancouver: Morris and Helen Belkin Art Gallery, 2003. Exhibition catalogue.

"Translation: Arts Abroad." Canada Council for the Arts website. Accessed November 26, 2018. https://tinyurl.com/y9yo3wvn.

"Translation: Arts Across Canada." Canada Council for the Arts website. Accessed November 26, 2018. https://tinyurl.com/y8mkuyph.

Vosters, Helene. "Beyond Memorialization: Activating Empathy for the 'Lost Subjects of History' through Embodied Memorial Performance." *Canadian Theatre Review* 157 (2014): 34–38.

Wall, Jeff. *Jeff Wall: Selected Essays and Interviews.* New York: Museum of Modern Art, 2007.

———. *Jeff Wall: Vancouver Art Gallery Collection*, edited by Grant Arnold. Vancouver: Vancouver Art Gallery, 2008. Exhibition catalogue.

Waugh, Linda R. "The Poetic Function in the Theory of Roman Jakobson." *Poetics Today* 2, no. 1a (1980): 57–82.

Weschler, Lawrence. *Mr. Wilson's Cabinet of Wonder: Pronged Ants, Horned Humans, Mice on Toast, and Other Marvels of Jurassic Technology.* New York: Vintage, 1996.

Wherry, Aaron. "What He Was Talking about When He Talked about Colonialism." *Maclean's*, October 1, 2009. https://tinyurl.com/ycw4j2uo.

Whyte, Murray. "Homage to a Man's Faux Life." *Toronto Star*, September 16, 2006.

Wittgenstein, Ludwig. *Culture and Value.* Translated by Peter Winch. Chicago: University of Chicago Press, 1984.

———. *Philosophical Investigations.* Translated by G. E. M. Anscombe. Oxford: Blackwell, 1972.

York, Lorraine. *Margaret Atwood and the Labour of Literary Celebrity.* Toronto: University of Toronto Press, 2013.

Zenith, Richard. "Introduction: The Birth of a Nation." In *A Little Larger Than the Entire Universe: Selected Poems,* by Fernando Pessoa. Edited and translated by Richard Zenith. New York: Penguin, 2006.

———. Introduction to *The Book of Disquiet,* by Fernando Pessoa. Edited and translated by Richard Zenith. New York: Penguin, 2002.

Index

History; Canadian Museum of
History; house museum; Museum
of Jurassic Technology; Museum of
Natural History; Smithsonian
museum-goer, 12, 32, 59, 118, 164. *See
also* museum visitor
museum labels, 29–30, 61, 83
Museum of Jurassic Technology, 3
Museum of Natural History, 78. *See
also* American Museum of Natural
History
museum visitor, 3, 10, 37, 55
Muybridge, Eadweard, 46, 48, 175n73
mystification, 5, 33–34, 56, 171n9
myth, 1–2, 11–12, 43, 49, 51, 70–71,
75–78, 104, 108, 114–16, 118, 157–58,
171n1, 186n91
mythology, 43, 71, 115

names, 2, 6, 38, 52, 109, 111, 117, 122, 135,
142, 164
Nanabozho, 42–44, 76
National Film Board (NFB), 70
National Gallery of Canada, 30, 178n13
National Historic Site, 23, 25, 29, 62
nationhood, 23, 158
Native, 23, 69, 71, 79, 83, 88–89, 103–4,
116; Nativeness, 79, 86–88
near-documentary, 9, 94–95, 105, 107
near-near documentary, 95
Nietzsche, Friedrich, 3, 171n6
non-fiction, 31, 124, 132

objets trouvés, 88
ode, 144
omnity, 125, 135, 143–44, 149, 156
ontology, 59, 124, 135
open eyes, 36, 39, 49
O'Shea, Mary, 2, 15, 19, 22–23, 25,
28–29, 36–38, 44, 48–49, 51–53,
55–56, 140, 152

Other, 135–36, 185n63. *See also* Levinas,
Emmanuel
Oxford English Dictionary, 4, 9, 171n7,
173n23, 183n7

pact, 10, 29, 31, 35, 54–55, 58, 62, 165
parafiction, 55–56, 60, 62, 173n29
Parker, Cornelia, 64–65
Parliamentary Select Committee on
Aboriginal Tribes, 179n44
participant observation, in archaeology,
98, 102, 181n83
Peaceful Settler, 12, 70, 77, 108, 114
People of the River, 97, 104. *See also*
Stó:lō
perception, 25, 58–59, 91, 120, 124
performance art, 2, 29, 63, 70, 111, 117
Pessoa, Fernando, 2, 6, 119–20, 122–24,
126, 130, 135, 137, 140–41, 151, 160, 163,
183n1, 183n14, 184n18, 184n21, 184n25
philosophy, 3, 59, 126–28, 134–36, 171n6,
172n23
photography, 8, 41, 48, 79, 81, 92–95,
98–99, 102, 105, 108, 181n75
Portuguese, 119, 126–30, 154, 157–58, 160
post-production, 94, 98, 102, 106
prejudice, 12, 83, 91–92
privilege, 12, 66, 80, 92, 105, 117, 148,
155
profit, 60, 117, 132
protocol, 43, 100, 104, 124
pseudonym, 52, 120, 122, 124–26,
143–44, 152, 171n11, 183n12
public, 17–18, 21, 24, 26, 31, 34, 36,
45, 48, 54–55, 58, 62, 67, 69, 71, 73,
75–78, 80–81, 84, 87, 91–92, 95, 115,
117–18, 124, 132–33, 142–45, 147–48,
154, 157–58, 160, 163
publication, 6, 10, 63, 80, 93, 123, 131,
133, 142, 154–55, 157–58
public education, 69, 73

Wall, Jeff, 1, 9, 12, 20, 22, 41, 69–70,
 78–81, 83, 92–108, 111, 114, 118, 125,
 133, 161–65, 174n61, 180n70, 180n74,
 181n99, 189n2
wax, 15, 19, 21, 23, 28–29, 31, 38, 44,
 49–53, 60, 66, 71, 152, 164
Welqámex, 98–101, 106. *See also*
 Greenwood Island
West Coast, 78, 83, 92
Whyte, Henry, 18–22, 29, 36, 49,
 52–53

Wild (Belmore), 9, 12, 70, 78–79,
 109–11, 114, 116–18, 125
wild west, 73
Wilson, Daniel, 3, 71
With My Tongue in My Cheek
 (Duchamp), 49, 51
Wittgenstein, Ludwig, 6–8, 22, 94, 102,
 107, 133, 172n14

Yes Men, 153–54, 157, 160
York, Lorraine, 147